Saul and David

Saul and David

with 41 lithographs by

Oskar Kokoschka

G.P. Putnam's Sons · New York

First Book of Samuel
Chapters 8–31

Second Book of Samuel
Chapters 1–22
Chapter 23, verses 1–7

And it came to pass, when Samuel was old, that he made his sons judges over Israel.

Now the name of his firstborn was Joel; and the name of his second, Abiah: they were judges in Beer-sheba.
And his sons walked not in his ways, but turned aside after lucre, and took bribes, and perverted judgment.
Then all the elders of Israel gathered themselves together, and came to Samuel unto Ramah,

And said unto him, Behold, thou art old, and thy sons walk not in thy ways: now make us a king to judge us like all the nations.

But the thing displeased Samuel, when they said, Give us a king to judge us. And Samuel prayed unto the Lord.

And the Lord said unto Samuel, Hearken unto the voice of the people in all that they say unto thee: for they have not rejected thee, but they have rejected me, that I should not reign over them.

According to all the works which they have done since the day that I brought them up out of Egypt even unto this day, wherewith they have forsaken me, and served other gods, so do they also unto thee.

Now therefore hearken unto their voice: howbeit yet protest solemnly unto them, and shew them the manner of the king that shall reign over them.

And Samuel told all the words of the Lord unto the people that asked of him a king.

And he said, This will be the manner of the king that shall reign over you: He will take your sons, and appoint them for himself, for his chariots, and to be his horsemen; and some shall run before his chariots.

And he will appoint him captains over thousands, and captains over fifties; and will set them to ear his ground, and to reap his harvest, and to make his instruments of war, and instruments of his chariots.

And he will take your daughters to be confectionaries, and to be cooks, and to be bakers.

And he will take your fields, and your vineyards, and your oliveyards, even the best of them, and give them to his servants.

And he will take the tenth of your seed, and of your vineyards, and give to his officers, and to his servants.

And he will take your menservants, and your maidservants, and your goodliest young men, and your asses, and put them to this work.

He will take the tenth of your sheep: and ye shall be his servants.

And ye shall cry out in that day because of your king which ye shall have chosen you; and the Lord will not hear you in that day.

Nevertheless the people refused to obey the voice of Samuel; and they said, Nay; but we will have a king over us;

That we also may be like all the nations; and that our king may judge us, and go out before us, and fight our battles.

And Samuel heard all the words of the people, and he rehearsed them in the ears of the Lord.

And the Lord said to Samuel, Hearken unto their voice, and make them a king. And Samuel said unto the men of Israel, Go ye every man unto his city.

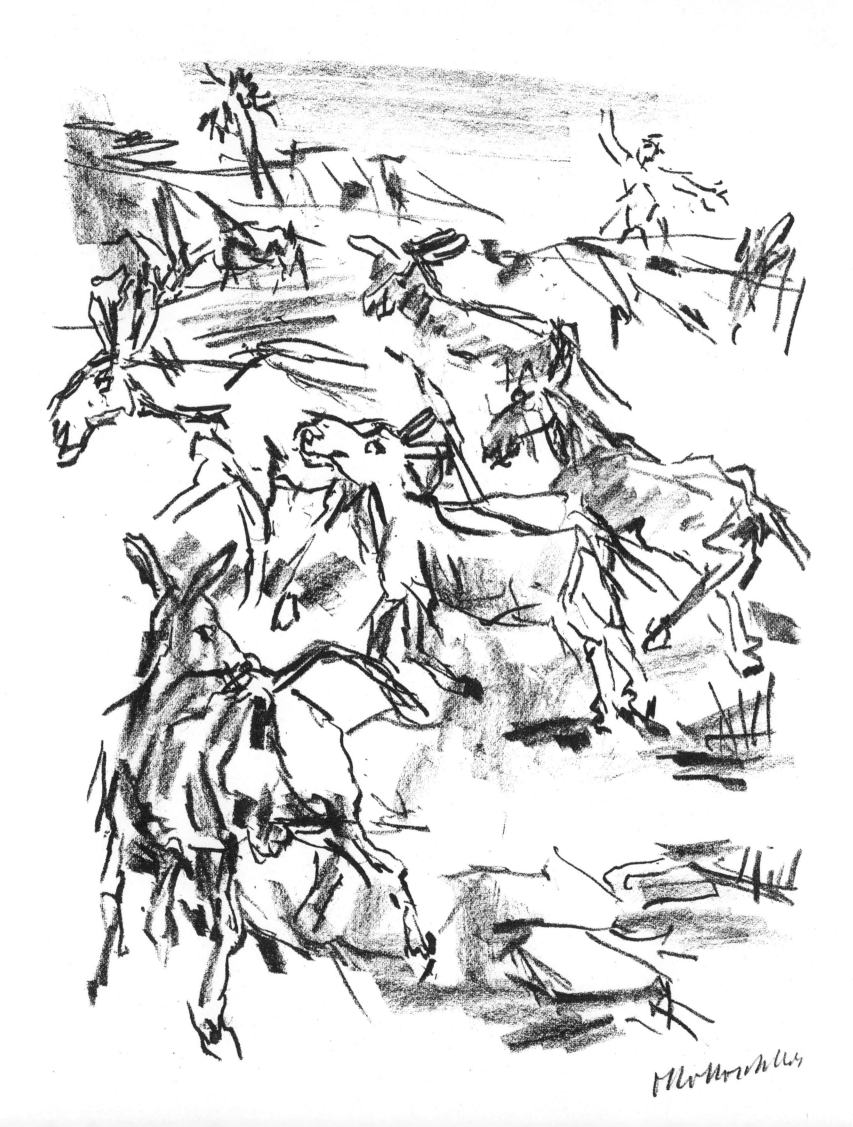

Now there was a man of Benjamin, whose name was Kish, the son of Abiel, the son of Zeror, the son of Bechorath, the son of Aphiah, a Benjamite, a mighty man of power.

And he had a son, whose name was Saul, a choice young man, and a goodly: and there was not among the children of Israel a goodlier person than he: from his shoulders and upward he was higher than any of the people.

And the asses of Kish Saul's father were lost. And Kish said to Saul his son, Take now one of the servants with thee, and arise, go seek the asses.

And he passed through mount Ephraim, and passed through the land of Shalisha, but they found them not: then they passed through the land of Shalim, and there they were not: and he passed through the land of the Benjamites, but they found them not.

And when they were come to the land of Zuph, Saul said to his servant that was with him, Come, and let us return; lest my father leave caring for the asses, and take thought for us.

And he said unto him, Behold now, there is in this city a man of God, and he is an honourable man; all that he saith cometh surely to pass: now let us go thither; peradventure he can shew us our way that we should go.

Then said Saul to his servant, But, behold, if we go, what shall we bring the man? for the bread is spent in our vessels, and there is not a present to bring to the man of God: what have we?

And the servant answered Saul again, and said, Behold, I have here at hand the fourth part of a shekel of silver: that will I give to the man of God, to tell us our way.

(Beforetime in Israel, when a man went to enquire of God, thus he spake, Come, and let us go to the seer: for he that is now called a Prophet was beforetime called a Seer.)

Then said Saul to his servant, Well said; come, let us go. So they went unto the city where the man of God was.

And as they went up the hill to the city, they found young maidens going out to draw water, and said unto them, Is the seer here?

And they answered them, and said, He is; behold, he is before you: make haste now, for he came today to the city; for there is a sacrifice of the people today in the high place:

As soon as ye be come into the city, ye shall straightway find him, before he go up to the high place to eat: for the people will not eat until he come, because he doth bless the sacrifice; and afterwards they eat that be bidden. Now therefore get you up; for about this time ye shall find him.

And they went up into the city: and when they were come into the city, behold, Samuel came out against them, for to go up to the high place.

Now the Lord had told Samuel in his ear a day before Saul came, saying,

Tomorrow about this time I will send thee a man out of the land of Benjamin, and thou shalt anoint him to be captain over my people Israel, that he may save my people out of the hand of the Philistines: for I have looked upon my people, because their cry is come unto me.

And when Samuel saw Saul, the Lord said unto him, Behold the man whom I spake to thee of! this same shall reign over my people.

Then Saul drew near to Samuel in the gate, and said, Tell me, I pray thee, where the seer's house is.

And Samuel answered Saul, and said, I am the seer: go up before me unto the high place; for ye shall eat with me today, and tomorrow I will let thee go, and will tell thee all that is in thine heart.

And as for thine asses that were lost three days ago, set not thy mind on them; for they are found. And on whom is all the desire of Israel? Is it not on thee, and on all thy father's house?

And Saul answered and said, Am not I a Benjamite, of the smallest of the tribes of Israel? and my family the least of all the families of the tribe of Benjamin? wherefore then speakest thou so to me?

And Samuel took Saul and his servant, and brought them into the parlour,

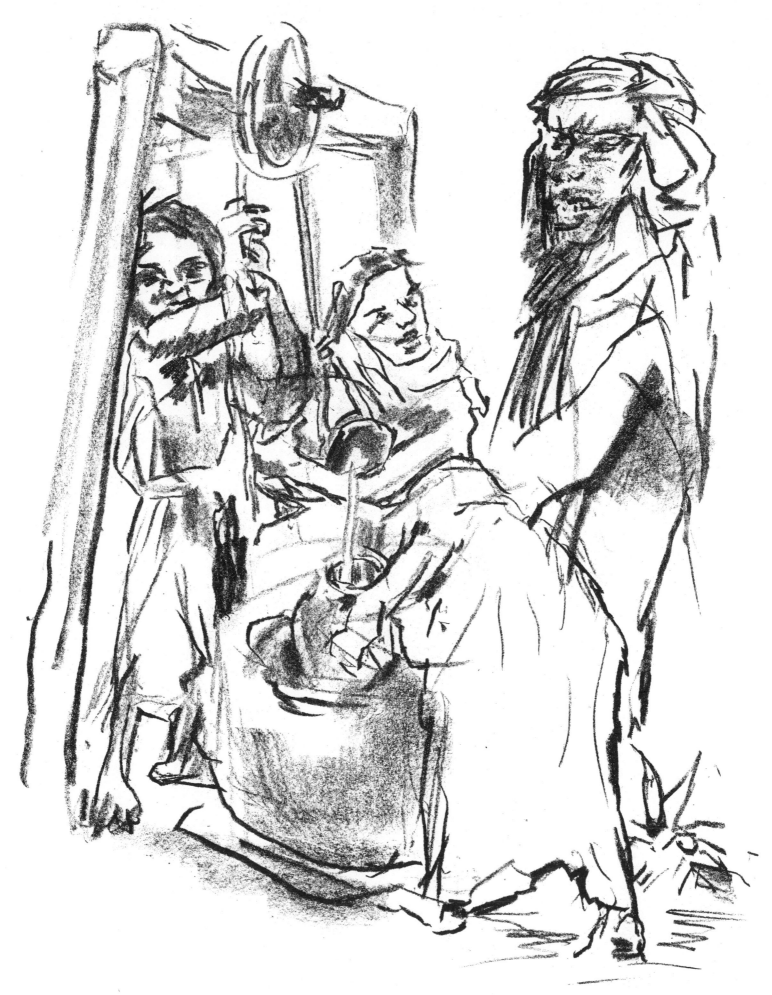

and made them sit in the chiefest place among them that were bidden, which were about thirty persons.

And Samuel said unto the cook, Bring the portion which I gave thee, of which I said unto thee, Set it by thee.

And the cook took up the shoulder, and that which was upon it, and set it before Saul. And Samuel said, Behold that which is left! set it before thee, and eat: for unto this time hath it been kept for thee since I said, I have invited the people. So Saul did eat with Samuel that day.

And when they were come down from the high place into the city, Samuel communed with Saul upon the top of the house.

And they arose early: and it came to pass about the spring of the day, that Samuel called Saul to the top of the house, saying, Up, that I may send thee away. And Saul arose, and they went out both of them, he and Samuel, abroad.

And as they were going down to the end of the city, Samuel said to Saul, Bid the servant pass on before us, (and he passed on,) but stand thou still a while, that I may shew thee the word of God.

Then Samuel took a vial of oil, and poured it upon his head, and kissed him, and said, Is it not because the Lord hath anointed thee to be captain over his inheritance?

When thou art departed from me today, then thou shalt find two men by Rachel's sepulchre in the border of Benjamin at Zelzah; and they will say unto thee, The asses which thou wentest to seek are found: and, lo, thy father hath left the care of the asses, and sorroweth for you, saying, What shall I do for my son?

Then shalt thou go on forward from thence, and thou shalt come to the plain of Tabor, and there shall meet thee three men going up to God to Beth-el, one carrying three kids, and another carrying three loaves of bread, and another carrying a bottle of wine:

And they will salute thee, and give thee two loaves of bread; which thou shalt receive of their hands.

After that thou shalt come to the hill of God, where is the garrison of the Philistines: and it shall come to pass, when thou art come thither to the city, that thou shalt meet a company of prophets coming down from the high place with a psaltery, and a tabret, and a pipe, and a harp, before them; and they shall prophesy:

And the Spirit of the Lord will come upon thee, and thou shalt prophesy with them, and shalt be turned into another man.

And let it be, when these signs are come unto thee, that thou do as occasion serve thee; for God is with thee.

And thou shalt go down before me to Gilgal; and, behold, I will come down unto thee, to offer burnt offerings, and to sacrifice sacrifices of peace offerings: seven days shalt thou tarry, till I come to thee, and shew thee what thou shalt do.

And it was so, that when he had turned his back to go from Samuel, God gave him another heart: and all those signs came to pass that day.

And when they came thither to the hill, behold, a company of prophets met him; and the Spirit of God came upon him, and he prophesied among them.

And it came to pass, when all that knew him beforetime saw that, behold, he prophesied among the prophets, then the people said one to another, What is this that is come unto the son of Kish? Is Saul also among the prophets?

And one of the same place answered and said, But who is their father? Therefore it became a proverb, Is Saul also among the prophets?

And when he had made an end of prophesying, he came to the high place.

And Saul's uncle said unto him and to his servant, Whither went ye? And he said, To seek the asses: and when we saw that they were nowhere, we came to Samuel.

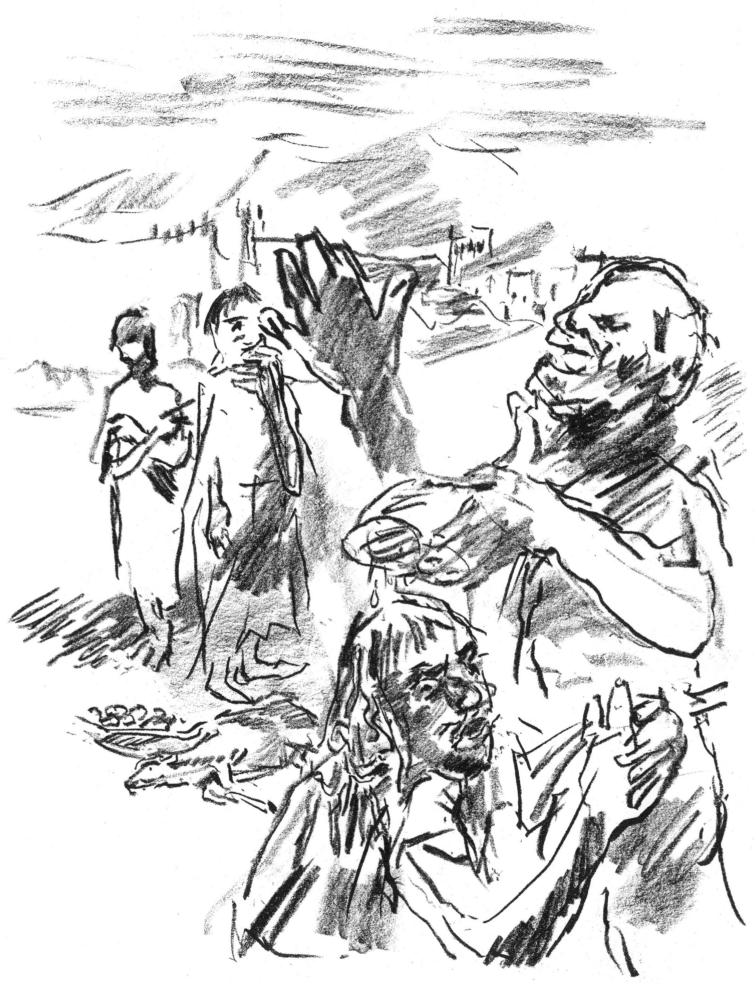

And Saul's uncle said, Tell me, I pray thee, what Samuel said unto you.

And Saul said unto his uncle, He told us plainly that the asses were found. But of the matter of the kingdom, whereof Samuel spake, he told him not.

And Samuel called the people together unto the Lord to Mizpeh;

And said unto the children of Israel, Thus saith the Lord God of Israel, I brought up Israel out of Egypt, and delivered you out of the hand of the Egyptians, and out of the hand of all kingdoms, and of them that oppressed you:

And ye have this day rejected your God, who himself saved you out of all your adversities and your tribulations; and ye have said unto him, Nay, but set a king over us. Now therefore present yourselves before the Lord by your tribes, and by your thousands.

And when Samuel had caused all the tribes of Israel to come near, the tribe of Benjamin was taken.

When he had caused the tribe of Benjamin to come near by their families, the family of Matri was taken, and Saul the son of Kish was taken: and when they sought him, he could not be found. Therefore they enquired of the Lord further, if the man should yet come thither. And the Lord answered, Behold, he hath hid himself among the stuff.

And they ran and fetched him thence: and when he stood among the people, he was higher than any of the people from his shoulders and upward.

And Samuel said to all the people, See ye him whom the Lord hath chosen, that there is none like him among all the people? And all the people shouted, and said, God save the king.

Then Samuel told the people the manner of the kingdom, and wrote it in a book, and laid it up before the Lord. And Samuel sent all the people away, every man to his house.

And Saul also went home to Gibeah; and there went with him a band of men, whose hearts God had touched.

But the children of Belial said, How shall this man save us? And they despised him, and brought him no presents. But he held his peace.

Then Nahash the Ammonite came up, and encamped against Jabesh-gilead: and all the men of Jabesh said unto Nahash, Make a covenant with us, and we will serve thee.

And Nahash the Ammonite answered them, On this condition will I make a covenant with you, that I may thrust out all your right eyes, and lay it for a reproach upon all Israel.

And the elders of Jabesh said unto him, Give us seven days' respite, that we may send messengers unto all the coasts of Israel: and then, if there be no man to save us, we will come out to thee.

Then came the messengers to Gibeah of Saul, and told the tidings in the ears of the people: and all the people lifted up their voices, and wept.

And, behold, Saul came after the herd out of the field; and Saul said, What aileth the people that they weep? And they told him the tidings of the men of Jabesh.

And the Spirit of God came upon Saul when he heard those tidings, and his anger was kindled greatly.

And he took a yoke of oxen, and hewed them in pieces, and sent them throughout all the coasts of Israel by the hands of messengers, saying, Whosoever cometh not forth after Saul and after Samuel, so shall it be done unto his oxen. And the fear of the Lord fell on the people, and they came out with one consent.

And when he numbered them in Bezek, the children of Israel were three hundred thousand, and the men of Judah thirty thousand.

And they said unto the messengers that came, Thus shall ye say unto the men of Jabesh-gilead, To morrow, by that time the sun be hot, ye shall

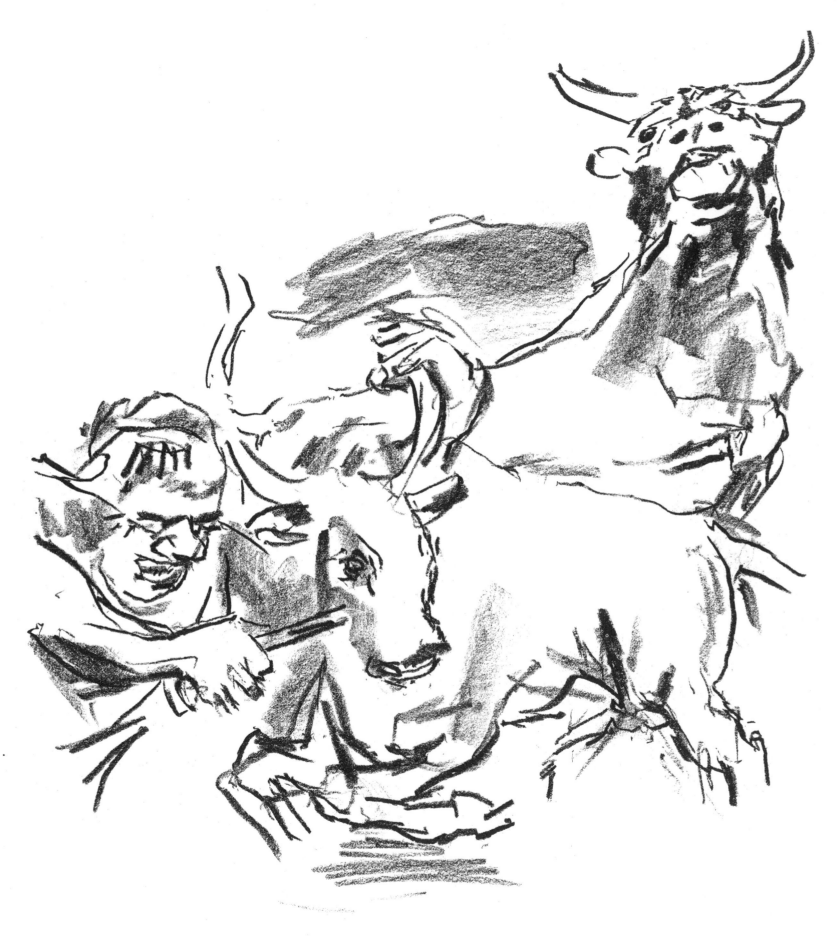

have help. And the messengers came and shewed it to the men of Jabesh; and they were glad.

Therefore the men of Jabesh said, Tomorrow we will come out unto you, and ye shall do with us all that seemeth good unto you.

And it was so on the morrow, that Saul put the people in three companies; and they came into the midst of the host in the morning watch, and slew the Ammonites until the heat of the day: and it came to pass, that they which remained were scattered, so that two of them were not left together.

And the people said unto Samuel, Who is he that said, Shall Saul reign over us? bring the men, that we may put them to death.

And Saul said, There shall not a man be put to death this day: for today the Lord hath wrought salvation in Israel.

Then said Samuel to the people, Come, and let us go to Gilgal, and renew the kingdom there.

And all the people went to Gilgal; and there they made Saul king before the Lord in Gilgal; and there they sacrificed sacrifices of peace offerings before the Lord; and there Saul and all the men of Israel rejoiced greatly.

And Samuel said unto all Israel, Behold, I have hearkened unto your voice in all that ye said unto me, and have made a king over you.

And now, behold, the king walketh before you: and I am old and grayheaded; and, behold, my sons are with you: and I have walked before you from my childhood unto this day.

Behold, here I am: witness against me before the Lord, and before his anointed: whose ox have I taken? or whose ass have I taken? or whom have I defrauded? whom have I oppressed? or of whose hand have I received any bribe to blind mine eyes therewith? and I will restore it you.

And they said, Thou hast not defrauded us, nor oppressed us, neither hast thou taken ought of any man's hand.

23

And he said unto them, The Lord is witness against you, and his anointed is witness this day, that ye have not found ought in my hand. And they answered, He is witness.

And Samuel said unto the people, It is the Lord that advanced Moses and Aaron, and that brought your fathers up out of the land of Egypt.

Now therefore stand still, that I may reason with you before the Lord of all the righteous acts of the Lord, which he did to you and to your fathers.

When Jacob was come into Egypt, and your fathers cried unto the Lord, then the Lord sent Moses and Aaron, which brought forth your fathers out of Egypt, and made them dwell in this place.

And when they forgat the Lord their God, he sold them into the hand of Sisera, captain of the host of Hazor, and into the hand of the Philistines, and into the hand of the king of Moab, and they fought against them.

And they cried unto the Lord, and said, We have sinned, because we have forsaken the Lord, and have served Baalim and Ashtaroth: but now deliver us out of the hand of our enemies, and we will serve thee.

And the Lord sent Jerubbaal, and Bedan, and Jephthah, and Samuel, and delivered you out of the hand of your enemies on every side, and ye dwelled safe.

And when ye saw that Nahash the king of the children of Ammon came against you, ye said unto me, Nay; but a king shall reign over us: when the Lord your God was your king.

Now therefore behold the king whom ye have chosen, and whom ye have desired! and, behold, the Lord hath set a king over you.

If ye will fear the Lord, and serve him, and obey his voice, and not rebel against the commandment of the Lord, then shall both ye and also the king that reigneth over you continue following the Lord your God:

But if ye will not obey the voice of the Lord, but rebel against the commandment of the Lord, then shall the hand of the Lord be against you, as it was against your fathers.

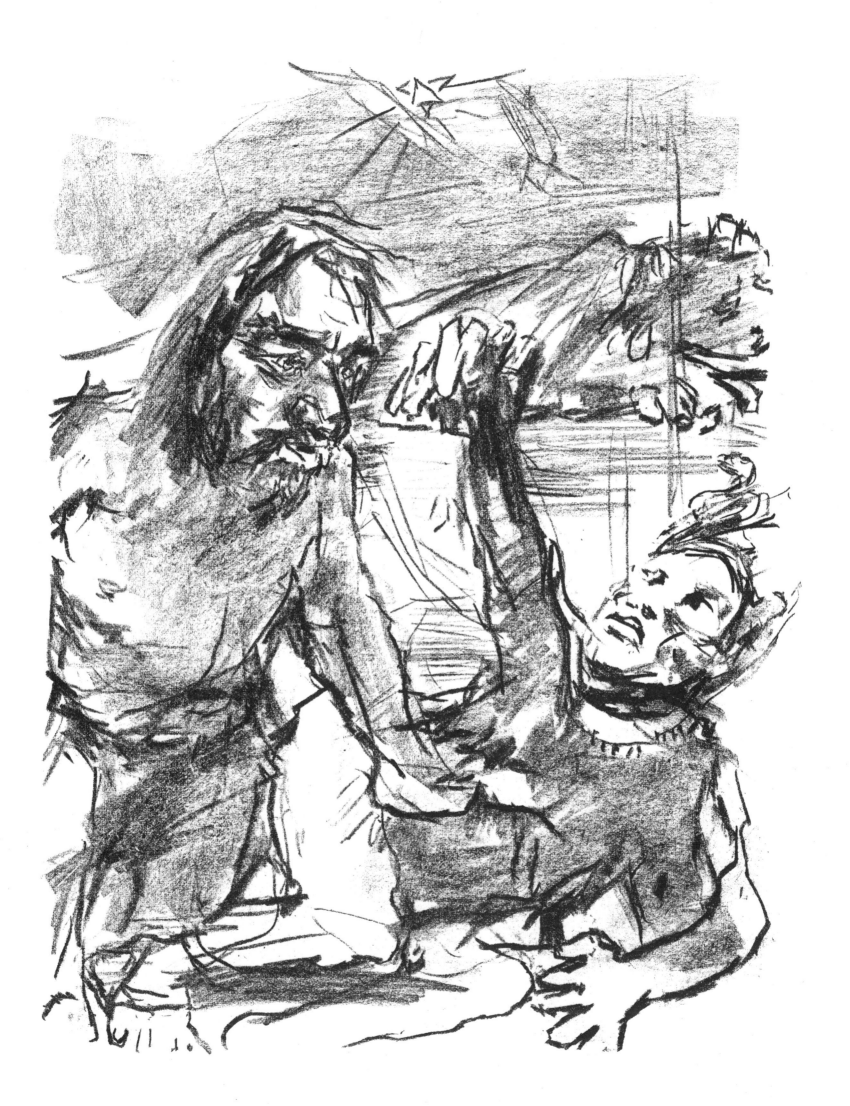

Now therefore stand and see this great thing, which the Lord will do before your eyes.

Is it not wheat harvest to day? I will call unto the Lord, and he shall send thunder and rain; that ye may perceive and see that your wickedness is great, which ye have done in the sight of the Lord, in asking you a king.

So Samuel called unto the Lord; and the Lord sent thunder and rain that day: and all the people greatly feared the Lord and Samuel.

And all the people said unto Samuel, Pray for thy servants unto the Lord thy God, that we die not: for we have added unto all our sins this evil, to ask us a king.

And Samuel said unto the people, Fear not: ye have done all this wickedness: yet turn not aside from following the Lord, but serve the Lord with all your heart;

And turn ye not aside: for then should ye go after vain things, which cannot profit nor deliver; for they are vain.

For the Lord will not forsake his people for his great name's sake: because it hath pleased the Lord to make you his people.

Moreover as for me, God forbid that I should sin against the Lord in ceasing to pray for you: but I will teach you the good and the right way:

Only fear the Lord, and serve him in truth with all your heart: for consider how great things he hath done for you.

But if ye shall still do wickedly, ye shall be consumed, both ye and your king.

Saul reigned one year; and when he had reigned two years over Israel,

Saul chose him three thousand men of Israel; whereof two thousand were with Saul in Michmash and in mount Beth-el, and a thousand were with Jonathan in Gibeah of Benjamin: and the rest of the people he sent every man to his tent.

And Jonathan smote the garrison of the Philistines that was in Geba, and

the Philistines heard of it. And Saul blew the trumpet throughout all the land, saying, Let the Hebrews hear.

And all Israel heard say that Saul had smitten a garrison of the Philistines, and that Israel also was had in abomination with the Philistines. And the people were called together after Saul to Gilgal.

And the Philistines gathered themselves together to fight with Israel, thirty thousand chariots, and six thousand horsemen, and people as the sand which is on the sea shore in multitude: and they came up, and pitched in Michmash, eastward from Beth-aven.

When the men of Israel saw that they were in a strait, (for the people were distressed,) then the people did hide themselves in caves, and in thickets, and in rocks, and in high places, and in pits.

And some of the Hebrews went over Jordan to the land of Gad and Gilead. As for Saul, he was yet in Gilgal, and all the people followed him trembling.

And he tarried seven days, according to the set time that Samuel had appointed: but Samuel came not to Gilgal; and the people were scattered from him.

And Saul said, Bring hither a burnt offering to me, and peace offerings. And he offered the burnt offering.

And it came to pass, that as soon as he had made an end of offering the burnt offering, behold, Samuel came; and Saul went out to meet him, that he might salute him.

And Samuel said, What hast thou done? And Saul said, Because I saw that the people were scattered from me, and that thou camest not within the days appointed, and that the Philistines gathered themselves together at Michmash;

Therefore said I, The Philistines will come down now upon me to Gilgal,

and I have not made supplication unto the Lord: I forced myself therefore, and offered a burnt offering.

And Samuel said to Saul, Thou hast done foolishly: thou hast not kept the commandment of the Lord thy God, which he commanded thee: for now would the Lord have established thy kingdom upon Israel for ever.

But now thy kingdom shall not continue: the Lord hath sought him a man after his own heart, and the Lord hath commanded him to be captain over his people, because thou hast not kept that which the Lord commanded thee.

And Samuel arose, and gat him up from Gilgal unto Gibeah of Benjamin. And Saul numbered the people that were present with him, about six hundred men.

And Saul, and Jonathan his son, and the people that were present with them, abode in Gibeah of Benjamin: but the Philistines encamped in Michmash.

And the spoilers came out of the camp of the Philistines in three companies: one company turned unto the way that leadeth to Ophrah, unto the land of Shual:

And another company turned the way to Beth-horon: and another company turned to the way of the border that looketh to the valley of Zeboim toward the wilderness.

Now there was no smith found throughout all the land of Israel: for the Philistines said, Lest the Hebrews make them swords or spears:

But all the Israelites went down to the Philistines, to sharpen every man his share, and his coulter, and his axe, and his mattock.

Yet they had a file for the mattocks, and for the coulters, and for the forks, and for the axes, and to sharpen the goads.

So it came to pass in the day of battle, that there was neither sword nor

spear found in the hand of any of the people that were with Saul and Jonathan: but with Saul and with Jonathan his son was there found.

And the garrison of the Philistines went out to the passage of Michmash.

Now it came to pass upon a day, that Jonathan the son of Saul said unto the young man that bare his armour, Come, and let us go over to the Philistines' garrison, that is on the other side. But he told not his father.

And Saul tarried in the uttermost part of Gibeah under a pomegranate tree which is in Migron: and the people that were with him were about six hundred men;

And Ahiah, the son of Ahitub, I-chabod's brother, the son of Phinehas, the son of Eli, the Lord's priest in Shiloh, wearing an ephod. And the people knew not that Jonathan was gone.

And between the passages, by which Jonathan sought to go over unto the Philistines' garrison, there was a sharp rock on the one side, and a sharp rock on the other side: and the name of the one was Bozez, and the name of the other Seneh.

The forefront of the one was situate northward over against Michmash, and the other southward over against Gibeah.

And Jonathan said to the young man that bare his armour, Come, and let us go over unto the garrison of these uncircumcised: it may be that the Lord will work for us: for there is no restraint to the Lord to save by many or by few.

And his armourbearer said unto him, Do all that is in thine heart: turn thee; behold, I am with thee according to thy heart.

Then said Jonathan, Behold, we will pass over unto these men, and we will discover ourselves unto them.

If they say thus unto us, Tarry until we come to you; then we will stand still in our place, and will not go up unto them.

But if they say thus, Come up unto us; then we will go up: for the Lord hath delivered them into our hand: and this shall be a sign unto us.

And both of them discovered themselves unto the garrison of the Philistines: and the Philistines said, Behold, the Hebrews come forth out of the holes where they had hid themselves.

And the men of the garrison answered Jonathan and his armourbearer, and said, Come up to us, and we will shew you a thing. And Jonathan said unto his armourbearer, Come up after me: for the Lord hath delivered them into the hand of Israel.

And Jonathan climbed up upon his hands and upon his feet, and his armourbearer after him: and they fell before Jonathan; and his armourbearer slew after him.

And that first slaughter, which Jonathan and his armourbearer made, was about twenty men, within as it were an half acre of land, which a yoke of oxen might plow.

And there was trembling in the host, in the field, and among all the people: the garrison, and the spoilers, they also trembled, and the earth quaked: so it was a very great trembling.

And the watchmen of Saul in Gibeah of Benjamin looked; and, behold, the multitude melted away, and they went on beating down one another.

Then said Saul unto the people that were with him, Number now, and see who is gone from us. And when they had numbered, behold, Jonathan and his armourbearer were not there.

And Saul said unto Ahiah, Bring hither the ark of God. For the ark of God was at that time with the children of Israel.

And it came to pass, while Saul talked unto the priest, that the noise that was in the host of the Philistines went on and increased: and Saul said unto the priest, Withdraw thine hand.

And Saul and all the people that were with him assembled themselves, and

they came to the battle: and, behold, every man's sword was against his fellow, and there was a very great discomfiture.

Moreover the Hebrews that were with the Philistines before that time, which went up with them into the camp from the country round about, even they also turned to be with the Israelites that were with Saul and Jonathan.

Likewise all the men of Israel which had hid themselves in mount Ephraim, when they heard that the Philistines fled, even they also followed hard after them in the battle.

So the Lord saved Israel that day: and the battle passed over unto Beth-aven.

And the men of Israel were distressed that day: for Saul had adjured the people, saying, Cursed be the man that eateth any food until evening, that I may be avenged on mine enemies. So none of the people tasted any food.

And all they of the land came to a wood; and there was honey upon the ground.

And when the people were come into the wood, behold, the honey dropped; but no man put his hand to his mouth: for the people feared the oath.

But Jonathan heard not when his father charged the people with the oath: wherefore he put forth the end of the rod that was in his hand, and dipped it in an honeycomb, and put his hand to his mouth; and his eyes were enlightened.

Then answered one of the people, and said, Thy father straitly charged the people with an oath, saying, Cursed be the man that eateth any food this day. And the people were faint.

Then said Jonathan, My father hath troubled the land: see, I pray you, how mine eyes have been enlightened, because I tasted a little of this honey.

How much more, if haply the people had eaten freely today of the spoil

of their enemies which they found? for had there not been now a much greater slaughter among the Philistines?

And they smote the Philistines that day from Michmash to Aijalon: and the people were very faint.

And the people flew upon the spoil, and took sheep, and oxen, and calves, and slew them on the ground: and the people did eat them with the blood.

Then they told Saul, saying, Behold, the people sin against the Lord, in that they eat with the blood. And he said, Ye have transgressed: roll a great stone unto me this day.

And Saul said, Disperse yourselves among the people, and say unto them, Bring me hither every man his ox, and every man his sheep, and slay them here, and eat; and sin not against the Lord in eating with the blood. And all the people brought every man his ox with him that night, and slew them there.

And Saul built an altar unto the Lord: the same was the first altar that he built unto the Lord.

And Saul said, Let us go down after the Philistines by night, and spoil them until the morning light, and let us not leave a man of them. And they said, Do whatsoever seemeth good unto thee. Then said the priest, Let us draw near hither unto God.

And Saul asked counsel of God, Shall I go down after the Philistines? wilt thou deliver them into the hand of Israel? But he answered him not that day.

And Saul said, Draw ye near hither, all the chief of the people: and know and see wherein this sin hath been this day.

For, as the Lord liveth, which saveth Israel, though it be in Jonathan my son, he shall surely die. But there was not a man among all the people that answered him.

Then said he unto all Israel, Be ye on one side, and I and Jonathan my son

will be on the other side. And the people said unto Saul, Do what seemeth good unto thee.

Therefore Saul said unto the Lord God of Israel, Give a perfect lot. And Saul and Jonathan were taken: but the people escaped.

And Saul said, Cast lots between me and Jonathan my son. And Jonathan was taken.

Then Saul said to Jonathan, Tell me what thou hast done. And Jonathan told him, and said, I did but taste a little honey with the end of the rod that was in mine hand, and, lo, I must die.
And Saul answered, God do so and more also, for thou shalt surely die, Jonathan.

And the people said unto Saul, Shall Jonathan die, who hath wrought this great salvation in Israel? God forbid: as the Lord liveth, there shall not one hair of his head fall to the ground; for he hath wrought with God this day. So the people rescued Jonathan, that he died not.

Then Saul went up from following the Philistines: and the Philistines went to their own place.

So Saul took the kingdom over Israel, and fought against all his enemies on every side, against Moab, and against the children of Ammon, and against Edom, and against the kings of Zobah, and against the Philistines: and whithersoever he turned himself, he vexed them.

And he gathered an host, and smote the Amalekites, and delivered Israel out of the hands of them that spoiled them.

Now the sons of Saul were Jonathan, and Ishui, and Melchishua; and the names of his two daughters were these; the name of the firstborn Merab, and the name of the younger Michal:

And the name of Saul's wife was Ahinoam, the daughter of Ahimaaz: and the name of the captain of his host was Abner, the son of Ner, Saul's uncle.

34

And Kish was the father of Saul; and Ner the father of Abner was the son of Abiel.

And there was sore war against the Philistines all the days of Saul: and when Saul saw any strong man, or any valiant man, he took him unto him.

Samuel also said unto Saul, The Lord sent me to anoint thee to be king over his people, over Israel: now therefore hearken thou unto the voice of the words of the Lord.

Thus saith the Lord of hosts, I remember that which Amalek did to Israel, how he laid wait for him in the way, when he came up from Egypt.

Now go and smite Amalek, and utterly destroy all that they have, and spare them not; but slay both man and woman, infant and suckling, ox and sheep, camel and ass.

And Saul gathered the people together, and numbered them in Telaim, two hundred thousand footmen, and ten thousand men of Judah.

And Saul came to a city of Amalek, and laid wait in the valley.

And Saul said unto the Kenites, Go, depart, get you down from among the Amalekites, lest I destroy you with them: for ye shewed kindness to all the children of Israel, when they came up out of Egypt. So the Kenites departed from among the Amalekites.

And Saul smote the Amelekites from Havilah until thou comest to Shur, that is over against Egypt.

And he took Agag the king of the Amalekites alive, and utterly destroyed all the people with the edge of the sword.

But Saul and the people spared Agag, and the best of the sheep, and of the oxen, and of the fatlings, and the lambs, and all that was good, and would not utterly destroy them: but every thing that was vile and refuse, that they destroyed utterly.

Then came the word of the Lord unto Samuel, saying,

It repenteth me that I have set up Saul to be king: for he is turned back from following me, and hath not performed my commandments. And it grieved Samuel; and he cried unto the Lord all night.

And when Samuel rose early to meet Saul in the morning, it was told Samuel, saying, Saul came to Carmel, and, behold, he set him up a place, and is gone about, and passed on, and gone down to Gilgal.

And Samuel came to Saul: and Saul said unto him, Blessed be thou of the Lord: I have performed the commandment of the Lord.

And Samuel said, What meaneth then this bleating of the sheep in mine ears, and the lowing of the oxen which I hear?

And Saul said, They have brought them from the Amalekites: for the people spared the best of the sheep and of the oxen, to sacrifice unto the Lord thy God; and the rest we have utterly destroyed.

Then Samuel said unto Saul, Stay, and I will tell thee what the Lord hath said to me this night. And he said unto him, Say on.

And Samuel said, When thou wast little in thine own sight, wast thou not made the head of the tribes of Israel and the Lord anointed thee king over Israel?

And the Lord sent thee on a journey, and said, Go and utterly destroy the sinners the Amalekites, and fight against them until they be consumed.

Wherefore then didst thou not obey the voice of the Lord, but didst fly upon the spoil, and didst evil in the sight of the Lord?

And Saul said unto Samuel, Yea, I have obeyed the voice of the Lord, and have gone the way which the Lord sent me, and have brought Agag the king of Amalek, and have utterly destroyed the Amalekites.

But the people took of the spoil, sheep and oxen, the chief of the things which should have been utterly destroyed, to sacrifice unto the Lord thy God in Gilgal.

And Samuel said, Hath the Lord as great delight in burnt offerings and

sacrifices, as in obeying the voice of the Lord? Behold, to obey is better than sacrifice, and to hearken than the fat of rams.

For rebellion is as the sin of witchcraft, and stubbornness is as iniquity and idolatry. Because thou hast rejected the word of the Lord, he hath also rejected thee from being king.

And Saul said unto Samuel, I have sinned: for I have transgressed the commandment of the Lord, and thy words: because I feared the people, and obeyed their voice.

Now therefore, I pray thee, pardon my sin, and turn again with me, that I may worship the Lord.

And Samuel said unto Saul, I will not return with thee: for thou hast rejected the word of the Lord, and the Lord hath rejected thee from being king over Israel.

And as Samuel turned about to go away, he laid hold upon the skirt of his mantle, and it rent.

And Samuel said unto him, The Lord hath rent the kingdom of Israel from thee this day, and hath given it to a neighbour of thine, that is better than thou.

And also the Strength of Israel will not lie nor repent: for he is not a man, that he should repent.

Then he said, I have sinned: yet honour me now, I pray thee, before the elders of my people, and before Israel, and turn again with me, that I may worship the Lord thy God.

So Samuel turned again after Saul; and Saul worshipped the Lord.

Then said Samuel, Bring ye hither to me Agag the king of the Amalekites. And Agag came unto him delicately. And Agag said, Surely the bitterness of death is past.

And Samuel said, As thy sword hath made women childless, so shall thy

mother be childless among women. And Samuel hewed Agag in pieces before the Lord in Gilgal.

Then Samuel went to Ramah; and Saul went up to his house to Gibeah of Saul.

And Samuel came no more to see Saul until the day of his death: nevertheless Samuel mourned for Saul: and the Lord repented that he had made Saul king over Israel.

And the Lord said unto Samuel, How long wilt thou mourn for Saul, seeing I have rejected him from reigning over Israel? fill thine horn with oil, and go, I will send thee to Jesse the Beth-lehemite: for I have provided me a king among his sons.

And Samuel said, How can I go? if Saul hear it, he will kill me. And the Lord said, Take an heifer with thee, and say, I am come to sacrifice to the Lord.

And call Jesse to the sacrifice, and I will shew thee what thou shalt do: and thou shalt anoint unto me him whom I name unto thee.

And Samuel did that which the Lord spake, and came to Beth-lehem. And the elders of the town trembled at his coming, and said, Comest thou peaceably?

And he said, Peaceably: I am come to sacrifice unto the Lord: sanctify yourselves, and come with me to the sacrifice. And he sanctified Jesse and his sons, and called them to the sacrifice.

And it came to pass, when they were come, that he looked on Eliab, and said, Surely the Lord's anointed is before him.

But the Lord said unto Samuel, Look not on his countenance, or on the height of his stature; because I have refused him: for the Lord seeth not as man seeth; for man looketh on the outward appearance, but the Lord looketh on the heart.

'I have transgressed the commandment of the Lord'

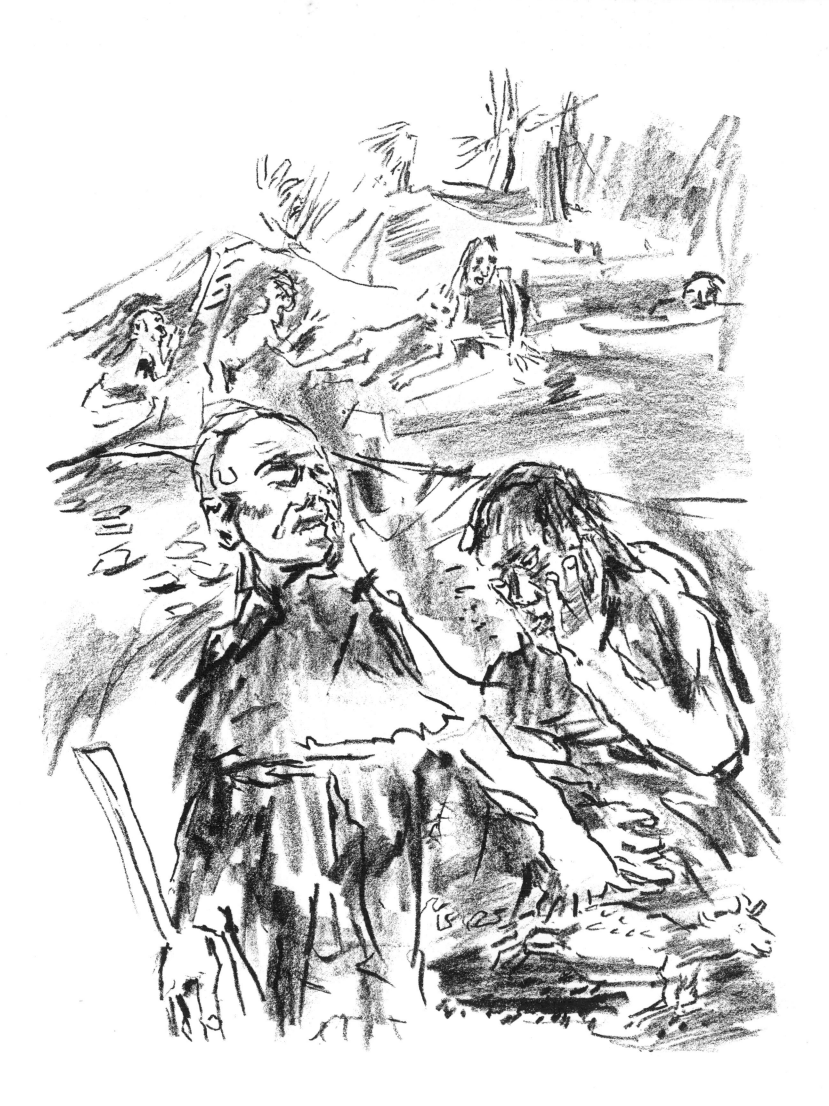

Then Jesse called Abinadab, and made him pass before Samuel. And he said, Neither hath the Lord chosen this.

Then Jesse made Shammah to pass by. And he said, Neither hath the Lord chosen this.

Again, Jesse made seven of his sons to pass before Samuel. And Samuel said unto Jesse, The Lord hath not chosen these.

And Samuel said unto Jesse, Are here all thy children? And he said, There remaineth yet the youngest, and, behold, he keepeth the sheep. And Samuel said unto Jesse, Send and fetch him: for we will not sit down till he come hither.

And he sent, and brought him in. Now he was ruddy, and withal of a beautiful countenance, and goodly to look to. And the Lord said, Arise, anoint him: for this is he.

Then Samuel took the horn of oil, and anointed him in the midst of his brethren: and the Spirit of the Lord came upon David from that day forward. So Samuel rose up, and went to Ramah.

But the Spirit of the Lord departed from Saul, and an evil spirit from the Lord troubled him.

And Saul's servants said unto him, Behold now, an evil spirit from God troubleth thee.

Let our lord now command thy servants, which are before thee, to seek out a man, who is a cunning player on an harp: and it shall come to pass, when the evil spirit from God is upon thee, that he shall play with his hand, and thou shalt be well.

And Saul said unto his servants, Provide me now a man that can play well, and bring him to me.

Then answered one of the servants, and said, Behold, I have seen a son of Jesse the Beth-lehemite, that is cunning in playing, and a mighty valiant man, and a man of war, and prudent in matters, and a comely person, and the Lord is with him.

Wherefore Saul sent messengers unto Jesse, and said, Send me David thy son, which is with the sheep.

And Jesse took an ass laden with bread, and a bottle of wine, and a kid, and sent them by David his son unto Saul.

And David came to Saul, and stood before him: and he loved him greatly; and he became his armourbearer.

And Saul sent to Jesse, saying, Let David, I pray thee, stand before me; for he hath found favour in my sight.

And it came to pass, when the evil spirit from God was upon Saul, that David took an harp, and played with his hand: so Saul was refreshed, and was well, and the evil spirit departed from him.

Now the Philistines gathered together their armies to battle, and were gathered together at Shochoh, which belongeth to Judah, and pitched between Shochoh and Azekah, in Ephes-dammim.

And Saul and the men of Israel were gathered together, and pitched by the valley of Elah, and set the battle in array against the Philistines.

And the Philistines stood on a mountain on the one side, and Israel stood on a mountain on the other side: and there was a valley between them.

And there went out a champion out of the camp of the Philistines, named Goliath, of Gath, whose height was six cubits and a span.

And he had an helmet of brass upon his head, and he was armed with a coat of mail; and the weight of the coat was five thousand shekels of brass.

And he had greaves of brass upon his legs, and a target of brass between his shoulders.

And the staff of his spear was like a weaver's beam; and his spear's head weighed six hundred shekels of iron: and one bearing a shield went before him.

And he stood and cried unto the armies of Israel, and said unto them, Why are ye come out to set your battle in array? am not I a Philistine, and ye

'Anoint him: for this is he'

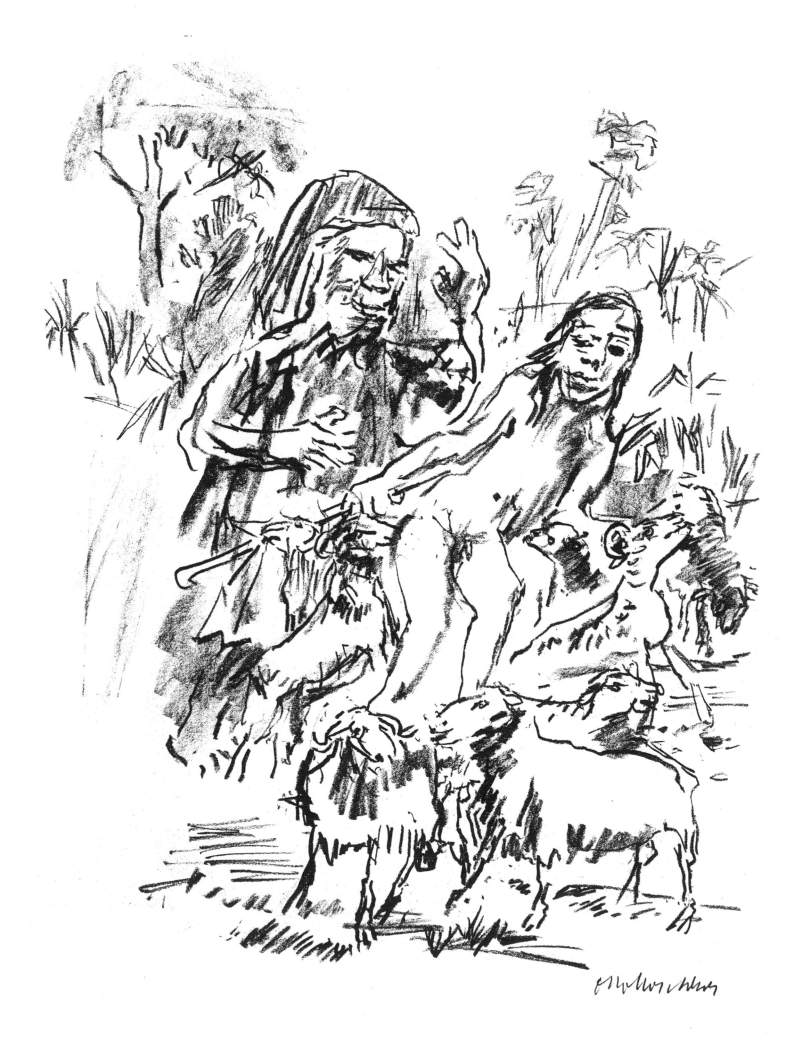

servants to Saul? choose you a man for you, and let him come down to me.

If he be able to fight with me, and to kill me, then will we be your servants: but if I prevail against him, and kill him, then shall ye be our servants, and serve us.

And the Philistine said, I defy the armies of Israel this day; give me a man, that we may fight together.

When Saul and all Israel heard those words of the Philistine, they were dismayed, and greatly afraid.

Now David was the son of that Ephrathite of Beth-lehem-judah, whose name was Jesse; and he had eight sons: and the man went among men for an old man in the days of Saul.

And the three eldest sons of Jesse went and followed Saul to the battle: and the names of his three sons that went to the battle were Eliab the firstborn, and next unto him Abinadab, and the third Shammah.

And David was the youngest: and the three eldest followed Saul.

But David went and returned from Saul to feed his father's sheep at Beth-lehem.

And the Philistine drew near morning and evening, and presented himself forty days.

And Jesse said unto David his son, Take now for thy brethren an ephah of this parched corn, and these ten loaves, and run to the camp to thy brethren;

And carry these ten cheeses unto the captain of their thousand, and look how thy brethren fare, and take their pledge.

Now Saul, and they, and all the men of Israel, were in the valley of Elah, fighting with the Philistines.

And David rose up early in the morning, and left the sheep with a keeper,

and took, and went, as Jesse had commanded him; and he came to the trench, as the host was going forth to the fight, and shouted for the battle.

For Israel and the Philistines had put the battle in array, army against army.

And David left his carriage in the hand of the keeper of the carriage, and ran into the army, and came and saluted his brethren.

And as he talked with them, behold, there came up the champion, the Philistine of Gath, Goliath by name, out of the armies of the Philistines, and spake according to the same words: and David heard them.

And all the men of Israel, when they saw the man, fled from him, and were sore afraid.

And the men of Israel said, Have ye seen this man that is come up? surely to defy Israel is he come up: and it shall be, that the man who killeth him, the king will enrich him with great riches, and will give him his daughter, and make his father's house free in Israel.

And David spake to the men that stood by him, saying, What shall be done to the man that killeth this Philistine, and taketh away the reproach from Israel? for who is this uncircumcised Philistine, that he should defy the armies of the living God?

And the people answered him after this manner, saying, So shall it be done to the man that killeth him.

And Eliab his eldest brother heard when he spake unto the men; and Eliab's anger was kindled against David, and he said, Why camest thou down hither? and with whom hast thou left those few sheep in the wilderness? I know thy pride, and the naughtiness of thine heart; for thou art come down that thou mightest see the battle.

And David said, What have I now done? Is there not a cause?

And he turned from him toward another, and spake after the same manner: and the people answered him again after the former manner.

David plays the harp before Saul

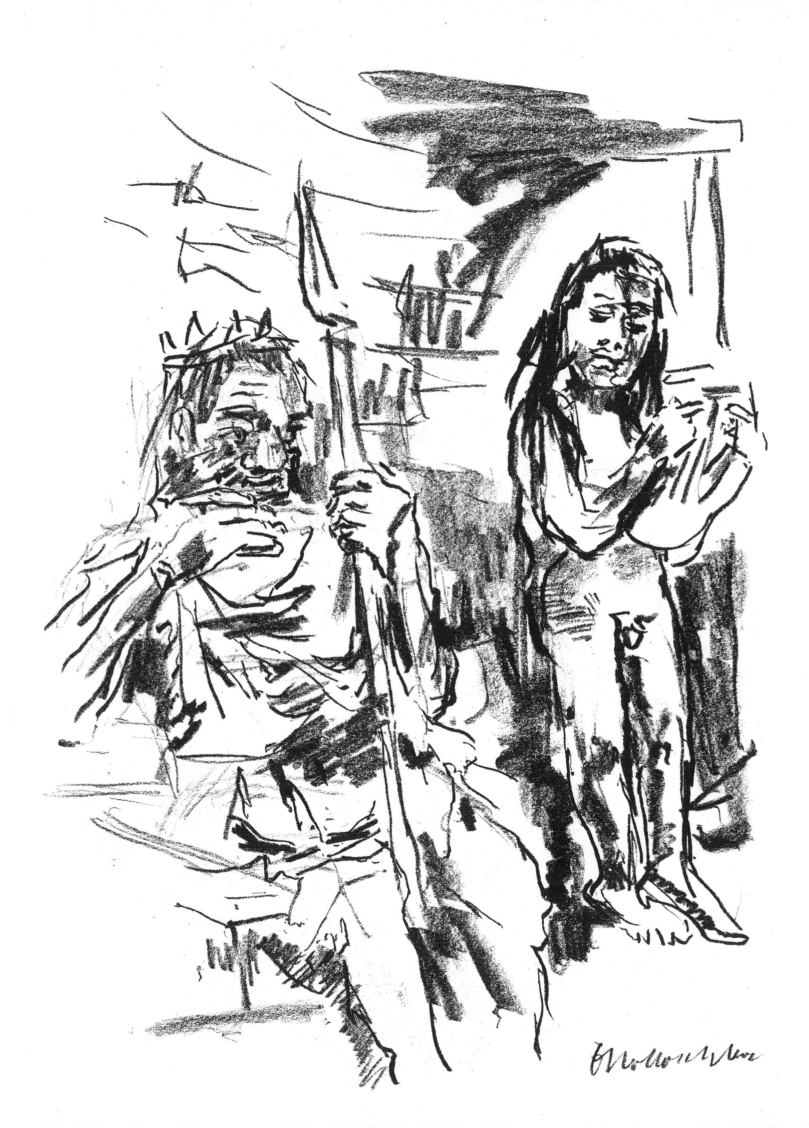

And when the words were heard which David spake, they rehearsed them before Saul: and he sent for him.

And David said to Saul, Let no man's heart fail because of him; thy servant will go and fight with this Philistine.

And Saul said to David, Thou art not able to go against this Philistine to fight with him: for thou art but a youth, and he a man of war from his youth.

And David said unto Saul, Thy servant kept his father's sheep, and there came a lion, and a bear, and took a lamb out of the flock:

And I went out after him, and smote him, and delivered it out of his mouth: and when he arose against me, I caught him by his beard, and smote him, and slew him.

Thy servant slew both the lion and the bear: and this uncircumcised Philistine shall be as one of them, seeing he hath defied the armies of the living God.

David said moreover, The Lord that delivered me out of the paw of the lion, and out of the paw of the bear, he will deliver me out of the hand of this Philistine. And Saul said unto David, Go, and the Lord be with thee.

And Saul armed David with his armour, and he put an helmet of brass upon his head; also he armed him with a coat of mail.

And David girded his sword upon his armour, and he assayed to go; for he had not proved it. And David said unto Saul, I cannot go with these; for I have not proved them. And David put them off him.

And he took his staff in his hand, and chose him five smooth stones out of the brook, and put them in a shepherd's bag which be had, even in a scrip; and his sling was in his hand: and he drew near to the Philistine.

And the Philistine came on and drew near unto David; and the man that bare the shield went before him.

And when the Philistine looked about, and saw David, he disdained him: for he was but a youth, and ruddy, and of a fair countenance.

And the Philistine said unto David, Am I a dog, that thou comest to me with staves? And the Philistine cursed David by his gods.

And the Philistine said to David, Come to me, and I will give thy flesh unto the fowls of the air, and to the beasts of the field.

Then said David to the Philistine, Thou comest to me with a sword, and with a spear, and with a shield: but I come to thee in the name of the Lord of hosts, the God of the armies of Israel, whom thou hast defied.

This day will the Lord deliver thee into mine hand; and I will smite thee, and take thine head from thee; and I will give the carcases of the host of the Philistines this day unto the fowls of the air, and to the wild beasts of the earth; that all the earth may know that there is a God in Israel.

And all this assembly shall know that the Lord saveth not with sword and spear: for the battle is the Lord's, and he will give you into our hands.

And it came to pass, when the Philistine arose, and came and drew nigh to meet David, that David hasted, and ran toward the army to meet the Philistine.

And David put his hand in his bag, and took thence a stone, and slang it, and smote the Philistine in his forehead, that the stone sunk into his forehead; and he fell upon his face to the earth.

So David prevailed over the Philistine with a sling and with a stone, and smote the Philistine, and slew him; but there was no sword in the hand of David.

Therefore David ran, and stood upon the Philistine, and took his sword, and drew it out of the sheath thereof, and slew him, and cut off his head therewith. And when the Philistines saw their champion was dead, they fled.

And the men of Israel and of Judah arose, and shouted, and pursued the Philistines, until thou come to the valley, and to the gates of Ekron. And

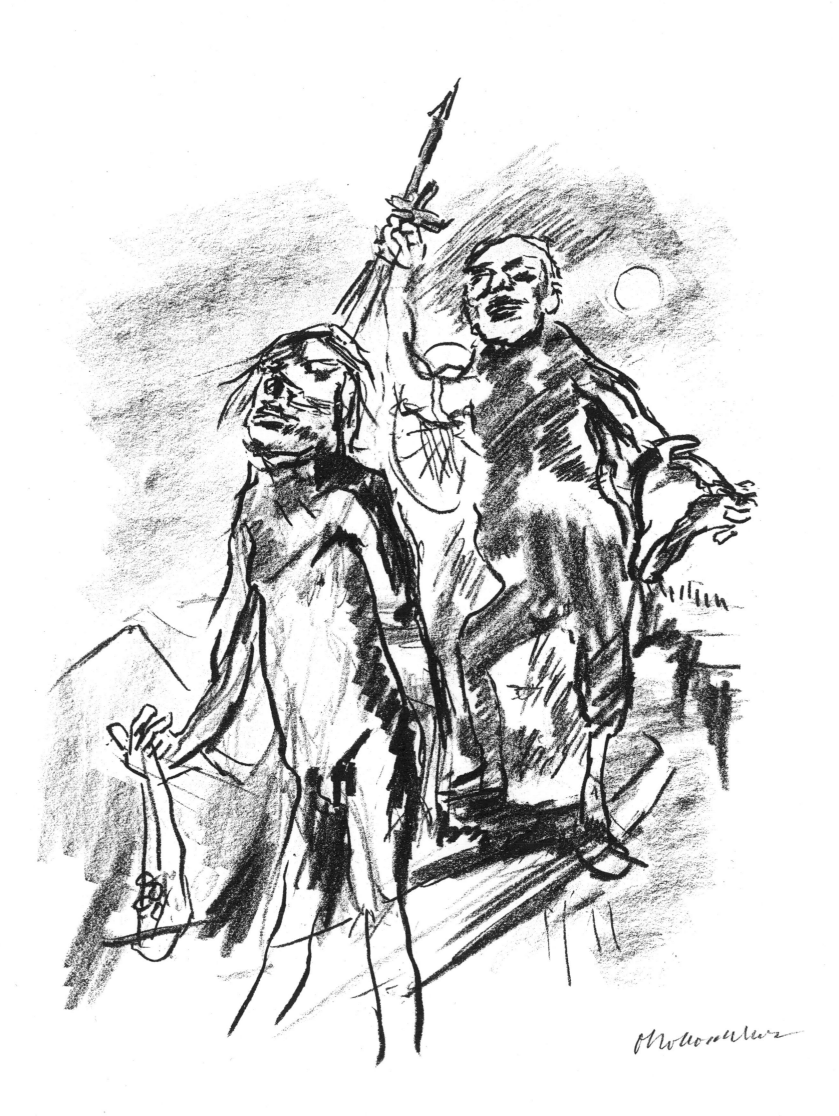

the wounded of the Philistines fell down by the way to Shaaraim, even unto Gath, and unto Ekron.

And the children of Israel returned from chasing after the Philistines, and they spoiled their tents.

And David took the head of the Philistine, and brought it to Jerusalem; but he put his armour in his tent.

And when Saul saw David go forth against the Philistine, he said unto Abner, the captain of the host, Abner, whose son is this youth? And Abner said, As thy soul liveth, O king, I cannot tell.

And the king said, Enquire thou whose son the stripling is.

And as David returned from the slaughter of the Philistine, Abner took him, and brought him before Saul with the head of the Philistine in his hand.

And Saul said to him, Whose son art thou, thou young man? And David answered, I am the son of thy servant Jesse the Beth-lehemite.

And it came to pass, when he had made an end of speaking unto Saul, that the soul of Jonathan was knit with the soul of David, and Jonathan loved him as his own soul.

And Saul took him that day, and would let him go no more home to his father's house.

Then Jonathan and David made a covenant, because he loved him as his own soul.

And Jonathan stripped himself of the robe that was upon him, and gave it to David, and his garments, even to his sword, and to his bow, and to his girdle.

And David went out whithersoever Saul sent him, and behaved himself wisely: and Saul set him over the men of war, and he was accepted in the sight of all the people, and also in the sight of Saul's servants.

And it came to pass as they came, when David was returned from the slaughter of the Philistine, that the women came out of all cities of Israel, singing and dancing, to meet king Saul, with tabrets, with joy, and with instruments of music.

And the women answered one another as they played, and said, Saul hath slain his thousands, and David his ten thousands.

And Saul was very wroth, and the saying displeased him; and he said, They have ascribed unto David ten thousands, and to me they have ascribed but thousands: and what can he have more but the kingdom?

And Saul eyed David from that day and forward.

And it came to pass on the morrow, that the evil spirit from God came upon Saul, and he prophesied in the midst of the house: and David played with his hand, as at other times: and there was a javelin in Saul's hand.

And Saul cast the javelin; for he said, I will smite David even to the wall with it. And David avoided out of his presence twice.

And Saul was afraid of David, because the Lord was with him, and was departed from Saul.

Therefore Saul removed him from him, and made him his captain over a thousand; and he went out and came in before the people.

And David behaved himself wisely in all his ways; and the Lord was with him.

Wherefore when Saul saw that he behaved himself very wisely, he was afraid of him.

But all Israel and Judah loved David, because he went out and came in before them.

And Saul said to David, Behold my elder daughter Merab, her will I give thee to wife: only be thou valiant for me, and fight the Lord's battles. For

David prevails over Goliath the Philistine

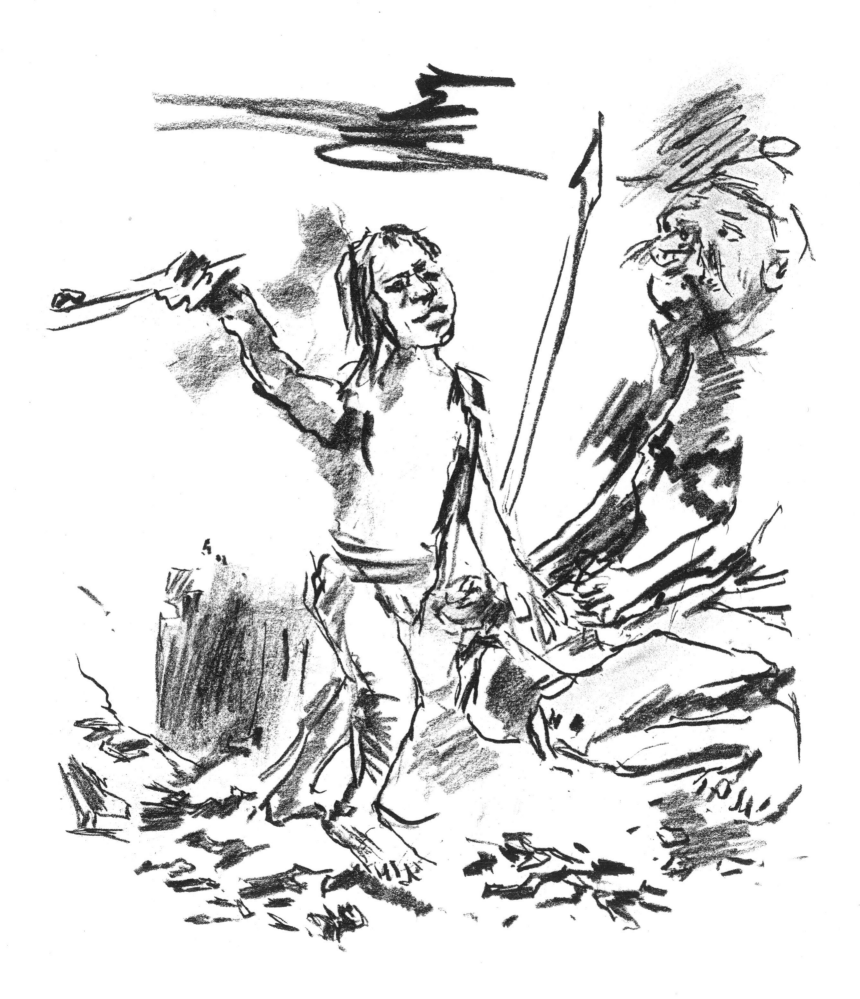

Saul said, Let not mine hand be upon him, but let the hand of the Philistines be upon him.

And David said unto Saul, Who am I? and what is my life, or my father's family in Israel, that I should be son in law to the king?

But it came to pass at the time when Merab Saul's daughter should have been given to David, that she was given unto Adriel the Meholathite to wife.

And Michal Saul's daughter loved David: and they told Saul, and the thing pleased him.

And Saul said, I will give him her, that she may be a snare to him, and that the hand of the Philistines may be against him. Wherefore Saul said to David, Thou shalt this day be my son in law in the one of the twain.

And Saul commanded his servants, saying, Commune with David secretly, and say, Behold, the king hath delight in thee, and all his servants love thee: now therefore be the king's son in law.

And Saul's servants spake those words in the ears of David. And David said, Seemeth it to you a light thing to be a king's son in law, seeing that I am a poor man, and lightly esteemed?

And the servants of Saul told him, saying, On this manner spake David.

And Saul said, Thus shall ye say to David, The king desireth not any dowry, but an hundred foreskins of the Philistines, to be avenged of the king's enemies. But Saul thought to make David fall by the hand of the Philistines.

And when his servants told David these words, it pleased David well to be the king's son in law: and the days were not expired.

Wherefore David arose and went, he and his men, and slew of the Philistines two hundred men; and David brought their foreskins, and they gave them in full tale to the king, that he might be the king's son in law. And Saul gave him Michal his daughter to wife.

And Saul saw and knew that the Lord was with David, and that Michal Saul's daughter loved him.

And Saul was yet the more afraid of David; and Saul became David's enemy continually.

Then the princes of the Philistines went forth: and it came to pass, after they went forth, that David behaved himself more wisely than all the servants of Saul; so that his name was much set by.

And Saul spake to Jonathan his son, and to all his servants, that they should kill David.

But Jonathan Saul's son delighted much in David: and Jonathan told David, saying, Saul my father seeketh to kill thee: now therefore, I pray thee, take heed to thyself until the morning, and abide in a secret place, and hide thyself:

And I will go out and stand beside my father in the field where thou art, and I will commune with my father of thee; and what I see, that I will tell thee.

And Jonathan spake good of David unto Saul his father, and said unto him, Let not the king sin against his servant, against David; because he hath not sinned against thee, and because his works have been to thee-ward very good:

For he did put his life in his hand, and slew the Philistine, and the Lord wrought a great salvation for all Israel: thou sawest it, and didst rejoice: wherefore then wilt thou sin against innocent blood, to slay David without a cause?

And Saul hearkened unto the voice of Jonathan: and Saul sware, As the Lord liveth, he shall not be slain.

And Jonathan called David, and Jonathan shewed him all those things. And Jonathan brought David to Saul, and he was in his presence, as in times past.

The dancing women

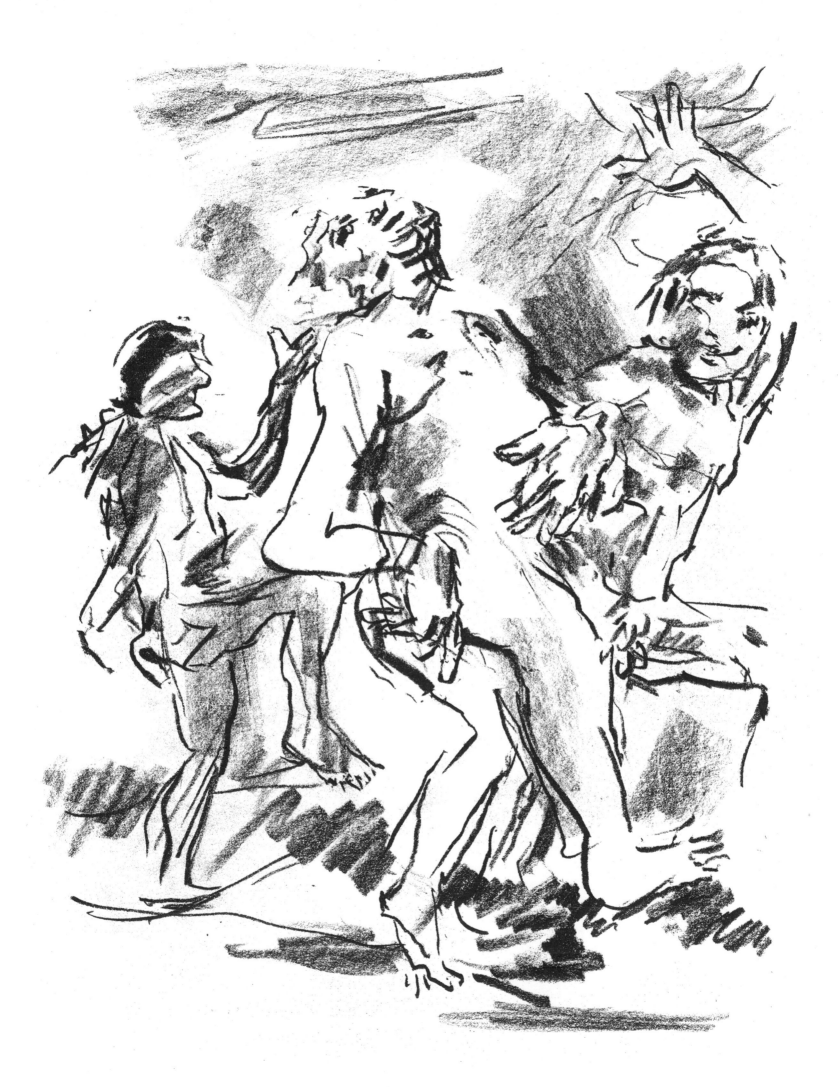

And there was war again: and David went out, and fought with the Philistines, and slew them with a great slaughter; and they fled from him.

And the evil spirit from the Lord was upon Saul, as he sat in his house with his javelin in his hand: and David played with his hand.

And Saul sought to smite David even to the wall with the javelin; but he slipped away out of Saul's presence, and he smote the javelin into the wall: and David fled, and escaped that night.

Saul also sent messengers unto David's house, to watch him, and to slay him in the morning: and Michal David's wife told him, saying, If thou save not thy life to night, to morrow thou shalt be slain.

So Michal let David down through a window: and he went, and fled, and escaped.

And Michal took an image, and laid it in the bed, and put a pillow of goats' hair for his bolster, and covered it with a cloth.

And when Saul sent messengers to take David, she said, He is sick.

And Saul sent the messengers again to see David, saying, Bring him up to me in the bed, that I may slay him.

And when the messengers were come in, behold, there was an image in the bed, with a pillow of goats' hair for his bolster.

And Saul said unto Michal, Why hast thou deceived me so, and sent away mine enemy, that he is escaped? And Michal answered Saul, He said unto me, Let me go; why should I kill thee?

So David fled, and escaped, and came to Samuel to Ramah, and told him all that Saul had done to him. And he and Samuel went and dwelt in Naioth.

And it was told Saul, saying, Behold, David is at Naioth in Ramah.

And Saul sent messengers to take David: and when they saw the company of the prophets prophesying, and Samuel standing as appointed over them,

the Spirit of God was upon the messengers of Saul, and they also prophesied.

And when it was told Saul, he sent other messengers, and they prophesied likewise. And Saul sent messengers again the third time, and they prophesied also.

Then went he also to Ramah, and came to a great well that is in Sechu: and he asked and said, Where are Samuel and David? And one said, Behold, they be at Naioth in Ramah.

And he went thither to Naioth in Ramah: and the Spirit of God was upon him also, and he went on, and prophesied, until he came to Naioth in Ramah.

And he stripped off his clothes also, and prophesied before Samuel in like manner, and lay down naked all that day and all that night. Wherefore they say, Is Saul also among the prophets?

And David fled from Naioth in Ramah, and came and said before Jonathan, What have I done? what is mine iniquity? and what is my sin before thy father, that he seeketh my life?

And he said unto him, God forbid; thou shalt not die: behold, my father will do nothing either great or small, but that he will shew it me: and why should my father hide this thing from me? it is not so.

And David sware moreover, and said, Thy father certainly knoweth that I have found grace in thine eyes; and he saith, Let-not Jonathan know this, lest he be grieved: but truly as the Lord liveth, and as thy soul liveth, there is but a step between me and death.

Then said Jonathan unto David, Whatsoever thy soul desireth, I will even do it for thee.

And David said unto Jonathan, Behold, tomorrow is the new moon, and I should not fail to sit with the king at meat: but let me go, that I may hide myself in the field unto the third day at even.

If thy father at all miss me, then say, David earnestly asked leave of me

Michal lets David down through a window

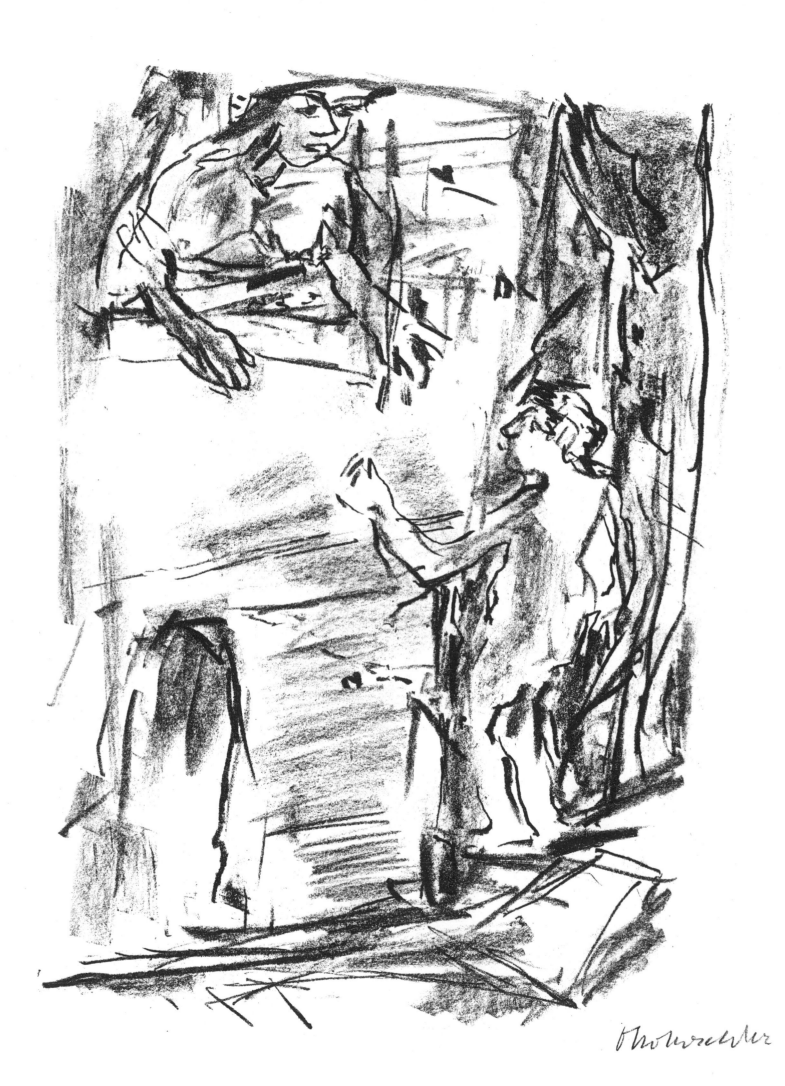

that he might run to Beth-lehem his city: for there is a yearly sacrifice there for all the family.

If he say thus, It is well; thy servant shall have peace: but if he be very wroth, then be sure that evil is determined by him.

Therefore thou shalt deal kindly with thy servant; for thou hast brought thy servant into a covenant of the Lord with thee: notwithstanding, if there be in me iniquity, slay me thyself; for why shouldest thou bring me to thy father?

And Jonathan said, Far be it from thee: for if I knew certainly that evil were determined by my father to come upon thee, then would not I tell it thee?

Then said David to Jonathan, Who shall tell me? or what if thy father answer thee roughly?

And Jonathan said unto David, Come, and let us go out into the field. And they went out both of them into the field.

And Jonathan said unto David, O Lord God of Israel, when I have sounded my father about tomorrow any time, or the third day, and, behold, if there be good toward David, and I then send not unto thee, and shew it thee;

The Lord do so and much more to Jonathan: but if it please my father to do thee evil, the I will shew it thee, and send thee away, that thou mayest go in peace: and the Lord be with thee, as he hath been with my father.

And thou shalt not only while yet I live shew me the kindness of the Lord, that I die not:

But also thou shalt not cut off thy kindness from my house for ever: no, not when the Lord hath cut off the enemies of David every one from the face of the earth.

So Jonathan made a covenant with the house of David, saying, Let the Lord even require it at the hand of David's enemies.

65

And Jonathan caused David to swear again because he loved him: for he loved him as he loved his own soul.

Then Jonathan said to David, Tomorrow is the new moon: and thou shalt be missed, because thy seat will be empty.

And when thou hast stayed three days, then thou shalt go down quickly, and come to the place where thou didst hide thyself when the business was in hand, and shalt remain by the stone Ezel.

And I will shoot three arrows on the side thereof, as though I shot at a mark.

And, behold, I will send a lad, saying, Go, find out the arrows. If I expressly say unto the lad, Behold, the arrows are on this side of thee, take them; then come thou: for there is peace to thee, and no hurt; as the Lord liveth.

But if I say thus unto the young man, Behold, the arrows are beyond thee; go thy way: for the Lord hath sent thee away.

And as touching the matter which thou and I have spoken of, behold, the Lord be between thee and me for ever.

So David hid himself in the field: and when the new moon was come, the king sat him down to eat meat.

And the king sat upon his seat, as at other times, even upon a seat by the wall: and Jonathan arose, and Abner sat by Saul's side, and David's place was empty.

Nevertheless Saul spake not any thing that day: for he thought, Something hath befallen him, he is not clean; surely he is not clean.

And it came to pass on the morrow, which was the second day of the month, that David's place was empty: and Saul said unto Jonathan his son, Wherefore cometh not the son of Jesse to meat, neither yesterday, nor to day?

And Jonathan answered Saul, David earnestly asked leave of me to go to Beth-lehem:

David hides himself in the field

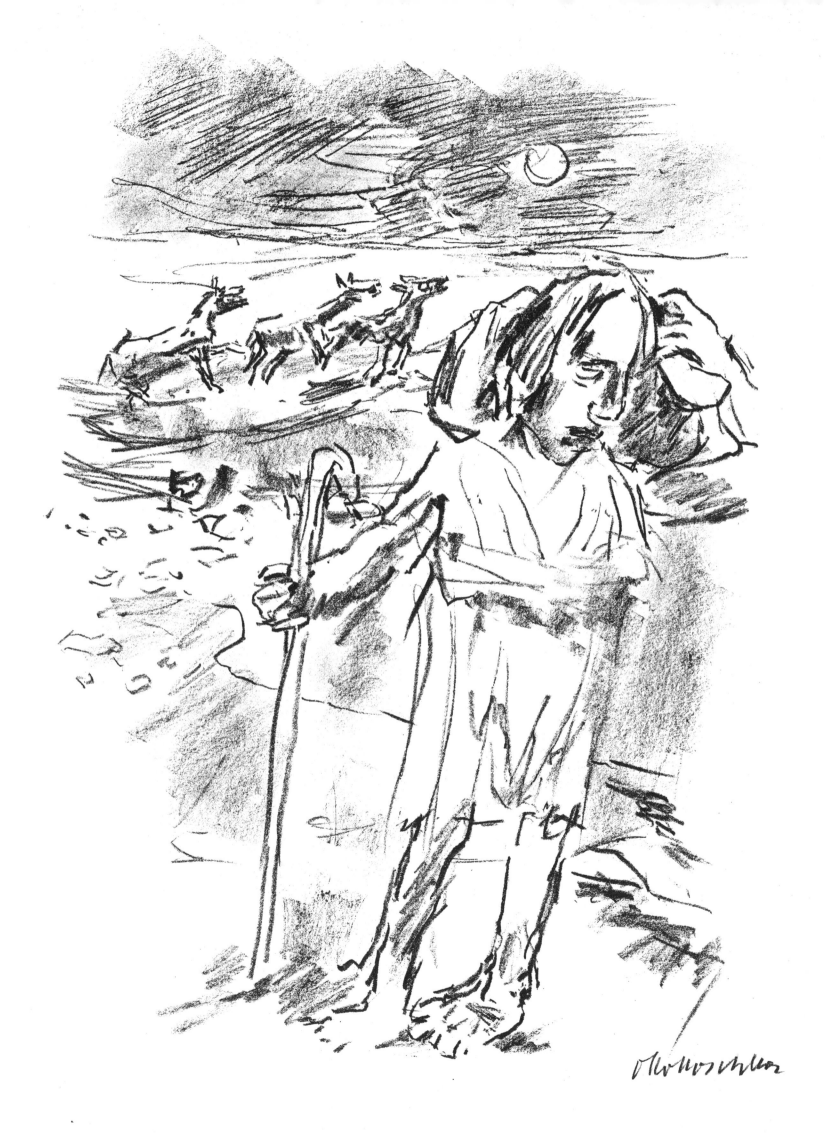

And he said, Let me go, I pray thee; for our family hath a sacrifice in the city; and my brother, he hath commanded me to be there: and now, if I have found favour in thine eyes, let me get away, I pray thee, and see my brethren. Therefore he cometh not unto the king's table.

Then Saul's anger was kindled against Jonathan, and he said unto him, Thou son of the perverse rebellious woman, do not I know that thou hast chosen the son of Jesse to thine own confusion, and unto the confusion of thy mother's nakedness?

For as long as the son of Jesse liveth upon the ground, thou shalt not be established, nor thy kingdom. Wherefore now send and fetch him unto me, for he shall surely die.

And Jonathan answered Saul his father, and said unto him, Wherefore shall he be slain? what hath he done?

And Saul cast a javelin at him to smite him: whereby Jonathan knew that it was determined of his father to slay David.

So Jonathan arose from the table in fierce anger, and did eat no meat the second day of the month: for he was grieved for David, because his father had done him shame.

And it came to pass in the morning, that Jonathan went out into the field at the time appointed with David, and a little lad with him.

And he said unto his lad, Run, find out now the arrows which I shoot. And as the lad ran, he shot an arrow beyond him.

And when the lad was come to the place of the arrow which Jonathan had shot, Jonathan cried after the lad, and said, Is not the arrow beyond thee?

And Jonathan cried after the lad, Make speed, haste, stay not. And Jonathan's lad gathered up the arrows, and came to his master.

But the lad knew not any thing: only Jonathan and David knew the matter.

And Jonathan gave his artillery unto his lad, and said unto him, Go, carry them to the city.

And as soon as the lad was gone, David arose out of a place toward the south, and fell on his face to the ground, and bowed himself three times: and they kissed one another, and wept one with another, until David exceeded.

And Jonathan said to David, Go in peace, forasmuch as we have sworn both of us in the name of the Lord, saying, The Lord be between me and thee, and between my seed and thy seed for ever. And he arose and departed: and Jonathan went into the city.

Then came David to Nob to Ahimelech the priest: and Ahimelech was afraid at the meeting of David, and said unto him, Why art thou alone, and no man with thee?

And David said unto Ahimelech the priest, The king hath commanded me a business, and hath said unto me, Let no man know any thing of the business whereabout I send thee, and what I have commanded thee: and I have appointed my servants to such and such a place.

Now therefore what is under thine hand? give me five loaves of bread in mine hand, or what there is present.

And the priest answered David, and said, There is no common bread under mine hand, but there is hallowed bread; if the young men have kept themselves at least from women.

And David answered the priest, and said unto him, Of a truth women have been kept from us about these three days, since I came out, and the vessels of the young men are holy, and the bread is in a manner common, yea, though it were sanctified this day in the vessel.

So the priest gave him hallowed bread: for there was no bread there but the shewbread, that was taken from before the Lord, to put hot bread in the day when it was taken away.

Now a certain man of the servants of Saul was there that day, detained before the Lord; and his name was Doeg, an Edomite, the chiefest of the herdmen that belonged to Saul.

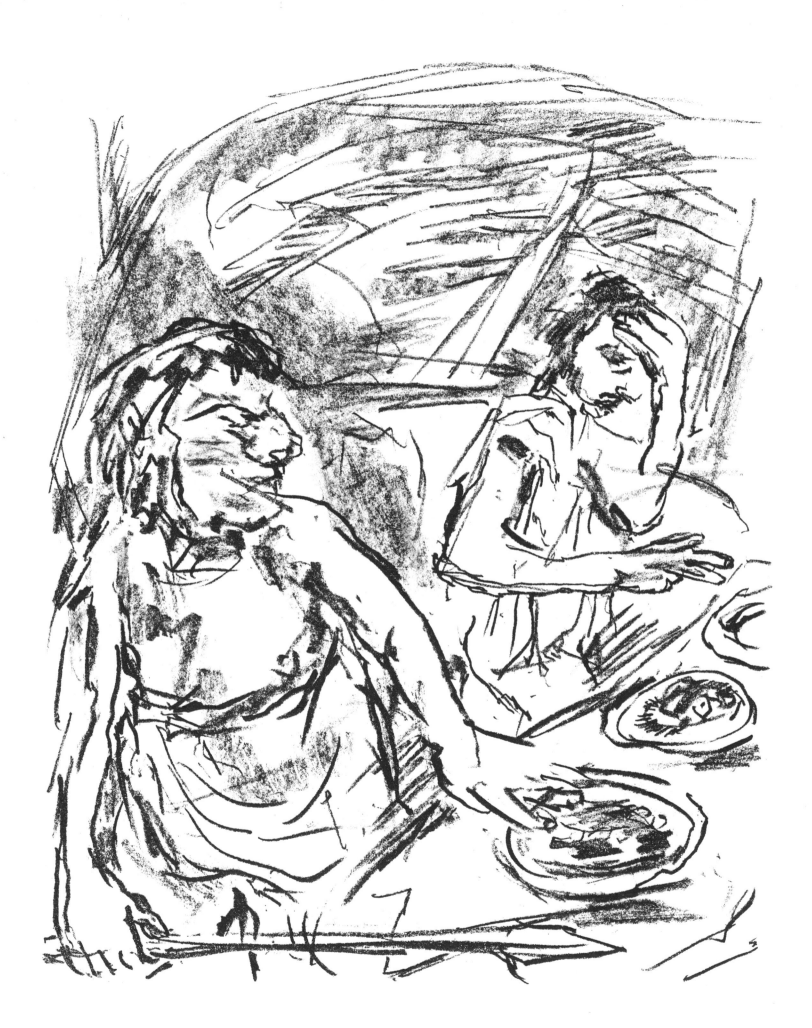

And David said unto Ahimelech, And is there not here under thine hand spear or sword? for I have neither brought my sword nor my weapons with me, because the king's business required haste.

And the priest said, The sword of Goliath the Philistine, whom thou slewest in the valley of Elah, behold, it is here wrapped in a cloth behind the ephod: if thou wilt take that, take it: for there is no other save that here. And David said, There is none like that; give it me.

And David arose, and fled that day for fear of Saul, and went to Achish the king of Gath.

And the servants of Achish said unto him, Is not this David the king of the land? did they not sing one to another of him in dances, saying, Saul hath slain his thousands, and David his ten thousands?

And David laid up these words in his heart, and was sore afraid of Achish the king of Gath.

And he changed his behaviour before them, and feigned himself mad in their hands, and scrabbled on the doors of the gate, and let his spittle fall down upon his beard.

Then said Achish unto his servants, Lo, ye see the man is mad: wherefore then have ye brought him to me?

Have I need of mad men, that ye have brought this fellow to play the mad man in my presence? shall this fellow come into my house?

David therefore departed thence, and escaped to the cave Adullam: and when his brethren and all his father's house heard it, they went down thither to him.

And every one that was in distress, and every one that was in debt, and every one that was discontented, gathered themselves unto him; and he became a captain over them: and there were with him about four hundred men.

And David went thence to Mizpeh of Moab: and he said unto the king of

Moab, Let my father and my mother, I pray thee, come forth, and be with you, till I know what God will do for me.

And he brought them before the king of Moab: and they dwelt with him all the while that David was in the hold.

And the prophet Gad said unto David, Abide not in the hold; depart, and get thee into the land of Judah. Then David departed, and came into the forest of Hareth.

When Saul heard that David was discovered, and the men that were with him, (now Saul abode in Gibeah under a tree in Ramah, having his spear in his hand, and all his servants were standing about him;)

Then Saul said unto his servants that stood about him, Hear now, ye Benjamites; will the son of Jesse give every one of you fields and vineyards, and make you all captains of thousands, and captains of hundreds;

That all of you have conspired against me, and there is none that sheweth me that my son hath made a league with the son of Jesse, and there is none of you that is sorry for me, or sheweth unto me that my son hath stirred up my servant against me, to lie in wait, as at this day?

Then answered Doeg the Edomite, which was set over the servants of Saul, and said, I saw the son of Jesse coming to Nob, to Ahimelech the son of Ahitub.

And he enquired of the Lord for him, and gave him victuals, and gave him the sword of Goliath the Philistine.

Then the king sent to call Ahimelech the priest, the son of Ahitub, and all his father's house, the priests that were in Nob: and they came all of them to the king.

And Saul said, Hear now, thou son of Ahitub. And he answered, Here I am, my lord.

And Saul said unto him, Why have ye conspired against me, thou and the

Jonathan's parting from David

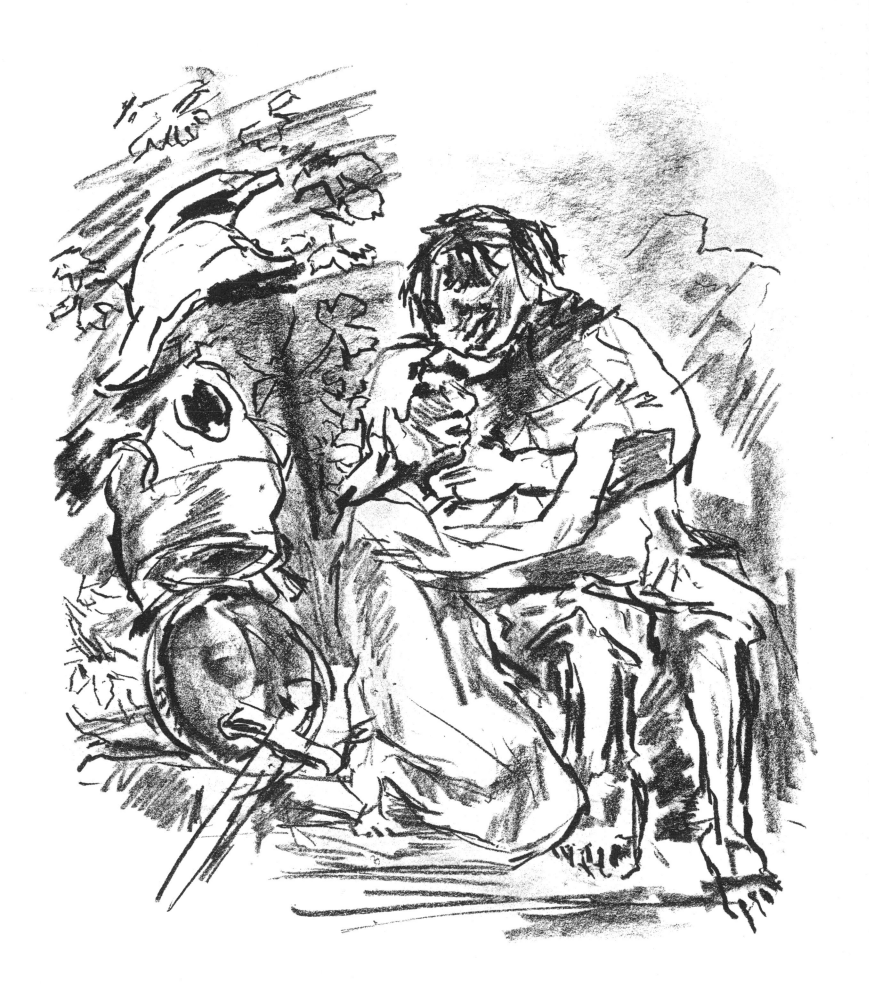

son of Jesse, in that thou hast given him bread, and a sword, and hast enquired of God for him, that he should rise against me, to lie in wait, as at this day?

Then Ahimelech answered the king, and said, And who is so faithful among all thy servants as David, which is the king's son in law, and goeth at thy bidding, and is honourable in thine house?

Did I then begin to enquire of God for him? be it far from me: let not the king impute any thing unto his servant, nor to all the house of my father: for thy servant knew nothing of all this, less or more.

And the king said, Thou shalt surely die, Ahimelech, thou, and all thy father's house.

And the king said unto the footmen that stood about him, Turn, and slay the priests of the Lord; because their hand also is with David, and because they knew when he fled, and did not shew it to me. But the servants of the king would not put forth their hand to fall upon the priests of the Lord.

And the king said to Doeg, Turn thou, and fall upon the priests. And Doeg the Edomite turned, and he fell upon the priests, and slew on that day fourscore and five persons that did wear a linen ephod.

And Nob, the city of the priests, smote he with the edge of the sword, both men and women, children and sucklings, and oxen, and asses, and sheep, with the edge of the sword.

And one of the sons of Ahimelech the son of Ahitub, named Abiathar, escaped, and fled after David.

And Abiathar shewed David that Saul had slain the Lord's priests.

And David said unto Abiathar, I knew it that day, when Doeg the Edomite was there, that he would surely tell Saul: I have occasioned the death of all the persons of thy father's house.

Abide thou with me, fear not: for he that seeketh my life seeketh thy life: but with me thou shalt be in safeguard.

Then they told David, saying, Behold, the Philistines fight against Keilah, and they rob the threshingfloors.

Therefore David enquired of the Lord, saying, Shall I go and smite these Philistines? And the Lord said unto David, Go, and smite the Philistines, and save Keilah.

And David's men said unto him, Behold, we be afraid here in Judah: how much more then if we come to Keilah against the armies of the Philistines?

Then David enquired of the Lord yet again. And the Lord answered him and said, Arise, go down to Keilah; for I will deliver the Philistines into thine hand.

So David and his men went to Keilah, and fought with the Philistines, and brought away their cattle, and smote them with a great slaughter. So David saved the inhabitants of Keilah.

And it came to pass, when Abiathar the son of Ahimelech fled to David to Keilah, that he came down with an ephod in his hand.

And it was told Saul that David was come to Keilah. And Saul said, God hath delivered him into mine hand; for he is shut in, by entering into a town that hath gates and bars.

And Saul called all the people together to war, to go down to Keilah, to besiege David and his men.

And David knew that Saul secretly practised mischief against him; and he said to Abiathar the priest, Bring hither the ephod.

Then said David, O Lord God of Israel, thy servant hath certainly heard that Saul seeketh to come to Keilah, to destroy the city for my sake.

Will the men of Keilah deliver me up into his hand? will Saul come down, as thy servant hath heard? O Lord God of Israel, I beseech thee, tell thy servant. And the Lord said, He will come down.

Then said David, Will the men of Keilah deliver me and my men into the hand of Saul? And the Lord said, They will deliver thee up.

Saul commands Doeg to slay the priests

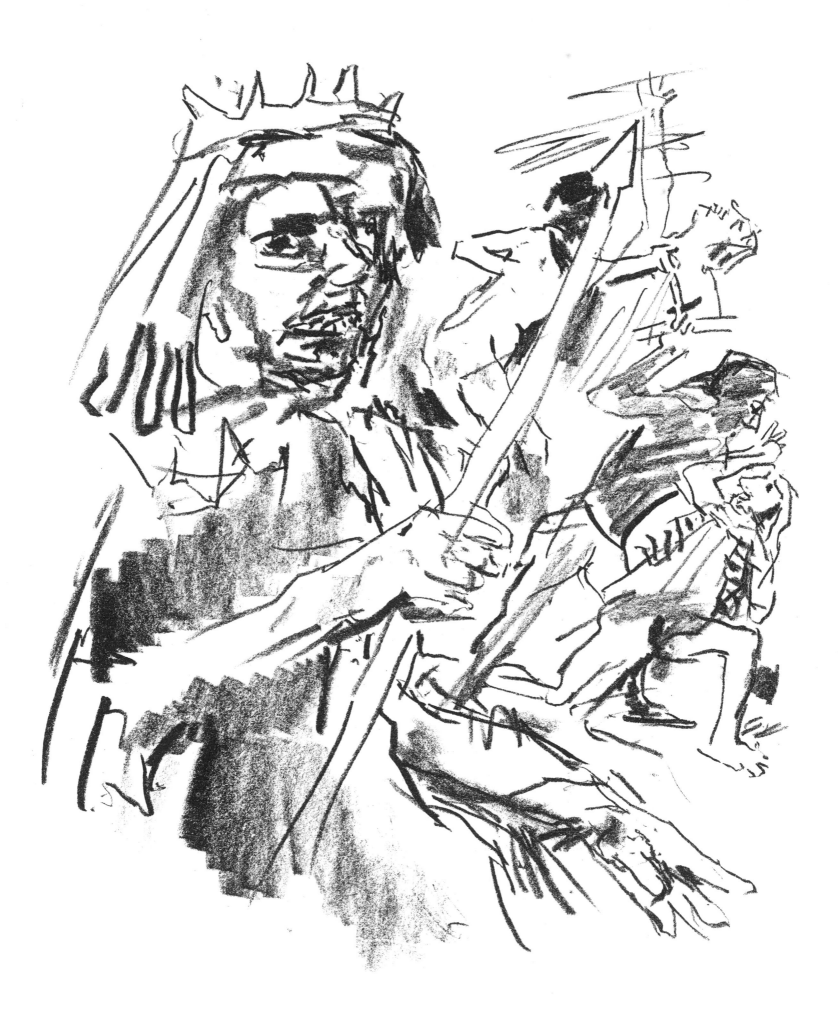

Then David and his men, which were about six hundred, arose and departed out of Keilah, and went whithersoever they could go. And it was told Saul that David was escaped from Keilah; and he forbare to go forth.

And David abode in the wilderness in strong holds, and remained in a mountain in the wilderness of Ziph. And Saul sought him every day, but God delivered him not into his hand.

And David saw that Saul was come out to seek his life: and David was in the wilderness of Ziph in a wood.

And Jonathan Saul's son arose, and went to David into the wood, and strengthened his hand in God.

And he said unto him, Fear not: for the hand of Saul my father shall not find thee; and thou shalt be king over Israel, and I shall be next unto thee; and that also Saul my father knoweth.

And they two made a covenant before the Lord: and David abode in the wood, and Jonathan went to his house.

Then came up the Ziphites to Saul to Gibeah, saying, Doth not David hide himself with us in strong holds in the wood, in the hill of Hachilah, which is on the south of Jeshimon?

Now therefore, O king, come down according to all the desire of thy soul to come down; and our part shall be to deliver him into the king's hand.

And Saul said, Blessed be ye of the Lord; for ye have compassion on me.

Go, I pray you, prepare yet, and know and see his place where his haunt is, and who hath seen him there: for it is told me that he dealeth very subtilly.

See therefore, and take knowledge of all the lurking places where he hideth himself, and come ye again to me with the certainty, and I will go with you: and it shall come to pass, if he be in the land, that I will search him out throughout all the thousands of Judah.

And they arose, and went to Ziph before Saul: but David and his men were in the wilderness of Maon, in the plain on the south of Jeshimon.

Saul also and his men went to seek him. And they told David: wherefore he came down into a rock, and abode in the wilderness of Maon. And when Saul heard that, he pursued after David in the wilderness of Maon.

And Saul went on this side of the mountain, and David and his men on that side of the mountain: and David made haste to get away for fear of Saul; for Saul and his men compassed David and his men round about to take them.

But there came a messenger unto Saul, saying, Haste thee, and come; for the Philistines have invaded the land.

Wherefore Saul returned from pursuing after David, and went against the Philistines: therefore they called that place Sela-hammahlekoth.

And David went up from thence, and dwelt in strong holds at En-gedi.

And it came to pass, when Saul was returned from following the Philistines, that it was told him, saying, Behold, David is in the wilderness of En-gedi.

Then Saul took three thousand chosen men out of all Israel, and went to seek David and his men upon the rocks of the wild goats.

And he came to the sheepcotes by the way, where was a cave; and Saul went in to cover his feet: and David and his men remained in the sides of the cave.

And the men of David said unto him, Behold the day of which the Lord said unto thee, Behold, I will deliver thine enemy into thine hand, that thou mayest do to him as it shall seem good unto thee. Then David arose, and cut off the skirt of Saul's robe privily.

And it came to pass afterward, that David's heart smote him, because he had cut off Saul's skirt.

David spares the life of Saul

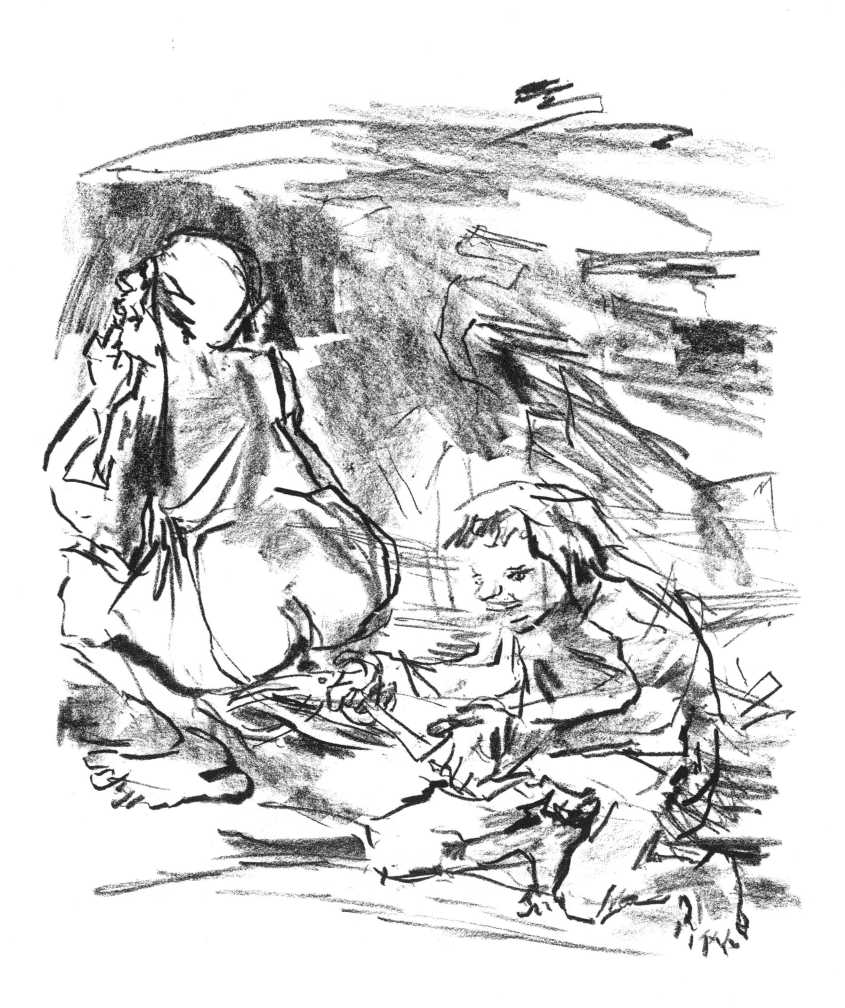

And he said unto his men, The Lord forbid that I should do this thing unto my master, the Lord's anointed, to stretch forth mine hand against him, seeing he is the anointed of the Lord.

So David stayed his servants with these words, and suffered them not to rise against Saul. But Saul rose up out of the cave, and went on his way.

David also arose afterward, and went out of the cave, and cried after Saul, saying, My lord the king. And when Saul looked behind him, David stooped with his face to the earth, and bowed himself.

And David said to Saul, Wherefore hearest thou men's words, saying, Behold, David seeketh thy hurt?

Behold, this day thine eyes have seen how that the Lord had delivered thee today into mine hand in the cave: and some bade me kill thee: but mine eye spared thee; and I said, I will not put forth mine hand against my lord; for he is the Lord's anointed.

Moreover, my father, see, yea, see the skirt of thy robe in my hand: for in that I cut off the skirt of thy robe, and killed thee not, know thou and see that there is neither evil nor transgression in mine hand, and I have not sinned against thee; yet thou huntest my soul to take it.

The Lord judge between me and thee, and the Lord avenge me of thee: but mine hand shall not be upon thee.

As saith the proverb of the ancients, Wickedness proceedeth from the wicked: but mine hand shall not be upon thee.

After whom is the king of Israel come out? after whom dost thou pursue? after a dead dog, after a flea.

The Lord therefore be judge, and judge between me and thee, and see, and plead my cause, and deliver me out of thine hand.

And it came to pass, when David had made an end of speaking these words unto Saul, that Saul said, Is this thy voice, my son David? And Saul lifted up his voice, and wept.

And he said to David, thou art more righteous than I: for thou hast rewarded me good, whereas I have rewarded thee evil.

And thou hast shewed this day how that thou hast dealt well with me: forasmuch as when the Lord had delivered me into thine hand, thou killedst me not.

For if a man find his enemy, will he let him go well away? wherefore the Lord reward thee good for that thou hast done unto me this day.

And now, behold, I know well that thou shalt surely be king, and that the kingdom of Israel shall be established in thine hand.

Swear now therefore unto me by the Lord, that thou wilt not cut off my seed after me, and that thou wilt not destroy my name out of my father's house.

And David sware unto Saul. And Saul went home; but David and his men gat them up unto the hold.

And Samuel died; and all the Israelites were gathered together, and lamented him, and buried him in his house at Ramah. And David arose, and went down to the wilderness of Paran.

And there was a man in Maon, whose possessions were in Carmel; and the man was very great, and he had three thousand sheep, and a thousand goats: and he was shearing his sheep in Carmel.

Now the name of the man was Nabal; and the name of his wife Abigail: and she was a woman of good understanding, and of a beautiful countenance: but the man was churlish and evil in his doings; and he was of the house of Caleb.

And David heard in the wilderness that Nabal did shear his sheep.

And David sent out ten young men, and David said unto the young men, Get you up to Carmel, and go to Nabal, and greet him in my name:

And thus shall ye say to him that liveth in prosperity, Peace be both to thee, and peace be to thine house, and peace be unto all that thou hast.

'Is this thy voice, my son David?'

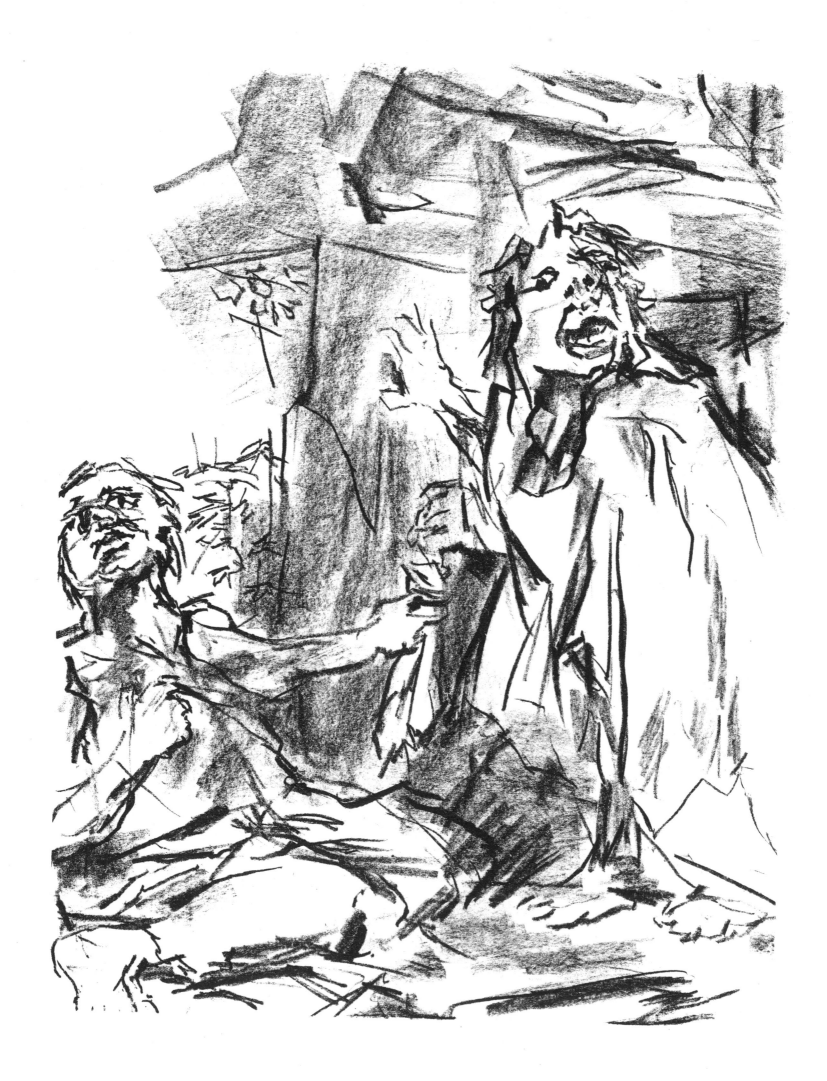

And now I have heard that thou hast shearers: now thy shepherds which were with us, we hurt them not, neither was there ought missing unto them, all the while they were in Carmel.

Ask thy young men, and they will shew thee. Wherefore let the young men find favour in thine eyes: for we come in a good day: give, I pray thee, whatsoever cometh to thine hand unto thy servants, and to thy son David.

And when David's young men came, they spake to Nabal according, to all those words in the name of David, and ceased.

And Nabal answered David's servants, and said, Who is David? and who is the son of Jesse? there be many servants now a days that break away every man from his master.

Shall I then take my bread, and my water, and my flesh that I have killed for my shearers, and give it unto men, whom I know not whence they be?

But the men were very good unto us, and we were not hurt, neither missed we any thing, as long as we were conversant with them, when we were in the fields:

They were a wall unto us both by night and day, all the while we were with them keeping the sheep.

So David's young men turned their way, and went again, and came and told him all those sayings.

And David said unto his men, Gird ye on every man his sword. And they girded on every man his sword; and David also girded on his sword: and there went up after David about four hundred men; and two hundred abode by the stuff.

But one of the young men told Abigail, Nabal's wife, saying, Behold, David sent messengers out of the wilderness to salute our master; and he railed on them.

Now therefore know and consider what thou wilt do; for evil is

determined against our master, and against all his household: for he is such a son of Belial, that a man cannot speak to him.

Then Abigail made haste, and took two hundred loaves, and two bottles of wine, and five sheep ready dressed, and five measures of parched corn, and an hundred clusters of raisins, and two hundred cakes of figs, and laid them on asses.

And she said unto her servants, Go on before me; behold, I come after you. But she told not her husband Nabal.

And it was so, as she rode on the ass, that she came down by the covert of the hill, and, behold, David and his men came down against her; and she met them.

Now David had said, Surely in vain have I kept all that this fellow hath in the wilderness, so that nothing was missed of all that pertained unto him: and he hath requited me evil for good.

So and more also do God unto the enemies of David, if I leave of all that pertain to him by the morning light any that pisseth against the wall.

And when Abigail saw David, she hasted, and lighted off the ass, and fell before David on her face, and bowed herself to the ground,

And fell at his feet, and said, Upon me, my lord, upon me let this iniquity be: and let thine handmaid, I pray thee, speak in thine audience, and hear the words of thine handmaid.

Let not my lord, I pray thee, regard this man of Belial, even Nabal: for as his name is, so is he; Nabal is his name, and folly is with him: but I thine handmaid saw not the young men of my lord, whom thou didst send.

Now therefore, my lord, as the Lord liveth, and as thy soul liveth, seeing the Lord hath withholden thee from coming to shed blood, and from avenging thyself with thine own hand, now let thine enemies, and they that seek evil to my lord, be as Nabal.

And now this blessing which thine handmaid hath brought unto my lord, let it even be given unto the young men that follow my lord.

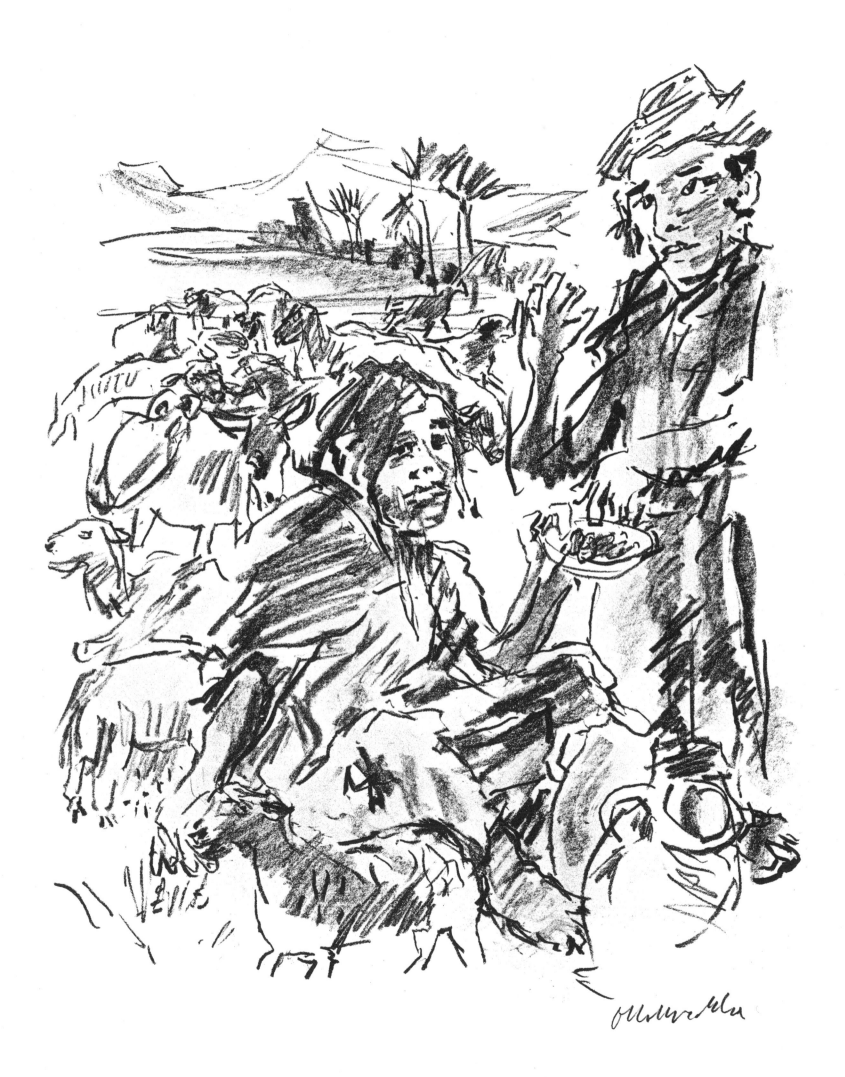

I pray thee, forgive the trespass of thine handmaid: for the Lord will certainly make my lord a sure house; because my lord fighteth the battles of the Lord, and evil hath not been found in thee all thy days.

Yet a man is risen to pursue thee, and to seek thy soul: but the soul of my lord shall be bound in the bundle of life with the Lord thy God; and the souls of thine enemies, them shall he sling out, as out of the middle of a sling.

And it shall come to pass, when the Lord shall have done to my lord according to all the good that he hath spoken concerning thee, and shall have appointed thee ruler over Israel;

That this shall be no grief unto thee, nor offence of heart unto my lord, either that thou hast shed blood causeless, or that my lord hath avenged himself: but when the Lord shall have dealt well with my lord, then remember thine handmaid.

And David said to Abigail, Blessed be the Lord God of Israel, which sent thee this day to meet me:

And blessed be thy advice, and blessed be thou, which hast kept me this day from coming to shed blood, and from avenging myself with mine own hand.

For in very deed, as the Lord God of Israel liveth, which hath kept me back from hurting thee, except thou hadst hasted and come to meet me, surely there had not been left unto Nabal by the morning light any that pisseth against the wall.

So David received of her hand that which she had brought him, and said unto her, Go up in peace to thine house; see, I have hearkened to thy voice, and have accepted thy person.

And Abigail came to Nabal; and, behold, he held a feast in his house, like the feast of a king; and Nabal's heart was merry within him, for he was very drunken: wherefore she told him nothing, less or more, until the morning light.

But it came to pass in the morning, when the wine was gone out of Nabal, and his wife had told him these things, that his heart died within him, and he became as a stone.

And it came to pass about ten days after, that the Lord smote Nabal, that he died.

And when David heard that Nabal was dead, he said, Blessed be the Lord, that hath pleaded the cause of my reproach from the hand of Nabal, and hath kept his servant from evil: for the Lord hath returned the wickedness of Nabal upon his own head. And David sent and communed with Abigail, to take her to him to wife.

And when the servants of David were come to Abigail to Carmel, they spake unto her, saying, David sent us unto thee, to take thee to him to wife.

And she arose, and bowed herself on her face to the earth, and said, Behold, let thine handmaid be a servant to wash the feet of the servants of my lord.

And Abigail hasted, and arose, and rode upon an ass, with five damsels of her's that went after her; and she went after the messengers of David, and became his wife.

David also took Ahinoam of Jezreel; and they were also both of them his wives.

But Saul had given Michal his daughter, David's wife, to Phalti the son of Laish, which was of Gallim.

And the Ziphites came unto Saul to Gibeah, saying, Doth not David hide himself in the hill of Hachilah, which is before Jeshimon?

Then Saul arose, and went down to the wilderness of Ziph, having three thousand chosen men of Israel with him, to seek David in the wilderness of Ziph.

And Saul pitched in the hill of Hachilah, which is before Jeshimon, by the

way. But David abode in the wilderness, and he saw that Saul came after him into the wilderness.

David therefore sent out spies, and understood that Saul was come in very deed.

And David arose, and came to the place where Saul had pitched: and David beheld the place where Saul lay, and Abner the son of Ner, the captain of his host: and Saul lay in the trench, and the people pitched round about him.

Then answered David and said to Ahimelech the Hittite, and to Abishai the son of Zeruiah, brother to Joab, saying, Who will go down with me to Saul to the camp? And Abishai said, I will go down with thee.

So David and Abishai came to the people by night: and, behold, Saul lay sleeping within the trench, and his spear stuck in the ground at his bolster: but Abner and the people lay round about him.

Then said Abishai to David, God hath delivered thine enemy into thine hand this day: now therefore let me smite him, I pray thee, with the spear even to the earth at once, and I will not smite him the second time.

And David said to Abishai, Destroy him not: for who can stretch forth his hand against the Lord's anointed, and be guiltless?

David said furthermore, As the Lord liveth, the Lord shall smite him; or his day shall come to die; or he shall descend into battle, and perish.

The Lord forbid that I should stretch forth mine hand against the Lord's anointed: but, I pray thee, take thou now the spear that is at his bolster, and the cruse of water, and let us go.

So David took the spear and the cruse of water from Saul's bolster; and they gat them away, and no man saw it, nor knew it, neither awaked: for they were all asleep; because a deep sleep from the Lord was fallen upon them.

Then David went over to the other side, and stood on the top of an hill afar off; a great space being between them:

And David cried to the people, and to Abner the son of Ner, saying, Answerest thou not, Abner? Then Abner answered and said, Who art thou that criest to the king?

And David said to Abner, Art not thou a valiant man? and who is like to thee in Israel? wherefore then hast thou not kept thy lord the king? for there came one of the people in to destroy the king thy lord.

This thing is not good that thou hast done. As the Lord liveth, ye are worthy to die, because ye have not kept your master, the Lord's anointed. And now see where the king's spear is, and the cruse of water that was at his bolster.

And Saul knew David's voice, and said, Is this thy voice, my son David? And David said, It is my voice, my lord, O king.

And he said, Wherefore doth my lord thus pursue after his servant? for what have I done? or what evil is in mine hand?

Now therefore, I pray thee, let my lord the king hear the words of his servant. If the Lord have stirred thee up against me, let him accept an offering: but if they be the children of men, cursed be they before the Lord; for they have driven me out his day from abiding in the inheritance of the Lord, saying, Go, serve other gods.

Now therefore, let not my blood fall to the earth before the face of the Lord: for the king of Israel is come out to seek a flea, as when one doth hunt a partridge in the mountains.

Then said Saul, I have sinned: return, my son David: for I will no more do thee harm, because my soul was precious in thine eyes this day: behold, I have played the fool, and have erred exceedingly.

And David answered and said, Behold the king's spear! and let one of the young men come over and fetch it.

The Lord render to every man his righteousness and his faithfulness: for the Lord delivered thee into my hand today, but I would not stretch forth mine hand against the Lord's anointed.

David spares Saul's life once more

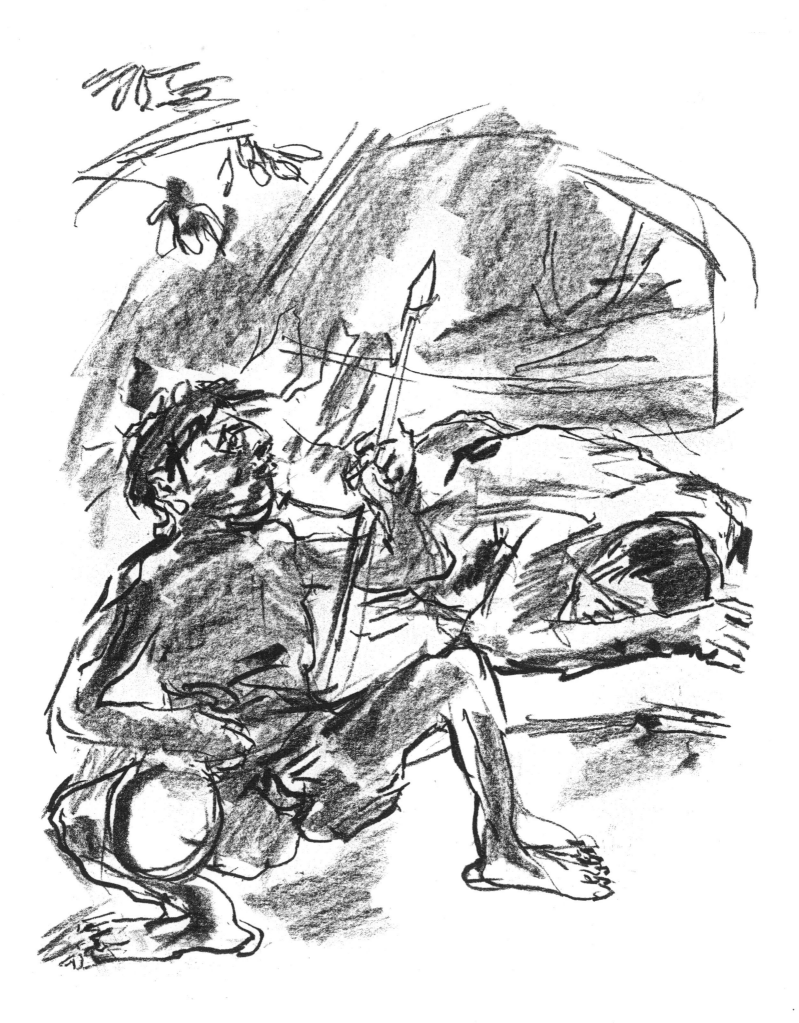

And, behold, as thy life was much set by this day in mine eyes, so let my life be much set by in the eyes of the Lord, and let him deliver me out of all tribulation.

Then Saul said to David, Blessed be thou, my son David: thou shalt both do great things, and also shalt still prevail. So David went on his way, and Saul returned to his place.

And David said in his heart, I shall now perish one day by the hand of Saul: there is nothing better for me than that I should speedily escape into the land of the Philistines; and Saul shall despair of me, to seek me any more in any coast of Israel: so shall I escape out of his hand.

And David arose, and he passed over with the six hundred men that were with him unto Achish, the son of Maoch, king of Gath.

And David dwelt with Achish at Gath, he and his men, every man with his household, even David with his two wives, Ahinoam the Jezreelitess, and Abigail the Carmelitess, Nabal's wife.

And it was told Saul that David was fled to Gath: and he sought no more again for him.

And David said unto Achish, If I have now found grace in thine eyes, let them give me a place in some town in the country, that I may dwell there: for why should thy servant dwell in the royal city with thee?

Then Achish gave him Ziklag that day: wherefore Ziklag pertaineth unto the kings of Judah unto this day.

And the time that David dwelt in the country of the Philistines was a full year and four months.

And David and his men went up, and invaded the Geshurites, and the Gezrites, and the Amalekites: for those nations were of old the inhabitants of the land, as thou goest to Shur, even unto the land of Egypt.

And David smote the land, and left neither man nor woman alive, and

took away the sheep, and the oxen, and the asses, and the camels, and the apparel, and returned, and came to Achish.

And Achish said, Whither have ye made a road today? And David said, Against the south of Judah, and against the south of the Jerahmeelites, and against the south of the Kenites.

And David saved neither man nor woman alive, to bring tidings to Gath, saying, Lest they should tell on us, saying, So did David, and so will be his manner all the while he dwelleth in the country of the Philistines.

And Achish believed David, saying, He hath made his people Israel utterly to abhor him; therefore he shall be my servant for ever.

And it came to pass in those days, that the Philistines gathered their armies together for warfare, to fight with Israel. And Achish said unto David, Know thou assuredly, that thou shalt go out with me to battle, thou and thy men.

And David said to Achish, Surely thou shalt know what thy servant can do. And Achish said to David, Therefore will I make thee keeper of mine head for ever.

Now Samuel was dead, and all Israel had lamented him, and buried him in Ramah, even in his own city. And Saul had put away those that had familiar spirits, and the wizards, out of the land.

And the Philistines gathered themselves together, and came and pitched in Shunem: and Saul gathered all Israel together, and they pitched in Gilboa.

And when Saul saw the host of the Philistines, he was afraid, and his heart greatly trembled.

And when Saul enquired of the Lord, the Lord answered him not, neither by dreams, nor by Urim, nor by prophets.

Then said Saul unto his servants, Seek me a woman that hath a familiar spirit, that I may go to her, and enquire of her. And his servants said to him, Behold, there is a woman that hath a familiar spirit at En-dor.

Saul and the witch of En-dor

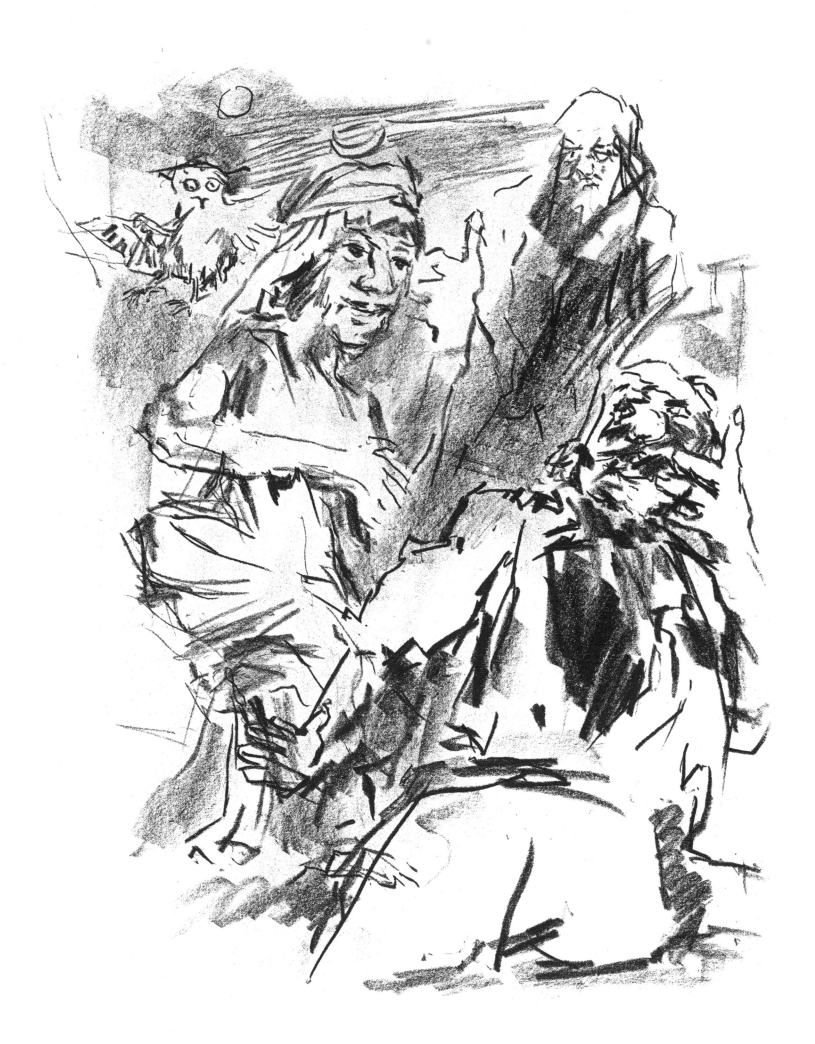

And Saul disguised himself, and put on other raiment, and he went, and two men with him, and they came to the woman by night: and he said, I pray thee, divine unto me by the familiar spirit, and bring me him up, whom I shall name unto thee.

And the woman said unto him, Behold, thou knowest what Saul hath done, how he hath cut off those that have familiar spirits, and the wizards, out of the land: wherefore then layest thou a snare for my life, to cause me to die?

And Saul sware to her by the Lord, saying, As the Lord liveth, there shall no punishment happen to thee for this thing.

Then said the woman, Whom shall I bring up unto thee? And he said, Bring me up Samuel.

And when the woman saw Samuel, she cried with a loud voice: and the woman spake to Saul, saying, Why hast thou deceived me? for thou art Saul.

And the king said unto her, Be not afraid: for what sawest thou? And the woman said unto Saul, I saw gods ascending out of the earth.

And he said unto her, What form is he of? And she said, An old man cometh up; and he is covered with a mantle. And Saul perceived that it was Samuel, and he stooped with his face to the ground, and bowed himself.

And Samuel said to Saul, Why hast thou disquieted me, to bring me up? And Saul answered, I am sore distressed; for the Philistines make war against me, and God is departed from me, and answereth me no more, neither by prophets, nor by dreams: therefore I have called thee, that thou mayest make known unto me what I shall do.

Then said Samuel, Wherefore then dost thou ask of me, seeing the Lord is departed from thee, and is become thine enemy?

And the Lord hath done to him, as he spake by me: for the Lord hath rent the kingdom out of thine hand, and given it to thy neighbour, even to David:

Because thou obeyedst not the voice of the Lord, nor executedst his fierce wrath upon Amalek, therefore hath the Lord done this thing unto thee this day.

Moreover the Lord will also deliver Israel with thee into the hand of the Philistines: and tomorrow shalt thou and thy sons be with me: the Lord also shall deliver the host of Israel into the hand of the Philistines.

Then Saul fell straightway all along on the earth, and was sore afraid, because of the words of Samuel: and there was no strength in him; for he had eaten no bread all the day, nor all the night.

And the woman came unto Saul, and saw that he was sore troubled, and said unto him, Behold, thine handmaid hath obeyed thy voice, and I have put my life in my hand, and have hearkened unto thy words which thou spakest unto me.

Now therefore, I pray thee, hearken thou also unto the voice of thine handmaid, and let me set a morsel of bread before thee; and eat, that thou mayest have strength, when thou goest on thy way.

But he refused, and said, I will not eat. But his servants, together with the woman, compelled him; and he hearkened unto their voice. So he arose from the earth, and sat upon the bed.

And the woman had a fat calf in the house; and she hasted, and killed it, and took flour, and kneaded it, and did bake unleavened bread thereof:

And she brought it before Saul, and before his servants; and they did eat. Then they rose up, and went away that night.

Now the Philistines gathered together all their armies to Aphek: and the Israelites pitched by a fountain which is in Jezreel.

And the lords of the Philistines passed on by hundreds, and by thousands: but David and his men passed on in the rereward with Achish.

Then said the princes of the Philistines, What do these Hebrews here? And Achish said unto the princes of the Philistines, Is not this David, the servant

The woman of En-dor waits upon Saul

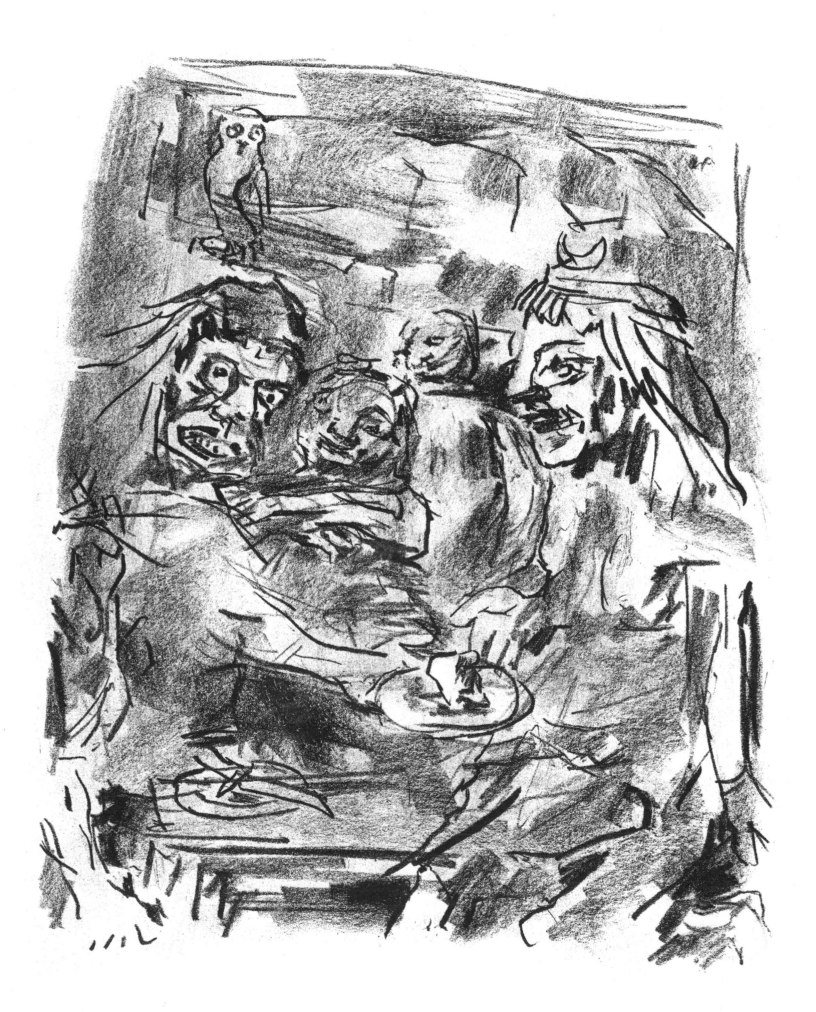

of Saul the king of Israel, which hath been with me these days, or these years, and I have found no fault in him since he fell unto me unto this day?

And the princes of the Philistines were wroth with him; and the princes of the Philistines said unto him, Make this fellow return, that he may go again to his place which thou hast appointed him, and let him not go down with us to battle, lest in the battle he be an adversary to us: for wherewith should he reconcile himself unto his master? should it not be with the heads of these men?

Is not this David, of whom they sang one to another in dances, saying, Saul slew his thousands, and David his ten thousands?

Then Achish called David, and said unto him, Surely, as the Lord liveth, thou hast been upright, and thy going out and thy coming in with me in the host is good in my sight: for I have not found evil in thee since the day of thy coming unto me unto this day: nevertheless the lords favour thee not.

Wherefore now return, and go in peace, that thou displease not the lords of the Philistines.

And David said unto Achish, But what have I done? and what hast thou found in thy servant so long as I have been with thee unto this day, that I may not go fight against the enemies of my lord the king?

And Achish answered and said to David, I know that thou art good in my sight, as an angel of God: notwithstanding the princes of the Philistines have said, He shall not go up with us to the battle.

Wherefore now rise up early in the morning with thy master's servants that are come with thee: and as soon as ye be up early in the morning, and have light, depart.

So David and his men rose up early to depart in the morning, to return into the land of the Philistines. And the Philistines went up to Jezreel.

And it came to pass, when David and his men were come to Ziklag on the third day, that the Amalekites had invaded the south, and Ziklag, and smitten Ziklag, and burned it with fire;

And had taken the women captives, that were therein: they slew not any, either great or small, but carried them away, and went on their way.

So David and his men came to the city, and, behold, it was burned with fire; and their wives, and their sons, and their daughters, were taken captives.

Then David and the people that were with him lifted up their voice and wept, until they had no more power to weep.

And David's two wives were taken captives, Ahinoam the Jezreelitess, and Abigail the wife of Nabal the Carmelite.

And David was greatly distressed; for the people spake of stoning him, because the soul of all the people was grieved, every man for his sons and for his daughters: but David encouraged himself in the Lord his God.

And David said to Abiathar the priest, Ahimelech's son, I pray thee, bring me hither the ephod. And Abiathar brought thither the ephod to David.

And David enquired at the Lord, saying, Shall I pursue after this troop? shall I overtake them? And he answered him, Pursue: for thou shalt surely overtake them, and without fail recover all.

So David went, he and the six hundred men that were with him, and came to the brook Besor, where those that were left behind stayed.

But David pursued, he and four hundred men: for two hundred abode behind, which were so faint that they could not go over the brook Besor.

And they found an Egyptian in the field, and brought him to David, and gave him bread, and he did eat; and they made him drink water;

And they gave him a piece of a cake of figs, and two clusters of raisins: and when he had eaten, his spirit came again to him: for he had eaten no bread, nor drunk any water, three days and three nights.

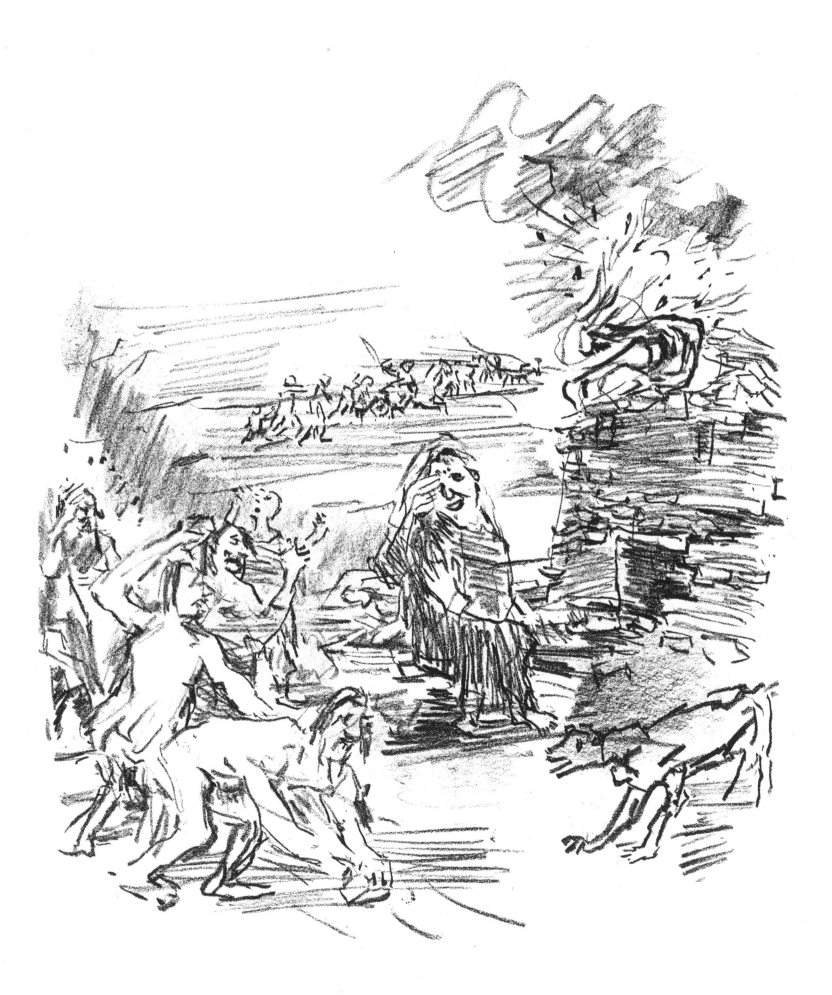

And David said unto him, To whom belongest thou? and whence art thou? And he said, I am a young man of Egypt, servant to an Amalekite; and my master left me, because three days agone I fell sick.

We made an invasion upon the south of the Cherethites, and upon the coast which belongeth to Judah, and upon the south of Caleb; and we burned Ziklag with fire.

And David said to him, Canst thou bring me down to this company? And he said, Swear unto me by God, that thou wilt neither kill me, nor deliver me into the hands of my master, and I will bring thee down to this company.

And when he had brought him down, behold, they were spread abroad upon all the earth, eating and drinking, and dancing, because of all the great spoil that they had taken out of the land of the Philistines, and out of the land of Judah.

And David smote them from the twilight even unto the evening of the next day: and there escaped not a man of them, save four hundred young men, which rode upon camels, and fled.

And David recovered all that the Amalekites had carried away: and David rescued his two wives.

And there was nothing lacking to them, neither small nor great, neither sons nor daughters, neither spoil, nor any thing that they had taken to them: David recovered all.

And David took all the flocks and the herds, which they drave before those other cattle, and said, This is David's spoil.

And David came to the two hundred men, which were so faint that they could not follow David, whom they had made also to abide at the brook Besor: and they went forth to meet David, and to meet the people that were with him: and when David came near to the people, he saluted them.

Then answered all the wicked men and men of Belial, of those that went with David, and said, Because they went not with us, we will not give

them ought of the spoil that we have recovered, save to every man his wife and his children, that they may lead them away, and depart.

Then said David, Ye shall not do so, my brethren, with that which the Lord hath given us, who hath preserved us, and delivered the company that came against us into our hand.

For who will hearken unto you in this matter? but as his part is that goeth down to the battle, so shall his part be that tarrieth by the stuff: they shall part alike.

And it was so from that day forward, that he made it a statute and an ordinance for Israel unto this day.

And when David came to Ziklag, he sent of the spoil unto the elders of Judah, even to his friends, saying, Behold a present for you of the spoil of the enemies of the Lord;

To them which were in Beth-el, and to them which were in south Ramoth, and to them which were in Jattir,

And to them which were in Aroer, and to them which were in Siphmoth, and to them which were in Eshtemoa,

And to them which were in Rachal, and to them which were in the cities of the Jerahmeelites, and to them which were in the cities of the Kenites,

And to them which were in Hormah, and to them which were in Chor-ashan, and to them which were in Athach,

And to them which were in Hebron, and to all the places where David himself and his men were wont to haunt.

Now the Philistines fought against Israel: and the men of Israel fled from before the Philistines, and fell down slain in mount Gilboa.

And the Philistines followed hard upon Saul and upon his sons; and the Philistines slew Jonathan, and Abinadab, and Melchi-shua, Saul's sons.

And the battle went sore against Saul, and the archers hit him; and he was sore wounded of the archers.

Then said Saul unto his armourbearer, Draw thy sword, and thrust me through therewith; lest these uncircumcised come and thrust me through, and abuse me. But his armourbearer would not; for he was sore afraid. Therefore Saul took a sword, and fell upon it.

And when his armourbearer saw that Saul was dead, he fell likewise upon his sword, and died with him.

So Saul died, and his three sons, and his armourbearer, and all his men, that same day together.

And when the men of Israel that were on the other side of the valley, and they that were on the other side Jordan, saw that the men of Israel fled, and that Saul and his sons were dead, they forsook the cities, and fled; and the Philistines came and dwelt in them.

And it came to pass on the morrow, when the Philistines came to strip the slain, that they found Saul and his three sons fallen in mount Gilboa.

And they cut off his head, and stripped off his armour, and sent into the land of the Philistines round about, to publish it in the house of their idols, and among the people.

And they put his armour in the house of Ashtaroth: and they fastened his body to the wall of Beth-shan.

And when the inhabitants of Jabesh-gilead heard of that which the Philistines had done to Saul;

All the valiant men arose, and went all night, and took the body of Saul and the bodies of his sons from the wall of Beth-shan, and came to Jabesh, and burnt them there.

And they took their bones, and buried them under a tree at Jabesh, and fasted seven days.

Now it came to pass after the death of Saul, when David was returned from the slaughter of the Amalekites, and David had abode two days in Ziklag;

It came even to pass on the third day, that, behold, a man came out of the camp from Saul with his clothes rent, and earth upon his head: and so it was, when he came to David, that he fell to the earth, and did obeisance.

And David said unto him, From whence comest thou? And he said unto him, Out of the camp of Israel am I escaped.

And David said unto him, How went the matter? I pray thee, tell me. And he answered, That the people are fled from the battle, and many of the people also are fallen and dead; and Saul and Jonathan his son are dead also.

And David said unto the young man that told him, How knowest thou that Saul and Jonathan his son be dead?

And the young man that told him said, As I happened by chance upon mount Gilboa, behold, Saul leaned upon his spear; and, lo, the chariots and horsemen followed hard after him.

And when he looked behind him, he saw me, and called unto me. And I answered, Here am I.

And he said unto me, Who art thou? And I answered him, I am an Amalekite.

He said unto me again, Stand, I pray thee, upon me, and slay me: for anguish is come upon me, because my life is yet whole in me.

So I stood upon him, and slew him, because I was sure that he could not live after that he was fallen: and I took the crown that was upon his head, and the bracelet that was on his arm, and have brought them hither unto my lord.

Then David took hold on his clothes, and rent them; and likewise all the men that were with him:

And they mourned, and wept, and fasted until even, for Saul, and for

The death of Saul

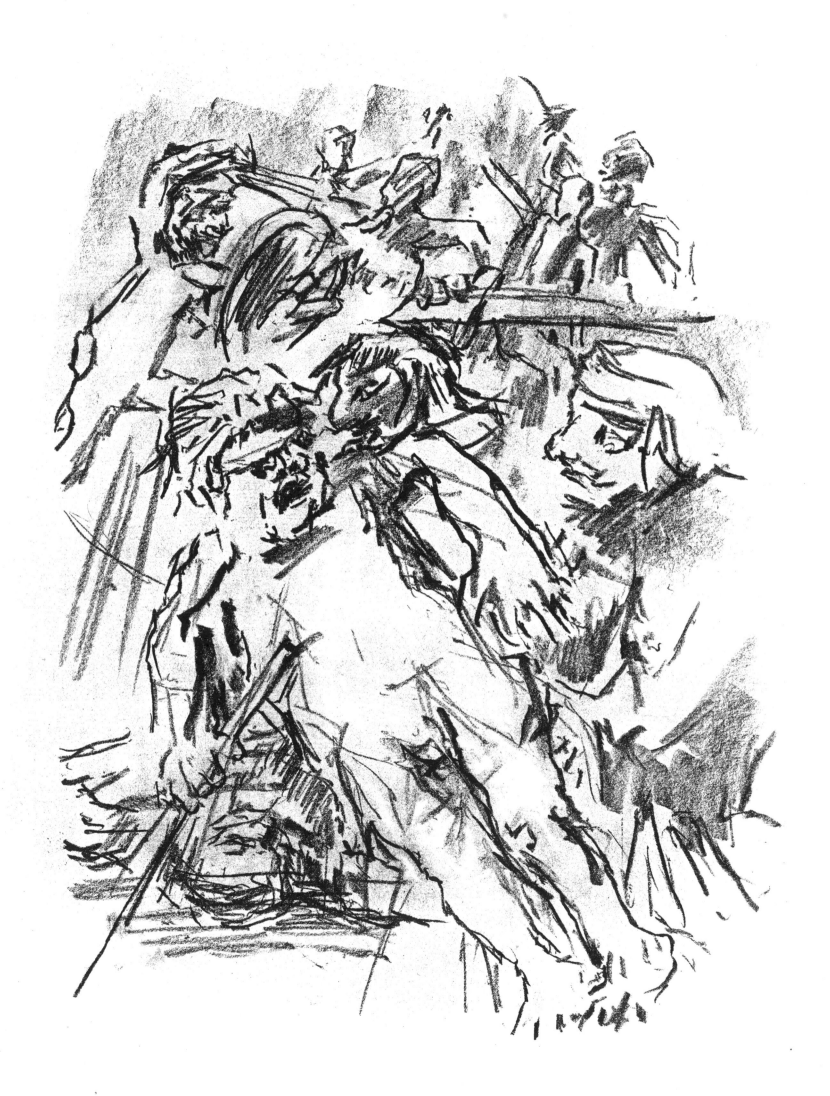

Jonathan his son, and for the people of the Lord, and for the house of Israel; because they were fallen by the sword.

And David said unto the young man that told him, Whence art thou? And he answered, I am the son of a stranger, an Amalekite.

And David said unto him, How wast thou not afraid to stretch forth thine hand to destroy the Lord's anointed?

And David called one of the young men, and said, Go near, and fall upon him. And he smote him that he died.

And David said unto him, Thy blood be upon thy head; for thy mouth hath testified against thee, saying, I have slain the Lord's anointed.

And David lamented with this lamentation over Saul and over Jonathan his son:

(Also he bade them teach the children of Judah the use of the bow: behold, it is written in the book of Jasher.)

The beauty of Israel is slain upon thy high places: how are the mighty fallen!

Tell it not in Gath, publish it not in the streets of Askelon; lest the daughters of the Philistines rejoice, lest the daughters of the uncircumcised triumph.

Ye mountains of Gilboa, let there be no dew, neither let there be rain, upon you, nor fields of offerings: for there the shield of the mighty is vilely cast away, the shield of Saul, as though he had not been anointed with oil.

From the blood of the slain, from the fat of the mighty, the bow of Jonathan turned not back, and the sword of Saul returned not empty.

Saul and Jonathan were lovely and pleasant in their lives, and in their death they were not divided: they were swifter than eagles, they were stronger than lions.

Ye daughters of Israel, weep over Saul, who clothed you in scarlet, with other delights, who put on ornaments of gold upon your apparel.

How are the mighty fallen in the midst of the battle! O Jonathan, thou wast slain in thine high places.

I am distressed for thee, my brother Jonathan: very pleasant hast thou been unto me: thy love to me was wonderful, passing the love of women.

How are the mighty fallen, and the weapons of war perished!

And it came to pass after this, that David enquired of the Lord, saying, Shall I go up into any of the cities of Judah? And the Lord said unto him, Go up. And David said, whither shall I go up? And he said, Unto Hebron.

So David went up thither, and his two wives also, Ahinoam the Jezreelitess, and Abigail Nabal's wife the Carmelite.

And his men that were with him did David bring up, every man with his household: and they dwelt in the cities of Hebron.

And the men of Judah came, and there they anointed David king over the house of Judah. And they told David, saying, That the men of Jabesh-gilead were they that buried Saul.

And David sent messengers unto the men of Jabesh-gilead, and said unto them, Blessed be ye of the Lord, that ye have shewed this kindness unto your lord, even unto Saul, and have buried him.

And now the Lord shew kindness and truth unto you: and I also will requite you this kindness, because ye have done this thing.

Therefore now let your hands be strengthened, and be ye valiant: for your master Saul is dead, and also the house of Judah have anointed me king over them.

But Abner the son of Ner, captain of Saul's host, took Ish-bosheth the son of Saul, and brought him over to Mahanaim;

And made him king over Gilead, and over the Ashurites, and over Jezreel, and over Ephraim, and over Benjamin, and over all Israel.

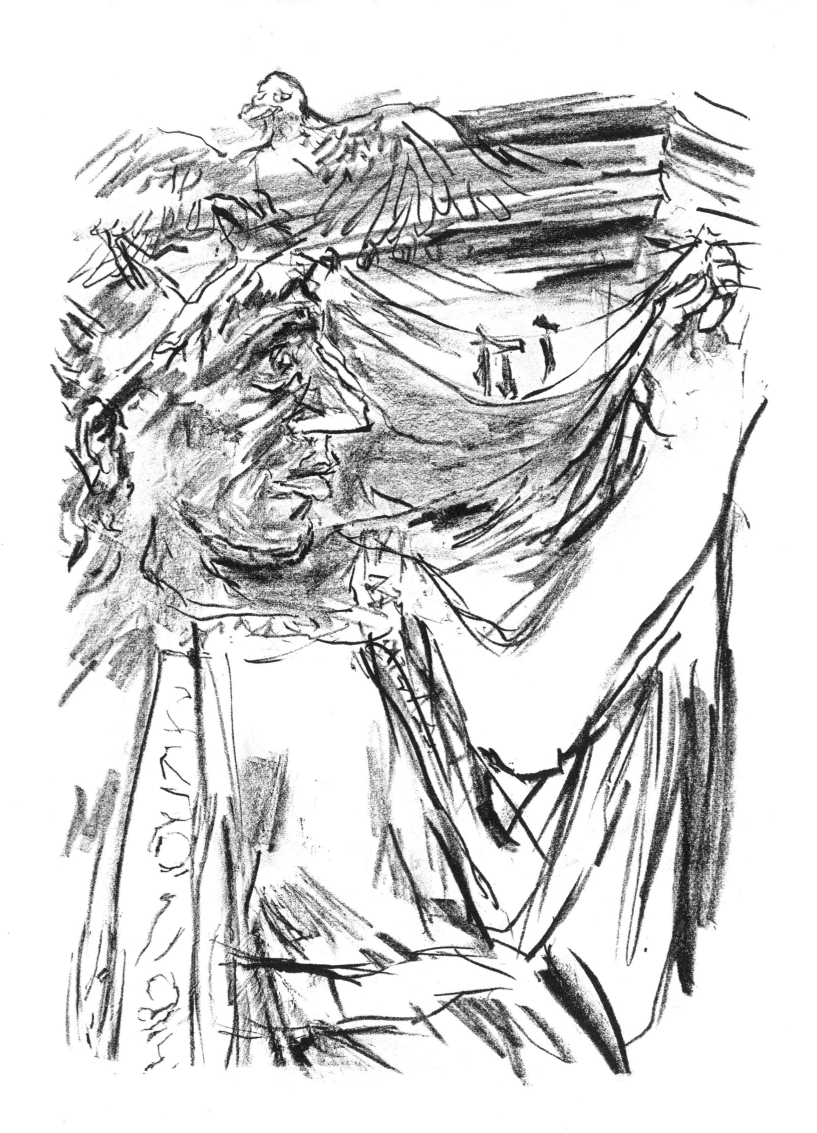

Ish-bosheth Saul's son was forty years old when he began to reign over Israel, and reigned two years. But the house of Judah followed David.

And the time that David was king in Hebron over the house of Judah was seven years and six months.

And Abner the son of Ner, and the servants of Ish-bosheth the son of Saul, went out from Mahanaim to Gibeon.

And Joab the son of Zeruiah, and the servants of David, went out, and met together by the pool of Gibeon: and they sat down, the one on the one side of the pool, and the other on the other side of the pool.

And Abner said to Joab, Let the young men now arise, and play before us. And Joab said, Let them arise.

Then there arose and went over by number twelve of Benjamin, which pertained to Ish-bosheth the son of Saul, and twelve of the servants of David.

And they caught every one his fellow by the head, and thrust his sword in his fellow's side; so they fell down together: wherefore that place was called Helkath-hazzurim, which is in Gibeon.

And there was a very sore battle that day; and Abner was beaten, and the men of Israel, before the servants of David.

And there were three sons of Zeruiah there, Joab, and Abishai, and Asahel: and Asahel was as light of foot as a wild roe.

And Asahel pursued after Abner; and in going he turned not to the right hand nor to the left from following Abner.

Then Abner looked behind him, and said, Art thou Asahel? And he answered, I am.

And Abner said to him, Turn thee aside to thy right hand or to thy left, and lay thee hold on one of the young men, and take thee his armour. But Asahel would not turn aside from following of him.

And Abner said again to Asahel, Turn thee aside from following me:

wherefore should I smite thee to the ground? how then should I hold up my face to Joab thy brother?

Howbeit he refused to turn aside: wherefore Abner with the hinder end of the spear smote him under the fifth rib, that the spear came out behind him; and he fell down there, and died in the same place: and it came to pass, that as many as came to the place where Asahel fell down and died stood still.

Joab also and Abishai pursued after Abner: and the sun went down when they were come to the hill of Ammah, that lieth before Giah by the way of the wilderness of Gibeon.

And the children of Benjamin gathered themselves together after Abner, and became one troop, and stood on the top of an hill.

Then Abner called to Joab, and said, Shall the sword devour for ever? knowest thou not that it will be bitterness in the latter end? how long shall it be then, ere thou bid the people return from following their brethren?

And Joab said, As God liveth, unless thou hadst spoken, surely then in the morning the people had gone up every one from following his brother.

So Joab blew a trumpet, and all the people stood still, and pursued after Israel no more, neither fought they any more.

And Abner and his men walked all that night through the plain, and passed over Jordan, and went through all Bithron, and they came to Mahanaim.

And Joab returned from following Abner: and when he had gathered all the people together, there lacked of David's servants nineteen men and Asahel.

But the servants of David had smitten of Benjamin, and of Abner's men, so that three hundred and threescore men died.

And they took up Asahel, and buried him in the sepulchre of his father,

which was in Bethlehem. And Joab and his men went all night, and they came to Hebron at break of day.

Now there was long war between the house of Saul and the house of David: but David waxed stronger and stronger, and the house of Saul waxed weaker and weaker.

And unto David were sons born in Hebron: and his firstborn was Amnon, of Ahinoam the Jezreelitess;

And his second, Chileab, of Abigail the wife of Nabal the Carmelite; and the third, Absalom the son of Maacah the daughter of Talmai king of Geshur;

And the fourth, Adonijah the son of Haggith; and the fifth, Shephatiah the son of Abital;

And the sixth, Ithream, by Eglah David's wife. These were born to David in Hebron.

And it came to pass, while there was war between the house of Saul and the house of David, that Abner made himself strong for the house of Saul.

And Saul had a concubine, whose name was Rizpah, the daughter of Aiah: and Ish-bosheth said to Abner, Wherefore hast thou gone in unto my father's concubine?

Then was Abner very wroth for the words of Ish-bosheth and said, Am I a dog's head, which against Judah do shew kindness this day unto the house of Saul thy father, to his brethren, and to his friends, and have not delivered thee into the hand of David, that thou chargest me today with a fault concerning this woman?

So do God to Abner, and more also, except, as the Lord hath sworn to David, even so I do to him;

To translate the kingdom from the house of Saul, and to set up the throne of David over Israel and over Judah, from Dan even to Beer-sheba.

And he could not answer Abner a word again, because he feared him.

And Abner sent messengers to David on his behalf, saying, whose is the land? saying also, Make thy league with me, and, behold, my hand shall be with thee, to bring about all Israel unto thee.

And he said, Well; I will make a league with thee: but one thing I require of thee, that is, Thou shalt not see my face, except thou first bring Michal Saul's daughter, when thou comest to see my face.

And David sent messengers to Ish-bosheth Saul's son, saying, Deliver me my wife Michal, which I espoused to me for an hundred foreskins of the Philistines.

And Ish-bosheth sent, and took her from her husband, even from Phaltiel the son of Laish.

And her husband went with her along weeping behind her to Bahurim. Then said Abner unto him, Go, return. And he returned.

And Abner had communication with the elders of Israel, saying, Ye sought for David in times past to be king over you:

Now then do it: for the Lord hath spoken of David, saying, By the hand of my servant David I will save my people Israel out of the hand of the Philistines, and out of the hand of all their enemies.

And Abner also spake in the ears of Benjamin: and Abner went also to speak in the ears of David in Hebron all that seemed good to Israel, and that seemed good to the whole house of Benjamin.

So Abner came to David to Hebron, and twenty men with him. And David made Abner and the men that were with him a feast.

And Abner said unto David, I will arise and go, and will gather all Israel unto my lord the king, that they may make a league with thee, and that thou mayest reign over all that thine heart desireth. And David sent Abner away; and he went in peace.

And, behold, the servants of David and Joab came from pursuing a troop, and brought in a great spoil with them: but Abner was not with David in Hebron; for he had sent him away, and he was gone in peace.

When Joab and all the host that was with him were come, they told Joab, saying, Abner the son of Ner came to the king, and he hath sent him away, and he is gone in peace.

Then Joab came to the king, and said, What hast thou done? behold, Abner came unto thee; why is it that thou hast sent him away, and he is quite gone?

Thou knowest Abner the son of Ner, that he came to deceive thee, and to know thy going out and thy coming in, and to know all that thou doest.

And when Joab was come out from David, he sent messengers after Abner, which brought him again from the well of Sirah: but David knew it not.

And when Abner was returned to Hebron, Joab took him aside in the gate to speak with him quietly, and smote him there under the fifth rib, that he died, for the blood of Asahel his brother.

And afterward when David heard it, he said, I and my kingdom are guiltless before the Lord for ever from the blood of Abner the son of Ner:

Let it rest on the head of Joab, and on all his father's house; and let there not fail from the house of Joab one that hath an issue, or that is a leper, or that leaneth on a staff, or that falleth on the sword, or that lacketh bread.

So Joab and Abishai his brother slew Abner, because he had slain their brother Asahel at Gibeon in the battel.

And David said to Joab, and to all the people that were with him, Rend your clothes, and gird you with sackcloth, and mourn before Abner. And king David himself followed the bier.

And they buried Abner in Hebron: and the king lifted up his voice, and wept at the grave of Abner; and all the people wept.

And the king lamented over Abner, and said, Died Abner as a fool dieth?

Thy hands were not bound, nor thy feet put into fetters: as a man falleth before wicked men, so fellest thou. And all the people wept again over him.

And when all the people came to cause David to eat meat while it was yet day, David sware, saying, So do God to me, and more also, if I taste bread, or ought else, till the sun be down.

And all the people took notice of it, and it pleased them: as whatsoever the king did pleased all the people.

For all the people and all Israel understood that day that it was not of the king to slay Abner the son of Ner.

And the king said unto his servants, Know ye not that there is a prince and a great man fallen this day in Israel?

And I am this day weak, though anointed king; and these men the sons of Zeruiah be too hard for me: the Lord shall reward the doer of evil according to his wickedness.

And when Saul's son heard that Abner was dead in Hebron, his hands were feeble, and all the Israelites were troubled.

And Saul's son had two men that were captains of bands: the name of the one was Baanah, and the name of the other Rechab, the sons of Rimmon a Beerothite, of the children of Benjamin: (for Beeroth also was reckoned to Benjamin:

And the Beerothites fled to Gittaim, and were sojourners there until this day.)

And Jonathan, Saul's son, had a son that was lame of his feet. He was five years old when the tidings came of Saul and Jonathan out of Jezreel, and his nurse took him up, and fled: and it came to pass, as she made haste to flee, that he fell, and became lame. And his name was Mephibosheth.

And the sons of Rimmon the Beerothite, Rechab and Baanah, went, and came about the heat of the day to the house of Ish-bosheth, who lay on a bed at noon.

And they came thither into the midst of the house, as though they would have fetched wheat; and they smote him under the fifth rib: and Rechab and Baanah his brother escaped.

For when they came into the house, he lay on his bed in his bedchamber, and they smote him, and slew him, and beheaded him, and took his head, and gat them away through the plain all night.

And they brought the head of Ish-bosheth unto David to Hebron, and said to the king, Behold the head of Ish-bosheth the son of Saul thine enemy, which sought thy life; and the Lord hath avenged my lord the king this day of Saul, and of his seed.

And David answered Rechab and Baanah his brother, the sons of Rimmon the Beerothite, and said unto them, As the Lord liveth, who hath redeemed my soul out of all adversity,

When one told me, saying, Behold, Saul is dead, thinking to have brought good tidings, I took hold of him, and slew him in Ziklag, who thought that I would have given him a reward for his tidings:

How much more, when wicked men have slain a righteous person in his own house upon his bed? shall I not therefore now require his blood of your hand, and take you away from the earth?

And David commanded his young men, and they slew them, and cut off their hands and their feet, and hanged them up over the pool in Hebron. But they took the head of Ish-bosheth, and buried it in the sepulchre of Abner in Hebron.

Then came all the tribes of Israel to David unto Hebron, and spake, saying, Behold, we are thy bone and thy flesh.

Also in time past, when Saul was king over us, thou wast he that leddest out and broughtest in Israel: and the Lord said to thee, Thou shalt feed my people Israel, and thou shalt be a captain over Israel.

So all the elders of Israel came to the king to Hebron; and king David

made a league with them in Hebron before the Lord: and they anointed David king over Israel.

David was thirty years old when he began to reign, and he reigned forty years.

In Hebron he reigned over Judah seven years and six months: and in Jerusalem he reigned thirty and three years over all Israel and Judah.

And the king and his men went to Jerusalem unto the Jebusites, the inhabitants of the land: which spake unto David, saying, Except thou take away the blind and the lame, thou shalt not come in hither: thinking, David cannot come in hither.

Nevertheless David took the strong hold of Zion: the same is the city of David.

And David said on that day, Whosoever getteth up to the gutter, and smiteth the Jebusites, and the lame and the blind, that are hated of David's soul, he shall be chief and captain. Wherefore they said, The blind and the lame shall not come into the house.

So David dwelt in the fort, and called it the city of David. And David built round about from Millo and inward.

And David went on, and grew great, and the Lord God of hosts was with him.

And Hiram king of Tyre sent messengers to David, and cedar trees, and carpenters, and masons: and they built David an house.

And David perceived that the Lord had established him king over Israel, and that he had exalted his kingdom for his people Israel's sake.

And David took him more concubines and wives out of Jerusalem, after he was come from Hebron: and there were yet sons and daughters born to David.

And these be the names of those that were born unto him in Jerusalem; Shammuah, and Shobab, and Nathan, and Solomon,

Ibhar also, and Elishua, and Nepheg, and Japhia,

And Elishama, and Eliada, and Eliphalet.

But when the Philistines heard that they had anointed David king over Israel, all the Philistines came up to seek David; and David heard of it, and went down to the hold.

The Philistines also came and spread themselves in the valley of Rephaim.

And David enquired of the Lord, saying, Shall I go up to the Philistines? wilt thou deliver them into mine hand? And the Lord said unto David, Go up: for I will doubtless deliver the Philistines into thine hand.

And David came to Baal-perazim, and David smote them there, and said, the Lord hath broken forth upon mine enemies before me, as the breach of waters. Therefore he called the name of that place Baal-perazim.

And there they left their images, and David and his men burned them.

And the Philistines came up yet again, and spread themselves in the valley of Rephaim.

And when David enquired of the Lord, he said, Thou shalt not go up; but fetch a compass behind them, and come upon them over against the mulberry trees.

And let it be, when thou hearest the sound of a going in the tips of the mulberry trees, that then thou shalt bestir thyself: for then shall the Lord go out before thee, to smite the host of the Philistines.

And David did so, as the Lord had commanded him; and smote the Philistines from Geba until thou come to Gazer.

Again, David gathered together all the chosen men of Israel, thirty thousand.

And David arose, and went with all the people that were with him from

Baale of Judah, to bring up from thence the ark of God, whose name is called by the name of the Lord of hosts that dwelleth between the cherubims.

And they set the ark of God upon a new cart, and brought it out of the house of Abinadab that was in Gibeah: and Uzzah and Ahio, the sons of Abinadab, drave the new cart.

And they brought it out of the house of Abinadab which was at Gibeah, accompanying the ark of God: and Ahio went before the ark.

And David and all the house of Israel played before the Lord on all manner of instruments made of fir wood, even on harps, and on psalteries, and on timbrels, and on cornets, and on cymbals.

And when they came to Nachon's threshingfloor, Uzzah put forth his hand to the ark of God, and took hold of it; for the oxen shook it.

And the anger of the Lord was kindled against Uzzah; and God smote him there for his error; and there he died by the ark of God.

And David was displeased, because the Lord had made a breach upon Uzzah: and he called the name of the place Perez-uzzah to this day.

And David was afraid of the Lord that day, and said, How shall the ark of the Lord come to me?

So David would not remove the ark of the Lord unto him into the city of David: but David carried it aside into the house of Obed-edom the Gittite.

And the ark of the Lord continued in the house of Obed-edom the Gittite three months: and the Lord blessed Obed-edom, and all his household.

And it was told king David, saying, The Lord hath blessed the house of Obed-edom, and all that pertaineth unto him, because of the ark of God. So David went and brought up the ark of God from the house of Obed-edom into the city of David with gladness.

And it was so, that when they that bare the ark of the Lord had gone six paces, he sacrificed oxen and fatlings.

David dances before the ark of the Lord

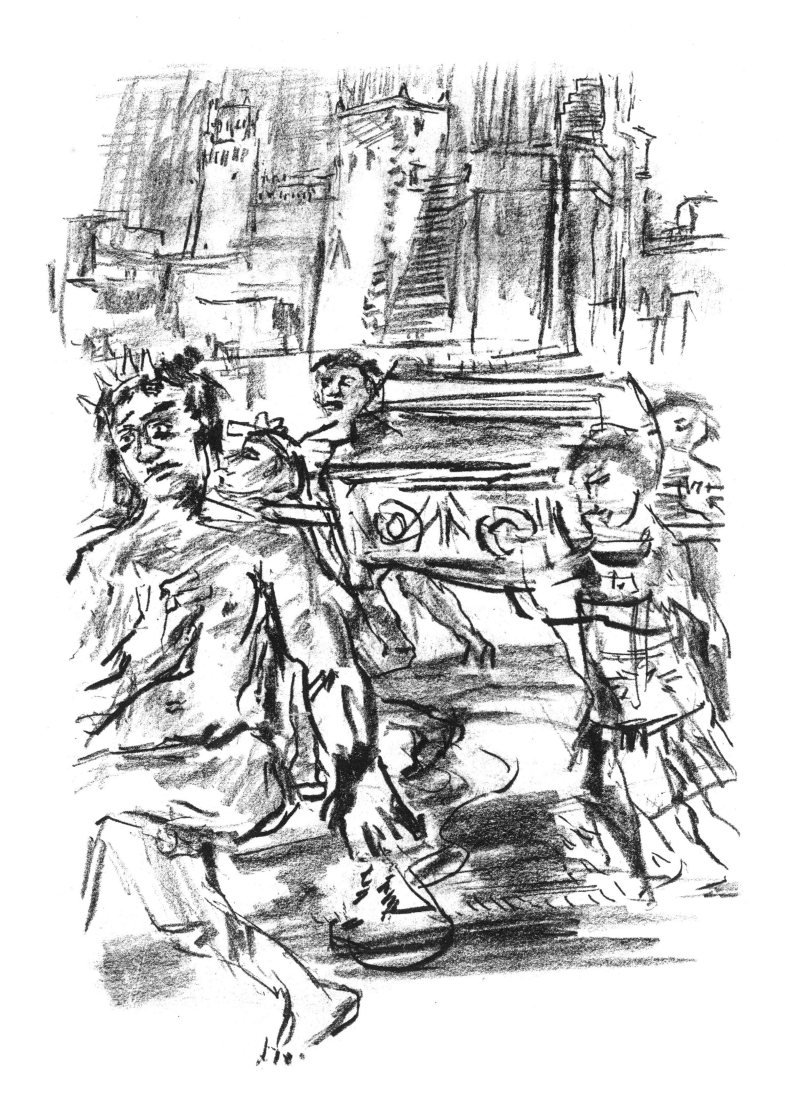

And David danced before the Lord with all his might; and David was girded with a linen ephod.

So David and all the house of Israel brought up the ark of the Lord with shouting, and with the sound of the trumpet.

And as the ark of the Lord came into the city of David, Michal Saul's daughter looked through a window, and saw king David leaping and dancing before the Lord; and she despised him in her heart.

And they brought in the ark of the Lord, and set it in his place, in the midst of the tabernacle that David had pitched for it: and David offered burnt offerings and peace offerings before the Lord.

And as soon as David had made an end of offering burnt offerings and peace offerings, he blessed the people in the name of the Lord of hosts.

And he dealt among all the people, even among the whole multitude of Israel, as well to the women as men, to every one a cake of bread, and a good piece of flesh, and a flagon of wine. So all the people departed every one to his house.

Then David returned to bless his household. And Michal the daughter of Saul came out to meet David, and said, How glorious was the king of Israel today, who uncovered himself today in the eyes of the handmaids of his servants, as one of the vain fellows shamelessly uncovered himself!

And David said unto Michal, It was before the Lord, which chose me before thy father, and before all his house, to appoint me ruler over the people of the Lord, over Israel: therefore will I play before the Lord.

And I will yet be more vile than thus, and will be base in mine own sight: and of the maidservants which thou hast spoken of, of them shall I be had in honour.

Therefore Michal the daughter of Saul had no child unto the day of her death.

And it came to pass, when the king sat in his house, and the Lord had given him rest round about from all his enemies;

That the king said unto Nathan the prophet, See now, I dwell in an house of cedar, but the ark of God dwelleth within curtains.

And Nathan said to the king, Go, do all that is in thine heart; for the Lord is with thee.

And it came to pass that night, that the word of the Lord came unto Nathan, saying,

Go and tell my servant David, Thus saith the Lord, Shalt thou build me an house for me to dwell in?

Whereas I have not dwelt in any house since the time that I brought up the children of Israel out of Egypt, even to this day, but have walked in a tent and in a tabernacle.

In all the places wherein I have walked with all the children of Israel spake I a word with any of the tribes of Israel, whom I commanded to feed my people Israel, saying, Why build ye not me an house of cedar?

Now therefore so shalt thou say unto my servant David, Thus saith the Lord of hosts, I took thee from the sheepcote, from following the sheep, to be ruler over my people, over Israel:

And I was with thee whithersoever thou wentest, and have cut off all thine enemies out of thy sight, and have made thee a great name, like unto the name of the great men that are in the earth.

Moreover I will appoint a place for my people Israel, and will plant them, that they may dwell in a place of their own, and move no more; neither shall the children of wickedness afflict them any more, as beforetime,

And as since the time that I commanded judges to be over my people Israel, and have caused thee to rest from all thine enemies. Also the Lord telleth thee that he will make thee an house.

And when thy days be fulfilled, and thou shalt sleep with thy fathers, I

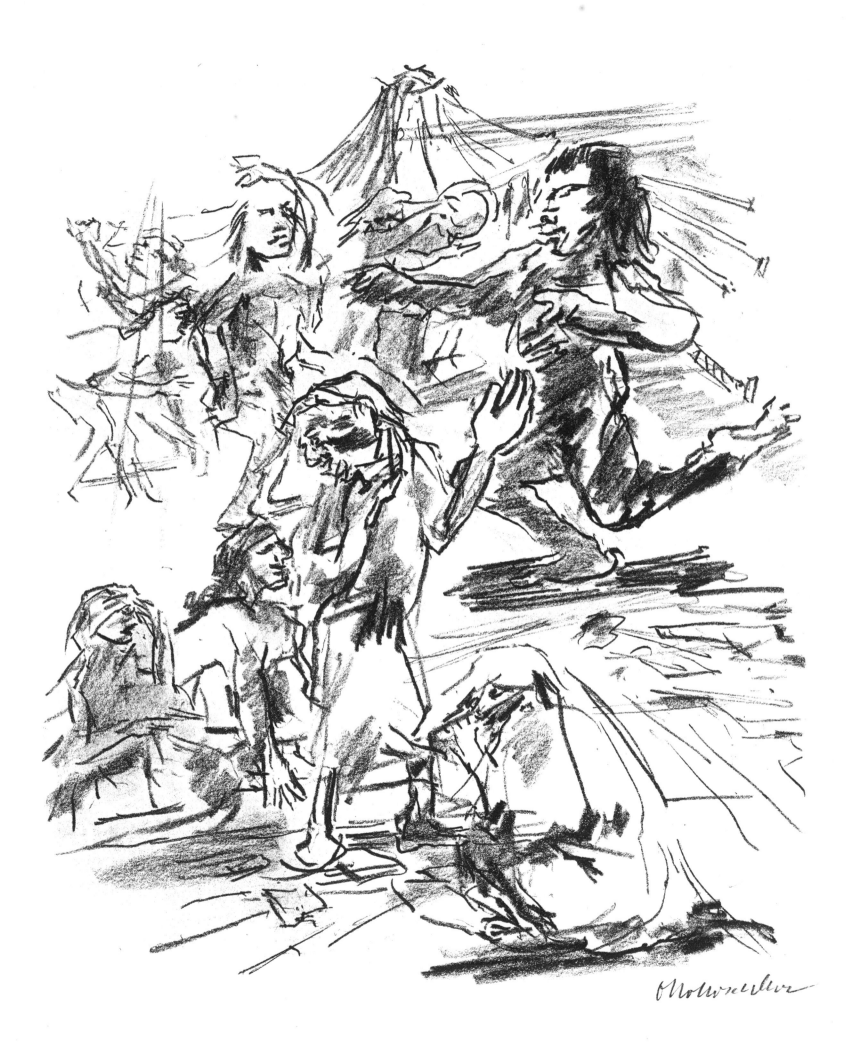

will set up thy seed after thee, which shall proceed out of thy bowels, and I will establish his kingdom.

He shall build an house for my name, and I will stablish the throne of his kingdom for ever.

I will be his father and he shall be my son. If he commit iniquity, I will chasten him with the rod of men, and with the stripes of the children of men:

But my mercy shall not depart away from him, as I took it from Saul, whom I put away before thee.

And thine house and thy kingdom shall be established for ever before thee: thy throne shall be established for ever.

According to all these words, and according to all this vision, so did Nathan speak unto David.

Then went king David in, and sat before the Lord, and he said, Who am I, O Lord God? and what is my house, that thou hast brought me hitherto?

And this was yet a small thing in thy sight, O Lord God; but thou hast spoken also of thy servant's house for a great while to come. And is this the manner of man, O Lord God?

And what can David say more unto thee? for thou, Lord God, knowest thy servant.

For thy word's sake, and according to thine own heart, hast thou done all these great things, to make thy servant know them.

Wherefore thou art great, O Lord God: for there is none like thee, neither is there any God beside thee, according to all that we have heard with our ears.

And what one nation in the earth is like thy people, even like Israel, whom God went to redeem for a people to himself, and to make him a name, and to do for you great things and terrible, for thy land, before thy people, which thou redeemedst to thee from Egypt, from the nations and their gods?

For thou hast confirmed to thyself thy people Israel to be a people unto thee for ever: and thou, Lord, art become their God.

And now, O Lord God, the word that thou hast spoken concerning thy servant, and concerning his house, establish it for ever, and do as thou hast said.

And let thy name be magnified for ever, saying, The Lord of hosts is the God over Israel: and let the house of thy servant David be established before thee.

For thou, O Lord of hosts, God of Israel, hast revealed to thy servant, saying, I will build thee an house: therefore hath thy servant found in his heart to pray this prayer unto thee.

And now, O Lord God, thou art that God, and thy words be true, and thou hast promised this goodness unto thy servant:

Therefore now let it please thee to bless the house of thy servant, that it may continue for ever before thee: for thou, O Lord God, hast spoken it: and with thy blessing let the house of thy servant be blessed for ever.

And after this it came to pass, that David smote the Philistines, and subdued them: and David took Metheg-ammah out of the hand of the Philistines.

And he smote Moab, and measured them with a line, casting them down to the ground; even with two lines measured he to put to death, and with one full line to keep alive. And so the Moabites became David's servants, and brought gifts.

David smote also Hadadezer, the son of Rehob, king of Zobah, as he went to recover his border at the river Euphrates.

And David took from him a thousand chariots, and seven hundred horsemen, and twenty thousand footmen: and David houghed all the chariot horses, but reserved of them for an hundred chariots.

And when the Syrians of Damascus came to succour Hadadezer king of Zobah, David slew of the Syrians two and twenty thousand men.

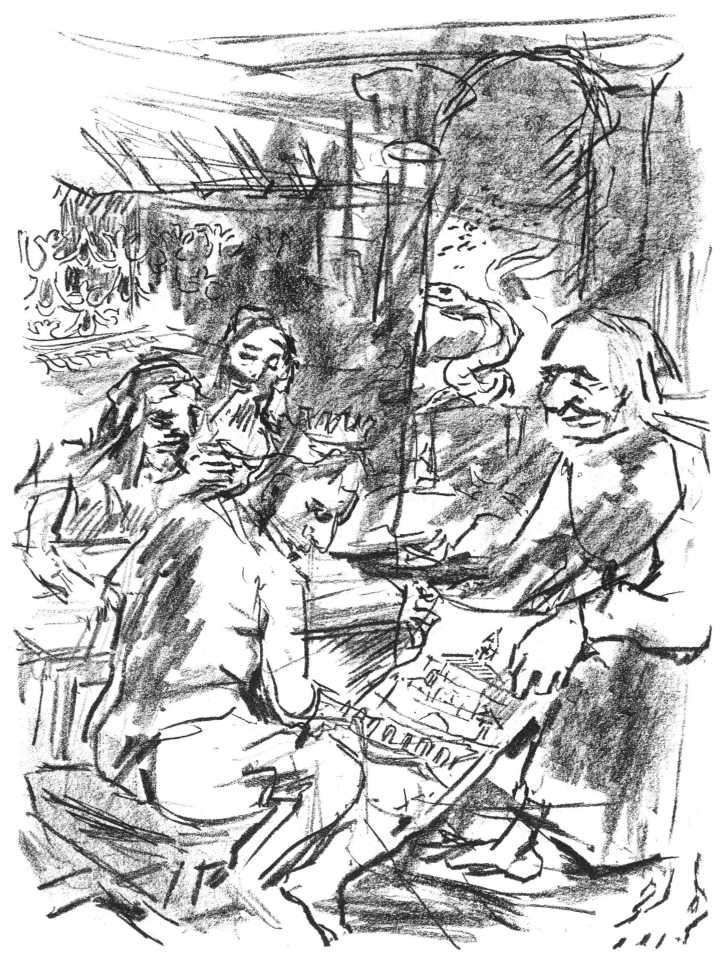

Then David put garrisons in Syria of Damascus: and the Syrians became servants to David, and brought gifts. And the Lord preserved David whithersoever he went.

And David took the shields of gold that were on the servants of Hadadezer, and brought them to Jerusalem.

And from Betah, and from Berothai, cities of Hadadezer, king David took exceeding much brass.

When Toi king of Hamath heard that David had smitten all the host of Hadadezer,

Then Toi sent Joram his son unto king David, to salute him, and to bless him, because he had fought against Hadadezer, and smitten him: for Hadadezer had wars with Toi. And Joram brought with him vessels of silver, and vessels of gold, and vessels of brass:

Which also king David did dedicate unto the Lord, with the silver and gold that he had dedicated of all nations which he subdued;

Of Syria, and of Moab, and of the children of Ammon, and of the Philistines, and of Amalek, and of the spoil of Hadadezer, son of Rehob, king of Zobah.

And David gat him a name when he returned from smiting of the Syrians in the valley of salt, being eighteen thousand men.

And he put garrisons in Edom; throughout all Edom put he garrisons, and all they of Edom became David's servants. And the Lord preserved David whithersoever he went.

And David reigned over all Israel; and David executed judgment and justice unto all his people.

And Joab the son of Zeruiah was over the host; and Jehoshaphat the son of Ahilud was recorder;

And Zadok the son of Ahitub, and Ahimelech the son of Abiathar, were the priests; and Seraiah was the scribe;

And Benaiah the son of Jehoiada was over both the Cherethites and the Pelethites; and David's sons were chief rulers.

And David said, Is there yet any that is left of the house of Saul, that I may shew him kindness for Jonathan's sake?

And there was of the house of Saul a servant whose name was Ziba. And when they had called him unto David, the king said unto him, Art thou Ziba? And he said, Thy servant is he.

And the king said, Is there not yet any of the house of Saul, that I may shew the kindness of God unto him? And Ziba said unto the king, Jonathan hath yet a son, which is lame on his feet.

And the king said unto him, Where is he? And Ziba said unto the king, Behold, he is in the house of Machir, the son of Ammiel, in Lo-debar.

Then king David sent, and fetched him out of the house of Machir, the son of Ammiel, from Lo-debar.

Now when Mephibosheth, the son of Jonathan, the son of Saul, was come unto David, he fell on his face, and did reverence. And David said, Mephibosheth. And he answered, Behold thy servant!

And David said unto him, Fear not: for I will surely shew thee kindness for Jonathan thy father's sake, and will restore thee all the land of Saul thy father; and thou shalt eat bread at my table continually.

And he bowed himself, and said, What is thy servant, that thou shouldest look upon such a dead dog as I am?

Then the king called to Ziba, Saul's servant, and said unto him, I have given unto thy master's son all that pertained to Saul and to all his house.

Thou therefore, and thy sons, and thy servants, shall till the land for him, and thou shalt bring in the fruits, that thy master's son may have food to eat: but Mephibosheth thy master's son shall eat bread alway at my table. Now Ziba had fifteen sons and twenty servants.

Then said Ziba unto the king, According to all that my lord the king hath commanded his servant, so shall thy servant do. As for Mephibosheth, said the king, he shall eat at my table, as one of the king's sons.

And Mephibosheth had a young son, whose name was Micha. And all that dwelt in the house of Ziba were servants unto Mephibosheth.

So Mephibosheth dwelt in Jerusalem: for he did eat continually at the king's table; and was lame on both his feet.

And it came to pass after this, that the king of the children of Ammon died, and Hanun his son reigned in his stead.

Then said David, I will shew kindness unto Hanun the son of Nahash, as his father shewed kindness unto me. And David sent to comfort him by the hand of his servants for his father. And David's servants came into the land of the children of Ammon.

And the princes of the children of Ammon said unto Hanun their lord, Thinkest thou that David doth honour thy father, that he hath sent comforters unto thee? hath not David rather sent his servants unto thee, to search the city, and to spy it out, and to overthrow it?

Wherefore Hanun took David's servants, and shaved off the one half of their beards, and cut off their garments in the middle, even to their buttocks, and sent them away.

When they told it unto David, he sent to meet them, because the men were greatly ashamed: and the king said, Tarry at Jericho until your beards be grown, and then return.

And when the children of Ammon saw that they stank before David, the children of Ammon sent and hired the Syrians of Beth-rehob, and the Syrians of Zoba, twenty thousand footmen, and of king Maacah a thousand men, and of Ish-tob twelve thousand men.

And when David heard of it, he sent Joab, and all the host of the mighty men.

And the children of Ammon came out, and put the battle in array at the entering in of the gate: and the Syrians of Zoba, and of Rehob, and Ishtob, and Maacah, were by themselves in the field.

When Joab saw that the front of the battle was against him before and behind, he chose of all the choice men of Israel, and put them in array against the Syrians:

And the rest of the people he delivered into the hand of Abishai his brother, that he might put them in array against the children of Ammon.

And he said, If the Syrians be too strong for me, then thou shalt help me: but if the children of Ammon be too strong for thee, then I will come and help thee.

Be of good courage, and let us play the men for our people, and for the cities of our God: and the Lord do that which seemeth him good.

And Joab drew nigh, and the people that were with him, unto the battle against the Syrians: and they fled before him.

And when the children of Ammon saw that the Syrians were fled, then fled they also before Abishai, and entered into the city. So Joab returned from the children of Ammon, and came to Jerusalem.

And when the Syrians saw that they were smitten before Israel, they gathered themselves together.

And Hadarezer sent, and brought out the Syrians that were beyond the river: and they came to Helam; and Shobach the captain of the host of Hadarezer went before them.

And when it was told David, he gathered all Israel together, and passed over Jordan, and came to Helam. And the Syrians set themselves in array against David, and fought with him.

And the Syrians fled before Israel; and David slew the men of seven hundred chariots of the Syrians, and forty thousand horsemen, and smote Shobach the captain of their host, who died there.

And when all the kings that were servants to Hadarezer saw that they were

smitten before Israel, they made peace with Israel, and served them. So the Syrians feared to help the children of Ammon any more.

And it came to pass, after the year was expired, at the time when kings go forth to battle, that David sent Joab, and his servants with him, and all Israel; and they destroyed the children of Ammon, and besieged Rabbah. But David tarried still at Jerusalem.

And it came to pass in an eveningtide, that David arose from off his bed, and walked upon the roof of the king's house: and from the roof he saw a woman washing herself; and the woman was very beautiful to look upon.

And David sent and enquired after the woman. And one said, Is not this Bath-sheba, the daughter of Eliam, the wife of Uriah the Hittite?

And David sent messengers, and took her; and she came in unto him, and he lay with her; for she was purified from her uncleanness: and she returned unto her house.

And the woman conceived, and sent and told David, and said, I am with child.

And David sent to Joab, saying, Send me Uriah the Hittite. And Joab sent Uriah to David.

And when Uriah was come unto him, David demanded of him how Joab did, and how the people did, and how the war prospered.

And David said to Uriah, Go down to thy house, and wash thy feet. And Uriah departed out of the king's house, and there followed him a mess of meat from the king.

But Uriah slept at the door of the king's house with all the servants of his lord, and went not down to his house.

And when they had told David, saying, Uriah went not down unto his house, David said unto Uriah, Camest thou not from thy journey? why then didst thou not go down unto thine house?

And Uriah said unto David, The ark, and Israel, and Judah, abide in tents; and my lord Joab, and the servants of my lord, are encamped in the open fields; shall I then go into mine house, to eat and to drink, and to lie with my wife? as thou livest, and as thy soul liveth, I will not do this thing.

And David said to Uriah, Tarry here today also, and tomorrow I will let thee depart. So Uriah abode in Jerusalem that day, and the morrow.

And when David had called him, he did eat and drink before him; and he made him drunk: and at even he went out to lie on his bed with the servants of his lord, but went not down to his house.

And it came to pass in the morning, that David wrote a letter to Joab, and sent it by the hand of Uriah.

And he wrote in the letter, saying, Set ye Uriah in the forefront of the hottest battle, and retire ye from him, that he may be smitten, and die.

And it came to pass, when Joab observed the city, that he assigned Uriah unto a place where he knew that valiant men were.

And the men of the city went out, and fought with Joab: and there fell some of the people of the servants of David; and Uriah the Hittite died also.

Then Joab sent and told David all the things concerning the war;

And charged the messenger, saying, When thou hast made an end of telling the matters of the war unto the king,

And if so be that the king's wrath arise, and he say unto thee, Wherefore approached ye so nigh unto the city when ye did fight? knew ye not that they would shoot from the wall?

Who smote Abimelech the son of Jerubbesheth? did not a woman cast a piece of a millstone upon him from the wall, that he died in Thebez? why went ye nigh the wall? then say thou, Thy servant Uriah the Hittite is dead also.

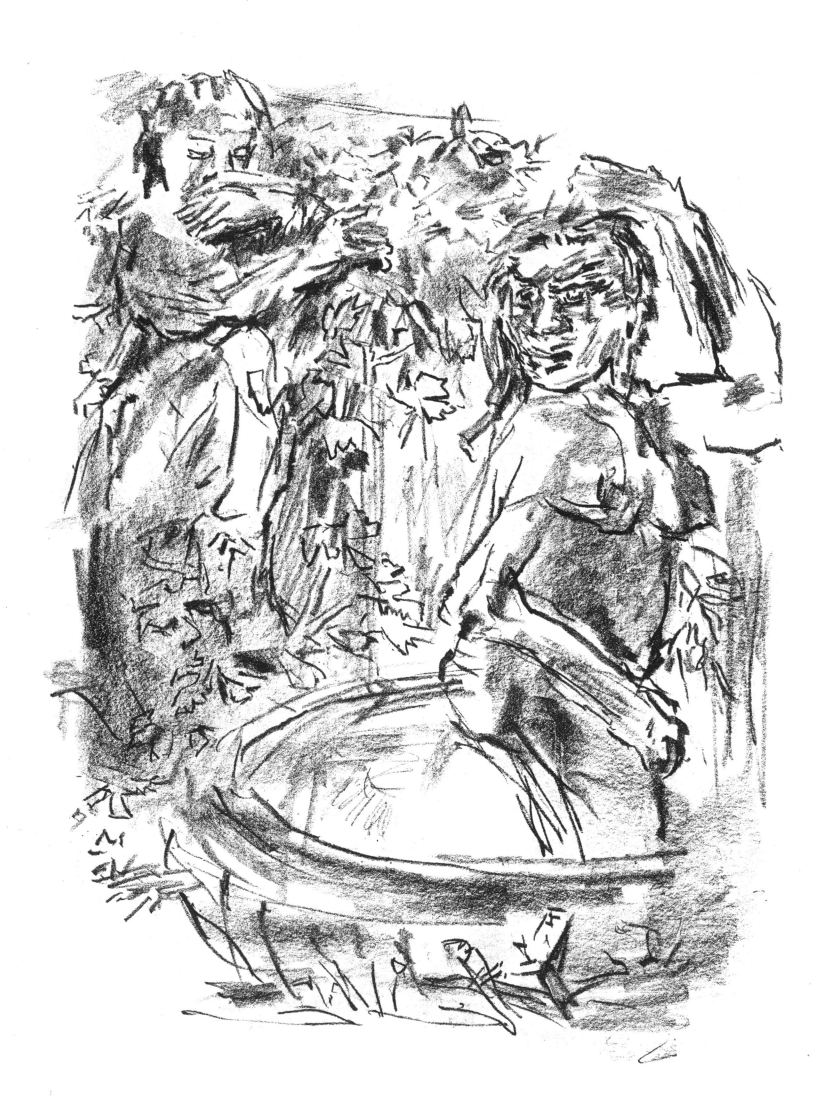

So the messenger went, and came and shewed David all that Joab had sent him for.

And the messenger said unto David, Surely the men prevailed against us, and came out unto us into the field, and we were upon them even unto the entering of the gate.

And the shooters shot from off the wall upon thy servants; and some of the king's servants be dead, and thy servant Uriah the Hittite is dead also.

Then David said unto the messenger, Thus shalt thou say unto Joab, Let not this thing displease thee, for the sword devoureth one as well as another: make thy battle more strong against the city, and overthrow it: and encourage thou him.

And when the wife of Uriah heard that Uriah her husband was dead, she mourned for her husband.

And when the mourning was past, David sent and fetched her to his house, and she became his wife, and bare him a son. But the thing that David had done displeased the Lord.

And the Lord sent Nathan unto David. And he came unto him, and said unto him, There were two men in one city; the one rich, and the other poor.

The rich man had exceeding many flocks and herds:

But the poor man had nothing, save one little ewe lamb, which he had bought and nourished up: and it grew up together with him, and with his children; it did eat of his own meat, and drank of his own cup, and lay in his bosom, and was unto him as a daughter.

And there came a traveller unto the rich man, and he spared to take of his own flock and of his own herd, to dress for the wayfaring man that was come unto him; but took the poor man's lamb, and dressed it for the man that was come to him.

And David's anger was greatly kindled against the man; and he said to

Nathan, As the Lord liveth, the man that hath done this thing shall surely die:

And he shall restore the lamb fourfold, because he did this thing, and because he had no pity.

And Nathan said to David, Thou art the man. Thus saith the Lord God of Israel, I anointed thee king over Israel, and I delivered thee out of the hand of Saul;

And I gave thee thy master's house, and thy master's wives into thy bosom, and gave thee the house of Israel and of Judah; and if that had been too little, I would moreover have given unto thee such and such things.

Wherefore hast thou despised the commandment of the Lord, to do evil in his sight? thou hast killed Uriah the Hittite with the sword, and hast taken his wife to be thy wife, and hast slain him with the sword of the children of Ammon.

Now therefore the sword shall never depart from thine house; because thou hast despised me, and hast taken the wife of Uriah the Hittite to be thy wife.

Thus saith the Lord, Behold, I will raise up evil against thee out of thine own house, and I will take thy wives before thine eyes, and give them unto thy neighbour, and he shall lie with thy wives in the sight of this sun.

For thou didst it secretly: but I will do this thing before all Israel, and before the sun.

And David said unto Nathan, I have sinned against the Lord. And Nathan said unto David, The Lord also hath put away thy sin; thou shalt not die.

Howbeit, because by this deed thou hast given great occasion to the enemies of the Lord to blaspheme, the child also that is born unto thee shall surely die.

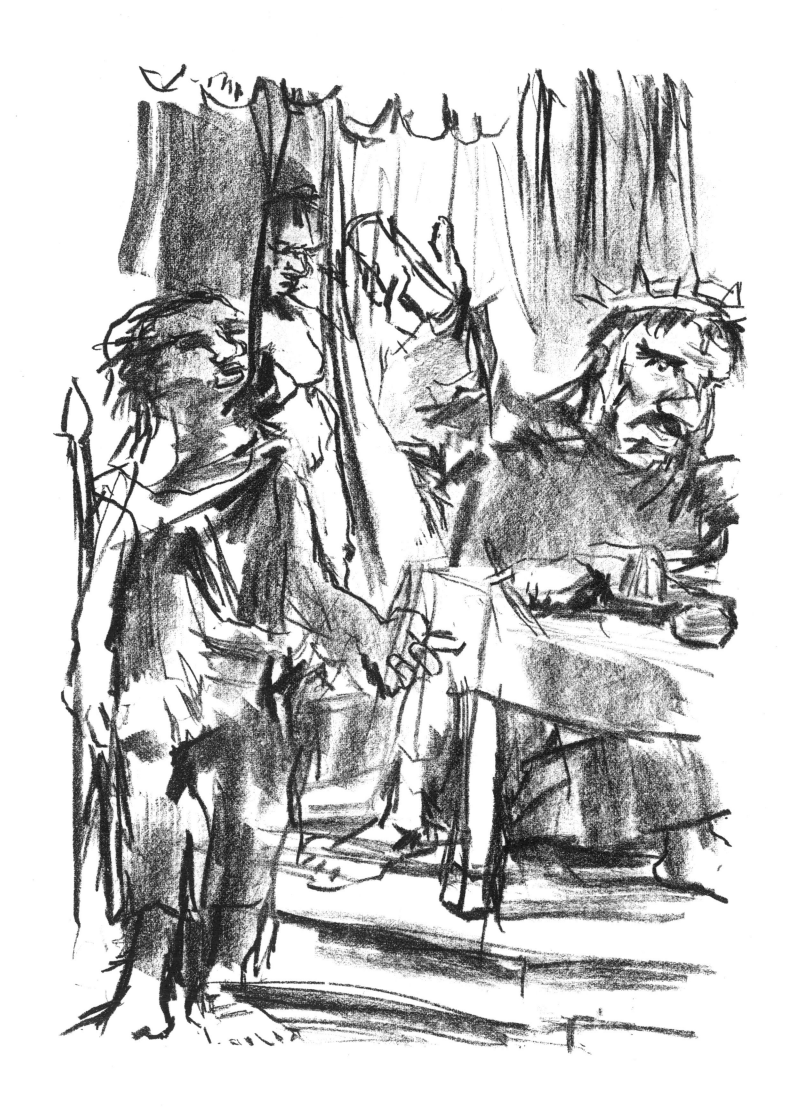

And Nathan departed unto his house. And the Lord struck the child that Uriah's wife bare unto David, and it was very sick.

David therefore besought God for the child; and David fasted, and went in, and lay all night upon the earth.

And the elders of his house arose, and went to him, to raise him up from the earth: but he would not, neither did he eat bread with them.

And it came to pass on the seventh day that the child died. And the servants of David feared to tell him that the child was dead: for they said, Behold, while the child was yet alive, we spake unto him, and he would not hearken unto our voice: how will he then vex himself, if we tell him that the child is dead?

But when David saw that his servants whispered, David perceived that the child was dead: therefore David said unto his servants, Is the child dead? And they said, He is dead.

Then David arose from the earth, and washed, and anointed himself, and changed his apparel, and came into the house of the Lord, and worshipped: then he came to his own house; and when he required, they set bread before him, and he did eat.

Then said his servants unto him, What thing is this that thou hast done? thou didst fast and weep for the child, while it was alive; but when the child was dead, thou didst rise and eat bread.

And he said, While the child was yet alive, I fasted and wept: for I said, who can tell whether God will be gracious to me, that the child may live?

But now he is dead, wherefore should I fast? can I bring him back again? I shall go to him, but he shall not return to me.

And David comforted Bath-sheba his wife, and went in unto her, and lay with her: and she bare a son, and he called his name Solomon: and the Lord loved him.

And he sent by the hand of Nathan the prophet; and he called his name Jedidiah, because of the Lord.

And Joab fought against Rabbah of the children of Ammon, and took the royal city.

And Joab sent messengers to David, and said, I have fought against Rabbah, and have taken the city of waters.

Now therefore gather the rest of the people together, and encamp against the city, and take it: lest I take the city, and it be called after my name.

And David gathered all the people together, and went to Rabbah, and fought against it, and took it.

And he took their king's crown from off his head, the weight whereof was a talent of gold with the precious stones: and it was set on David's head. And he brought forth the spoil of the city in great abundance.

And he brought forth the people that were therein, and put them under saws, and under harrows of iron, and under axes of iron, and made them pass through the brickkiln: and thus did he unto all the cities of the children of Ammon. So David and all the people returned unto Jerusalem.

And it came to pass after this, that Absalom the son of David had a fair sister, whose name was Tamar; and Amnon the son of David loved her.

And Amnon was so vexed, that he fell sick for his sister Tamar; for she was a virgin; and Amnon thought it hard for him to do any thing to her.

But Amnon had a friend, whose name was Jonadab, the son of Shimeah David's brother: and Jonadab was a very subtil man.

And he said unto him, why art thou, being the king's son, lean from day to day? wilt thou not tell me? And Amnon said unto him, I love Tamar, my brother Absalom's sister.

And Jonadab said unto him, Lay thee down on thy bed, and make thyself sick: and when thy father cometh to see thee, say unto him, I pray thee, let my sister Tamar come, and give me meat, and dress the meat in my sight, that I may see it, and eat it at her hand.

So Amnon lay down, and made himself sick: and when the king was

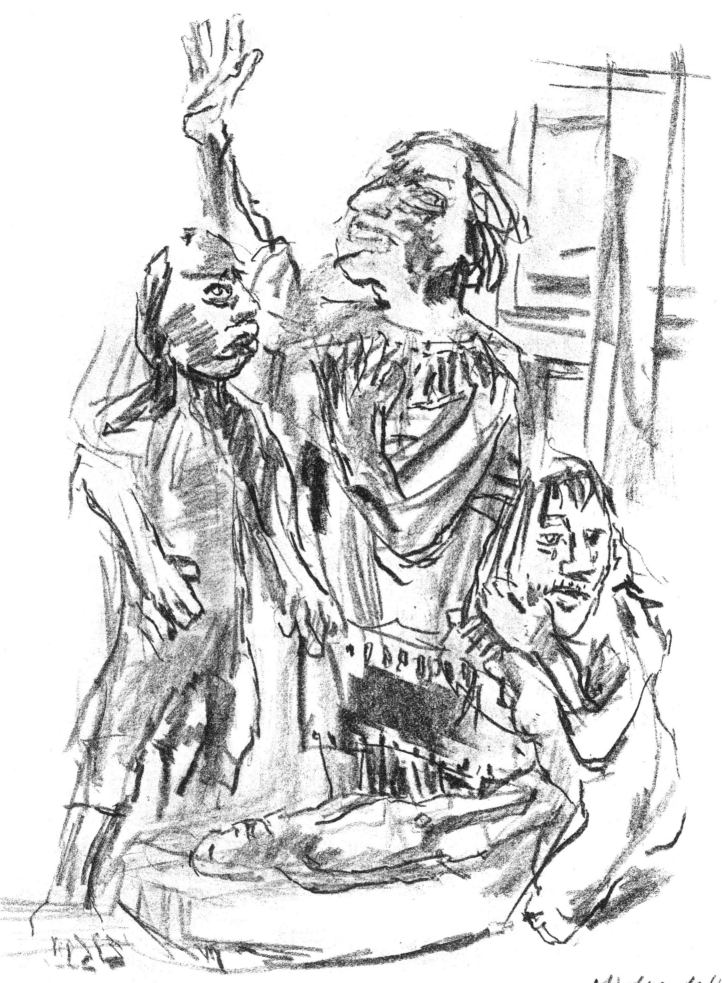

come to see him, Amnon said unto the king, I pray thee, let Tamar my sister come, and make me a couple of cakes in my sight, that I may eat at her hand.

Then David sent home to Tamar, saying, Go now to thy brother Amnon's house, and dress him meat.

So Tamar went to her brother Amnon's house; and he was laid down. And she took flour, and kneaded it, and made cakes in his sight, and did bake the cakes.

And she took a pan, and poured them out before him; but he refused to eat. And Amnon said, Have out all men from me. And they went out every man from him.

And Amnon said unto Tamar, Bring the meat into the chamber, that I may eat of thine hand. And Tamar took the cakes which she had made, and brought them into the chamber to Amnon her brother.

And when she had brought them unto him to eat, he took hold of her, and said unto her, Come lie with me, my sister.

And she answered him, Nay, my brother, do not force me; for no such thing ought to be done in Israel: do not thou this folly.

And I, whither shall I cause my shame to go? and as for thee, thou shalt be as one of the fools in Israel. Now therefore, I pray thee, speak unto the king; for he will not withhold me from thee.

Howbeit he would not hearken unto her voice: but, being stronger than she, forced her, and lay with her.

Then Amnon hated her exceedingly; so that the hatred wherewith he hated her was greater than the love wherewith he had loved her. And Amnon said unto her, Arise, begone.

And she said unto him, There is no cause: this evil in sending me away is greater than the other that thou didst unto me. But he would not hearken unto her.

Then he called his servant that ministered unto him, and said, Put now this woman out from me, and bolt the door after her.

And she had a garment of divers colours upon her: for with such robes were the king's daughters that were virgins apparelled. Then his servant brought her out, and bolted the door after her.

And Tamar put ashes on her head, and rent her garment of divers colours that was on her, and laid her hand on her head, and went on crying.

And Absalom her brother said unto her, Hath Amnon thy brother been with thee? but hold now thy peace, my sister: he is thy brother; regard not this thing. So Tamar remained desolate in her brother Absalom's house.

But when king David heard of all these things, he was very wroth.

And Absalom spake unto his brother Amnon neither good nor bad: for Absalom hated Amnon, because he had forced his sister Tamar.

And it came to pass after two full years, that Absalom had sheepshearers in Baal-hazor, which is beside Ephraim: and Absalom invited all the king's sons.

And Absalom came to the king, and said, Behold now, thy servant hath sheepshearers; let the king, I beseech thee, and his servants go with thy servant.

And the king said to Absalom, Nay, my son, let us not all now go, lest we be chargeable unto thee. And he pressed him: howbeit he would not go, but blessed him.

Then said Absalom, If not, I pray thee, let my brother Amnon go with us. And the king said unto him, Why should he go with thee?

But Absalom pressed him, that he let Amnon and all the king's sons go with him.

Now Absalom had commanded his servants, saying, Mark ye now when Amnon's heart is merry with wine, and when I say unto you, Smite

The birth of Solomon

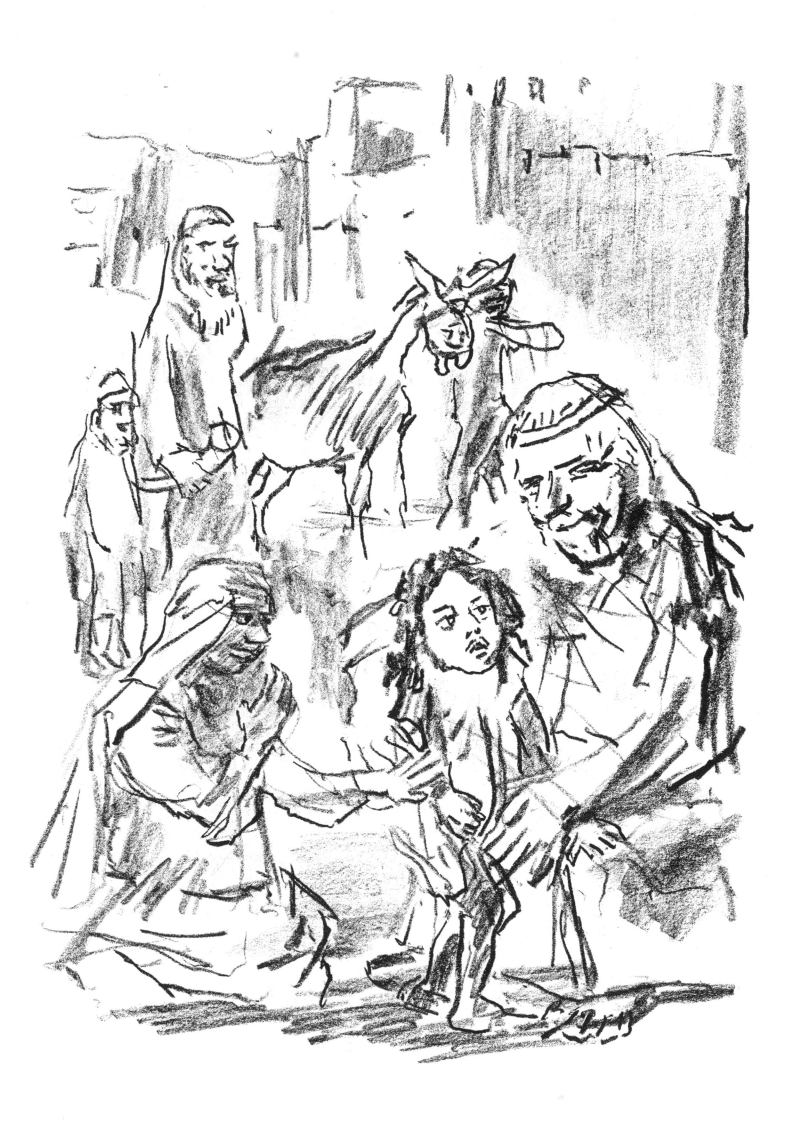

Amnon; then kill him, fear not: have not I commanded you? be courageous, and be valiant.

And the servants of Absalom did unto Amnon as Absalom had commanded. Then all the king's sons arose, and every man gat him up upon his mule, and fled.

And it came to pass, while they were in the way, that tidings came to David, saying, Absalom hath slain all the king's sons, and there is not one of them left.

Then the king arose, and tare his garments, and lay on the earth; and all his servants stood by with their clothes rent.

And Jonadab, the son of Shimeah David's brother, answered and said, Let not my lord suppose that they have slain all the young men the king's sons; for Amnon only is dead: for by the appointment of Absalom this hath been determined from the day that he forced his sister Tamar.

Now therefore let not my lord the king take the thing to his heart, to think that all the king's sons are dead: for Amnon only is dead.

But Absalom fled. And the young man that kept the watch lifted up his eyes, and looked, and, behold, there came much people by the way of the hill side behind him.

And Jonadab said unto the king, Behold, the king's sons come: as thy servant said, so it is.

And it came to pass, as soon as he had made an end of speaking, that, behold, the king's sons came, and lifted up their voice and wept: and the king also and all his servants wept very sore.

But Absalom fled, and went to Talmai, the son of Ammihud, king of Geshur. And David mourned for his son every day.

So Absalom fled, and went to Geshur, and was there three years.

And the soul of king David longed to go forth unto Absalom: for he was comforted concerning Amnon, seeing he was dead.

Now Joab the son of Zeruiah perceived that the king's heart was toward Absalom.

And Joab sent to Tekoah, and fetched thence a wise woman, and said unto her, I pray thee, feign thyself to be a mourner, and put on now mourning apparel, and anoint not thyself with oil, but be as a woman that had a long time mourned for the dead:

And come to the king, and speak on this manner unto him. So Joab Put the words in her mouth.

And when the woman of Tekoah spake to the king, she fell on her face to the ground, and did obeisance, and said, Help, O king.

And the king said unto her, What aileth thee? And she answered, I am indeed a widow woman, and mine husband is dead.

And thy handmaid had two sons, and they two strove together in the field, and there was none to part them, but the one smote the other, and slew him.

And, behold, the whole family is risen against thine handmaid, and they said, Deliver him that smote his brother, that we may kill him, for the life of his brother whom he slew; and we will destroy the heir also: and so they shall quench my coal which is left, and shall not leave to my husband neither name nor remainder upon the earth.

And the king said unto the woman, Go to thine house, and I will give charge concerning thee.

And the woman of Tekoah said unto the king, My lord, O king, the iniquity be on me, and on my father's house: and the king and his throne be guiltless.

And the king said, whosoever saith ought unto thee, bring him to me, and he shall not touch thee any more.

Then said she, I pray thee, let the king remember the Lord thy God, that thou wouldest not suffer the revengers of blood to destroy any more, lest

they destroy my son. And he said, As the Lord liveth, there shall not one hair of thy son fall to the earth.

Then the woman said, Let thine handmaid, I pray thee, speak one word unto my lord the king. And he said, Say on.

And the woman said, Wherefore then hast thou thought such a thing against the people of God? for the king doth speak this thing as one which is faulty, in that the king doth not fetch home again his banished.

For we must needs die, and are as water spilt on the ground, which cannot be gathered up again; neither doth God respect any person: yet doth he devise means, that his banished be not expelled from him.

Now therefore that I am come to speak of this thing unto my lord the king, it is because the people have made me afraid: and thy handmaid said, I will now speak unto the king; it may be that the king will perform the request of his handmaid.

For the king will hear, to deliver his handmaid out of the hand of the man that would destroy me and my son together out of the inheritance of God.

Then thine handmaid said, The word of my lord the king shall now be comfortable: for as an angel of God, so is my lord the king to discern good and bad: therefore the Lord thy God will be with thee.

Then the king answered and said unto the woman, Hide not from me, I pray thee, the thing that I shall ask thee. And the woman said, Let my lord the king now speak.

And the king said, Is not the hand of Joab with thee in all this? And the woman answered and said, As thy soul liveth, my lord the king, none can turn to the right hand or to the left from ought that my lord the king hath spoken: for thy servant Joab, he bade me, and he put all these words in the mouth of thine handmaid:

To fetch about this form of speech hath thy servant Joab done this thing: and my lord is wise, according to the wisdom of an angel of God, to know all things that are in the earth.

And the king said unto Joab, Behold now, I have done this thing: go therefore, bring the young man Absalom again.

And Joab fell to the ground on his face, and bowed himself, and thanked the king: and Joab said, Today thy servant knoweth that I have found grace in thy sight, my lord, O king, in that the king hath fulfilled the request of his servant.

So Joab arose and went to Geshur, and brought Absalom to Jerusalem.

And the king said, Let him turn to his own house, and let him not see my face. So Absalom returned to his own house, and saw not the king's face.

But in all Israel there was none to be so much praised as Absalom for his beauty: from the sole of his foot even to the crown of his head there was no blemish in him.

And when he polled his head, (for it was at every year's end that he polled it: because the hair was heavy on him, therefore he polled it:) he weighed the hair of his head at two hundred shekels after the king's weight.

And unto Absalom there were born three sons, and one daughter, whose name was Tamar: she was a woman of a fair countenance.

So Absalom dwelt two full years in Jerusalem, and saw not the king's face.

Therefore Absalom sent for Joab, to have sent him to the king; but he would not come to him: and when he sent again the second time, he would not come.

Therefore he said unto his servants, See, Joab's field is near mine, and he hath barley there; go and set it on fire. And Absalom's servants set the field on fire.

Then Joab arose, and came to Absalom unto his house, and said unto him, Wherefore have thy servants set my field on fire?

And Absalom answered Joab, Behold, I sent unto thee, saying, Come hither, that I may send thee to the king, to say, wherefore am I come from Geshur? it had been good for me to have been there still: now

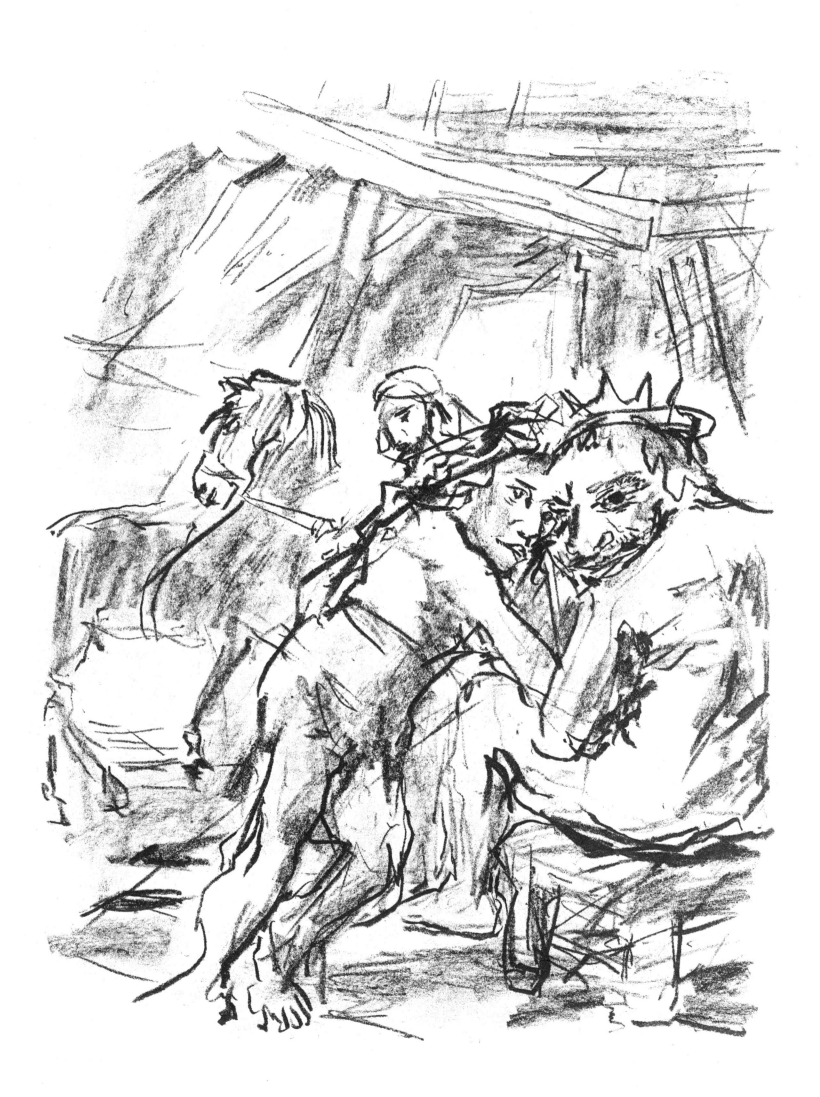

therefore let me see the king's face; and if there be any iniquity in me, let him kill me.

So Joab came to the king, and told him: and when he had called for Absalom, he came to the king, and bowed himself on his face to the ground before the king: and the king kissed Absalom.

And it came to pass after this, that Absalom prepared him chariots and horses, and fifty men to run before him.

And Absalom rose up early, and stood beside the way of the gate: and it was so, that when any man that had a controversy came to the king for judgment, then Absalom called unto him, and said, Of what city art thou? And he said, Thy servant is of one of the tribes of Israel.

And Absalom said unto him, See, thy matters are good and right; but there is no man deputed of the king to hear thee.

Absalom said moreover, Oh that I were made judge in the land, that every man which hath any suit or cause might come unto me, and I would do him justice!

And it was so, that when any man came nigh to him to do him obeisance, he put forth his hand, and took him, and kissed him.

And on this manner did Absalom to all Israel that came to the king for judgment: so Absalom stole the hearts of the men of Israel.

And it came to pass after forty years, that Absalom said unto the king, I pray thee, let me go and pay my vow which I have vowed unto the Lord, in Hebron.

For thy servant vowed a vow while I abode at Geshur in Syria, saying, If the Lord shall bring me again indeed to Jerusalem, then I will serve the Lord.

And the king said unto him, Go in peace. So he arose, and went to Hebron.

But Absalom sent spies throughout all the tribes of Israel, saying, As soon as ye hear the sound of the trumpet, then ye shall say, Absalom reigneth in Hebron.

And with Absalom went two hundred men out of Jerusalem, that were called; and they went in their simplicity, and they knew not any thing.

And Absalom sent for Ahithophel the Gilonite, David's counsellor, from his city, even from Giloh, while he offered sacrifices. And the conspiracy was strong; for the people increased continually with Absalom.

And there came a messenger to David, saying, The hearts of the men of Israel are after Absalom.

And David said unto all his servants that were with him at Jerusalem, Arise, and let us flee; for we shall not else escape from Absalom: make speed to depart, lest he overtake us suddenly, and bring evil upon us, and smite the city with the edge of the sword.

And the king's servants said unto the king, Behold, thy servants are ready to do whatsoever my lord the king shall appoint.

And the king went forth, and all his household after him. And the king left ten women, which were concubines, to keep the house.

And the king went forth, and all the people after him, and tarried in a place that was far off.

And all his servants passed on beside him; and all the Cherethites, and all the Pelethites, and all the Gittites, six hundred men which came after him from Gath, passed on before the king.

Then said the king to Ittai the Gittite, Wherefore goest thou also with us? return to thy place, and abide with the king: for thou art a stranger, and also an exile.

Whereas thou camest but yesterday, should I this day make thee go up and down with us? seeing I go whither I may, return thou, and take thy brethren: mercy and truth be with thee.

Absalom steals the hearts of the men of Israel

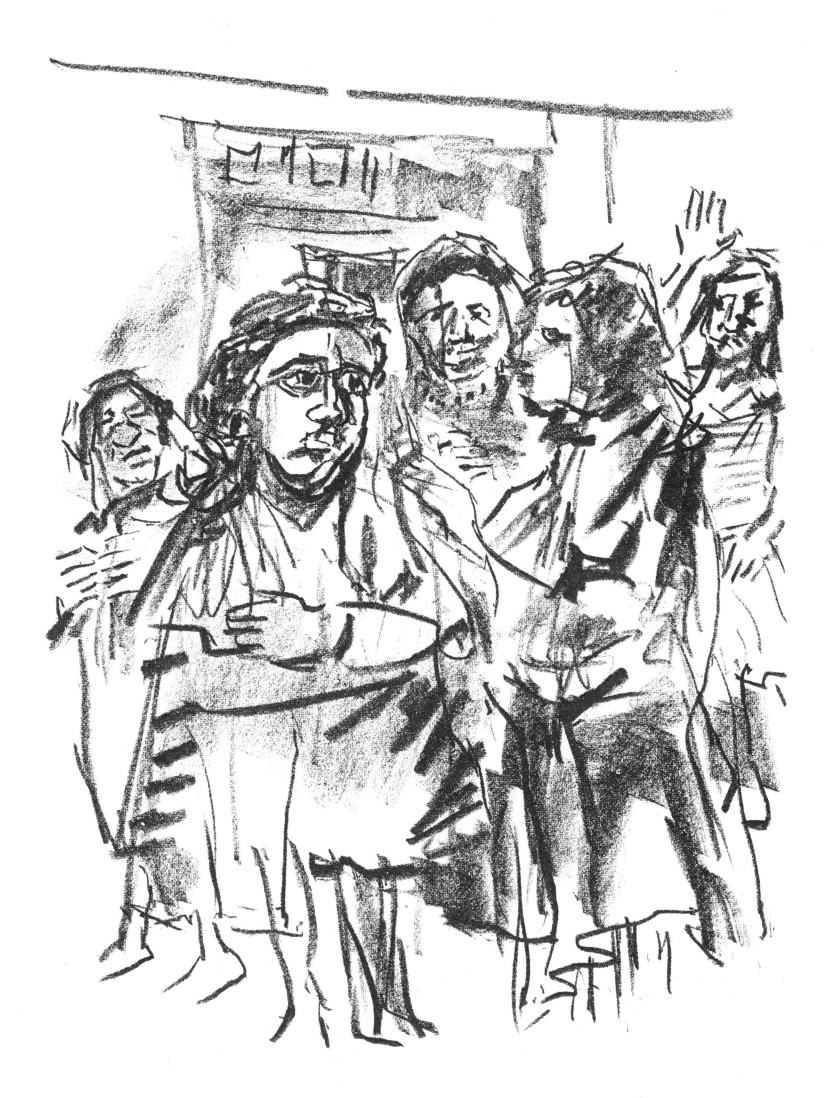

And Ittai answered the king, and said, As the Lord liveth, and as my lord the king liveth, surely in what place my lord the king shall be, whether in death or life, even there also will thy servant be.

And David said to Ittai, Go and pass over. And Ittai the Gittite passed over, and all his men, and all the little ones that were with him.

And all the country wept with a loud voice, and all the people passed over: the king also himself passed over the brook Kidron, and all the people passed over, toward the way of the wilderness.

And lo Zadok also, and all the Levites were with him, bearing the ark of the covenant of God: and they set down the ark of God; and Abiathar went up, until all the people had done passing out of the city.

And the king said unto Zadok, Carry back the ark of God into the city: if I shall find favour in the eyes of the Lord, he will bring me again, and shew me both it, and his habitation:

But if he thus say, I have no delight in thee; behold, here am I, let him do to me as seemeth good unto him.

The king said also unto Zadok the priest, Art not thou a seer? return into the city in peace, and your two sons with you, Ahimaaz thy son, and Jonathan the son of Abiathar.

See, I will tarry in the plain of the wilderness, until there come word from you to certify me.

Zadok therefore and Abiathar carried the ark of God again to Jerusalem: and they tarried there.

And David went up by the ascent of mount Olivet, and wept as he went up, and had his head covered, and he went barefoot: and all the people that was with him covered every man his head, and they went up, weeping as they went up.

And one told David, saying, Ahithophel is among the conspirators with

Absalom. And David said, O Lord, I pray thee, turn the counsel of Ahithophel into foolishness.

And it came to pass, that when David was come to the top of the mount, where he worshipped God, behold, Hushai the Archite came to meet him with his coat rent, and earth upon his head:

Unto whom David said, If thou passest on with me, then thou shalt be a burden unto me:

But if thou return to the city, and say unto Absalom, I will be thy servant, O king; as I have been thy father's servant hitherto, so will I now also be thy servant: then mayest thou for me defeat the counsel of Ahithophel.

And hast thou not there with thee Zadok and Abiathar the priests? therefore it shall be, that what thing soever thou shalt hear out of the king's house, thou shalt tell it to Zadok and Abiathar the priests.

Behold, they have there with them their two sons, Ahimaaz Zadok's son, and Jonathan Abiathar's son; and by them ye shall send unto me every thing that ye can hear.

So Hushai David's friend came into the city, and Absalom came into Jerusalem.

And when David was a little past the top of the hill, behold, Ziba the servant of Mephibosheth met him, with a couple of asses saddled, and upon them two hundred loaves of bread, and an hundred bunches of raisins, and an hundred of summer fruits, and a bottle of wine.

And the king said unto Ziba, What meanest thou by these? And Ziba said, The asses be for the king's household to ride on; and the bread and summer fruit for the young men to eat; and the wine, that such as be faint in the wilderness may drink.

And the king said, And where is thy master's son? And Ziba said unto the king, Behold, he abideth at Jerusalem: for he said, Today shall the house of Israel restore me the kingdom of my father.

Then said the king to Ziba, Behold, thine are all that pertained unto Mephibosheth. And Ziba said, I humbly beseech thee that I may find grace in thy sight, my lord, O king.

And when king David came to Bahurim, behold, thence came out a man of the family of the house of Saul, whose name was Shimei, the son of Gera: he came forth, and cursed still as he came.

And he cast stones at David, and at all the servants of king David: and all the people and all the mighty men were on his right hand and on his left.

And thus said Shimei when he cursed, Come out, come out, thou bloody man, and thou man of Belial:

The Lord hath returned upon thee all the blood of the house of Saul, in whose stead thou hast reigned; and the Lord hath delivered the kingdom into the hand of Absalom thy son: and, behold, thou art taken in thy mischief, because thou art a bloody man.

Then said Abishai the son of Zeruiah unto the king, Why should this dead dog curse my lord the king? let me go over, I pray thee, and take off his head.

And the king said, What have I to do with you, ye sons of Zeruiah? so let him curse, because the Lord hath said unto him, Curse David. Who shall then say, wherefore hast thou done so?

And David said to Abishai, and to all his servants, Behold, my son, which came forth of my bowels, seeketh my life: how much more now may this Benjamite do it? let him alone, and let him curse; for the Lord hath bidden him.

It may be that the Lord will look on mine affliction, and that the Lord will requite me good for his cursing this day.

And as David and his men went by the way, Shimei went along on the hill's side over against him, and cursed as he went, and threw stones at him, and cast dust.

And the king, and all the people that were with him, came weary, and refreshed themselves there.

And Absalom, and all the people the men of Israel, came to Jerusalem, and Ahithophel with him.

And it came to pass, when Hushai the Archite, David's friend, was come unto Absalom, that Hushai said unto Absalom, God save the king, God save the king.

And Absalom said to Hushai, Is this thy kindness to thy friend? why wentest thou not with thy friend?

And Hushai said unto Absalom, Nay; but whom the Lord, and this people, and all the men of Israel, choose, his will I be, and with him will I abide.

And again, whom should I serve? should I not serve in the presence of his son? as I have served in thy father's presence, so will I be in thy presence.

Then said Absalom to Ahithophel, Give counsel among you what we shall do.

And Ahithophel said unto Absalom, Go in unto thy father's concubines, which he hath left to keep the house; and all Israel shall hear that thou art abhorred of thy father: then shall the hands of all that are with thee be strong.

So they spread Absalom a tent upon the top of the house; and Absalom went in unto his father's concubines in the sight of all Israel.

And the counsel of Ahithophel, which he counselled in those days, was as if a man had enquired at the oracle of God: so was all the counsel of Ahitophel both with David and with Absalom.

Moreover Ahithophel said unto Absalom, Let me now choose out twelve thousand men, and I will arise and pursue after David this night:

And I will come upon him while he is weary and weak handed, and will

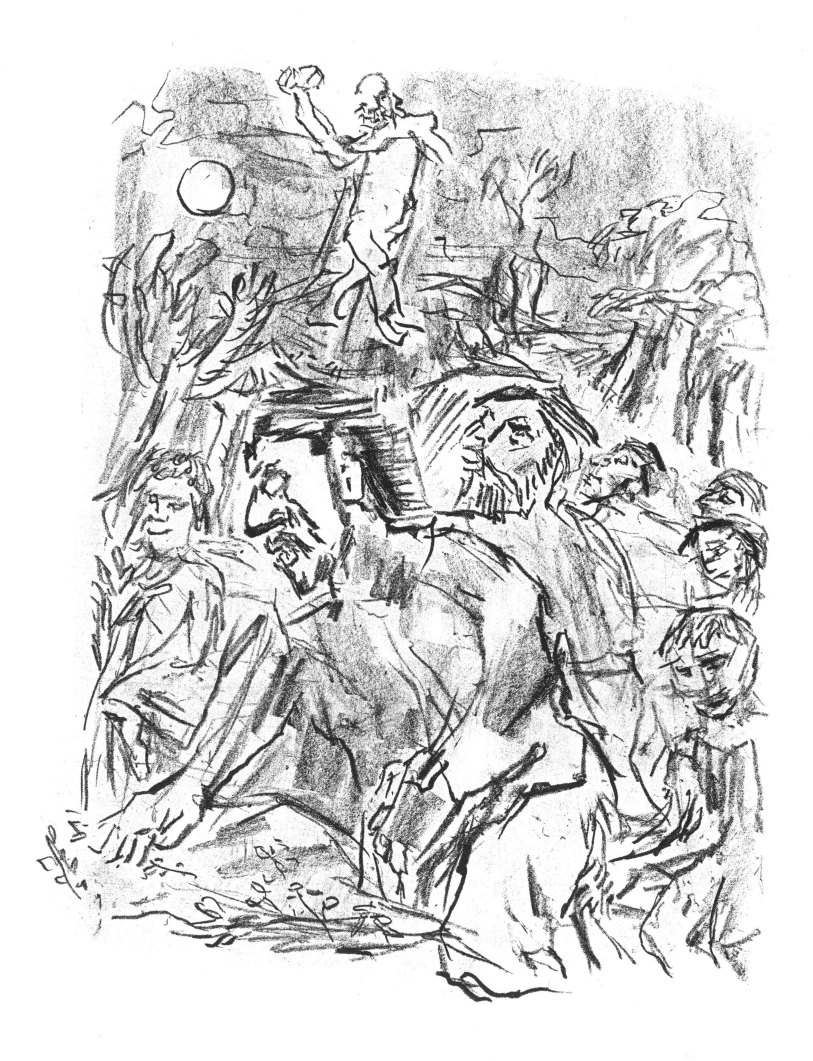

make him afraid: and all the people that are with him shall flee; and I will smite the king only:

And I will bring back all the people unto thee: the man whom thou seekest is as if all returned: so all the people shall be in peace.

And the saying pleased Absalom well, and all the elders of Israel.

Then said Absalom, Call now Hushai the Archite also, and let us hear likewise what he saith.

And when Hushai was come to Absalom, Absalom spake unto him, saying, Ahitophel hath spoken after this manner: shall we do after his saying? if not; speak thou.

And Hushai said unto Absalom, The counsel that Ahithophel hath given is not good at this time.

For, said Hushai, thou knowest thy father and his men, that they be mighty men, and they be chafed in their minds, as a bear robbed of her whelps in the field: and thy father is a man of war, and will not lodge with the people.

Behold, he is hid now in some pit, or in some other place: and it will come to pass, when some of them be overthrown at the first, that whosoever heareth it will say, There is a slaughter among the people that follow Absalom.

And he also that is valiant, whose heart is as the heart of a lion, shall utterly melt: for all Israel knoweth that thy father is a mighty man, and they which be with him are valiant men.

Therefore I counsel that all Israel be generally gathered unto thee, from Dan even to Beer-sheba, as the sand that is by the sea for multitude; and that thou go to battle in thine own person.

So shall we come upon him in some place where he shall be found, and we will light upon him as the dew falleth on the ground: and of him and of all the men that are with him there shall not be left so much as one.

Moreover, if he be gotten into a city, then shall all Israel bring ropes to

that city, and we will draw it into the river, until there be not one small stone found there.

And Absalom and all the men of Israel said, The counsel of Hushai the Archite is better than the counsel of Ahithophel. For the Lord had appointed to defeat the good counsel of Ahithophel, to the intent that the Lord might bring evil upon Absalom.

Then said Hushai unto Zadok and to Abiathar the priests, Thus and thus did Ahitophel counsel Absalom and the elders of Israel; and thus and thus have I counselled.

Now therefore send quickly, and tell David, saying, Lodge not this night in the plains of the wilderness, but speedily pass over; lest the king be swallowed up, and all the people that are with him.

Now Jonathan and Ahimaaz stayed by En-rogel; for they might not be seen to come into the city: and a wench went and told them; and they went and told king David.

Nevertheless a lad saw them, and told Absalom: but they went both of them away quickly, and came to a man's house in Bahurim, which had a well in his court; whither they went down.

And the woman took and spread a covering over the well's mouth, and spread ground corn thereon; and the thing was not known.

And when Absalom's servants came to the woman to the house, they said, Where is Ahimaaz and Jonathan? And the woman said unto them, They be gone over the brook of water. And when they had sought and could not find them, they returned to Jerusalem.

And it came to pass, after they were departed, that they came up out of the well, and went and told king David, and said unto David, Arise, and pass quickly over the water: for thus hath Ahithophel counselled against you.

Then David arose, and all the people that were with him, and they passed over Jordan: by the morning light there lacked not one of them that was not gone over Jordan.

And when Ahithophel saw that his counsel was not followed, he saddled his ass, and arose, and gat him home to his house, to his city, and put his household in order, and hanged himself, and died, and was buried in the sepulchre of his father.

Then David came to Mahanaim. And Absalom passed over Jordan, he and all the men of Israel with him.

And Absalom made Amas a captain of the host instead of Joab: which Amasa was a man's son, whose name was Ithra an Israelite, that went in to Abigail the daughter of Nahash, sister to Zeruiah Joab's mother.

So Israel and Absalom pitched in the land of Gilead.

And it came to pass, when David was come to Mahanaim, that Shobi the son of Nahash of Rabbah of the children of Ammon, and Machir the son of Ammiel of Lo-debar, and Barzillai the Gileadite of Rogelim,

Brought beds, and basons, and earthen vessels, and wheat, and barley, and flour, and parched corn, and beans, and lentiles, and parched pulse,

And honey, and butter, and sheep, and cheese of kine, for David, and for the people that were with him, to eat: for they said, The people is hungry, and weary, and thirsty, in the wilderness.

And David numbered the people that were with him, and set captains of thousands and captains of hundreds over them.

And David sent forth a third part of the people under the hand of Joab, and a third part under the hand of Abishai the son of Zeruiah, Joab's brother, and a third part under the hand of Ittai the Gittite. And the king said unto the people, I will surely go forth with you myself also.

But the people answered, Thou shalt not go forth: for if we flee away, they will not care for us; neither if half of us die, will they care for us: but now thou art worth ten thousand of us: therefore now it is better that thou succour us out of the city.

And the king said unto them, What seemeth you best I will do. And the

king stood by the gate side, and all the people came out by hundreds and by thousands.

And the king commanded Joab and Abishai and Ittai, saying, Deal gently for my sake with the young man, even with Absalom. And all the people heard when the king gave all the captains charge concerning Absalom.

So the people went out into the field against Israel: and the battle was in the wood of Ephraim;

Where the people of Israel were slain before the servants of David, and there was there a great slaughter that day of twenty thousand men.

For the battle was there scattered over the face of all the country: and the wood devoured more people that day than the sword devoured.

And Absalom met the servants of David. And Absalom rode upon a mule, and the mule went under the thick boughs of a great oak, and his head caught hold of the oak, and he was taken up between the heaven and the earth; and the mule that was under him went away.

And a certain man saw it, and told Joab, and said, Behold, I saw Absalom hanged in an oak.

And Joab said unto the man that told him, And, behold, thou sawest him, and why didst thou not smite him there to the ground? and I would have given thee ten shekels of silver, and a girdle.

And the man said unto Joab, Though I should receive a thousand shekels of silver in mine hand, yet would I not put forth mine hand against the king's son: for in our hearing the king charged thee and Abishai and Ittai, saying, Beware that none touch the young man Absalom.

Otherwise I should have wrought falsehood against mine own life: for there is no matter hid from the king, and thou thyself wouldest have set thyself against me.

Then said Joab, I may not tarry thus with thee. And he took three darts in

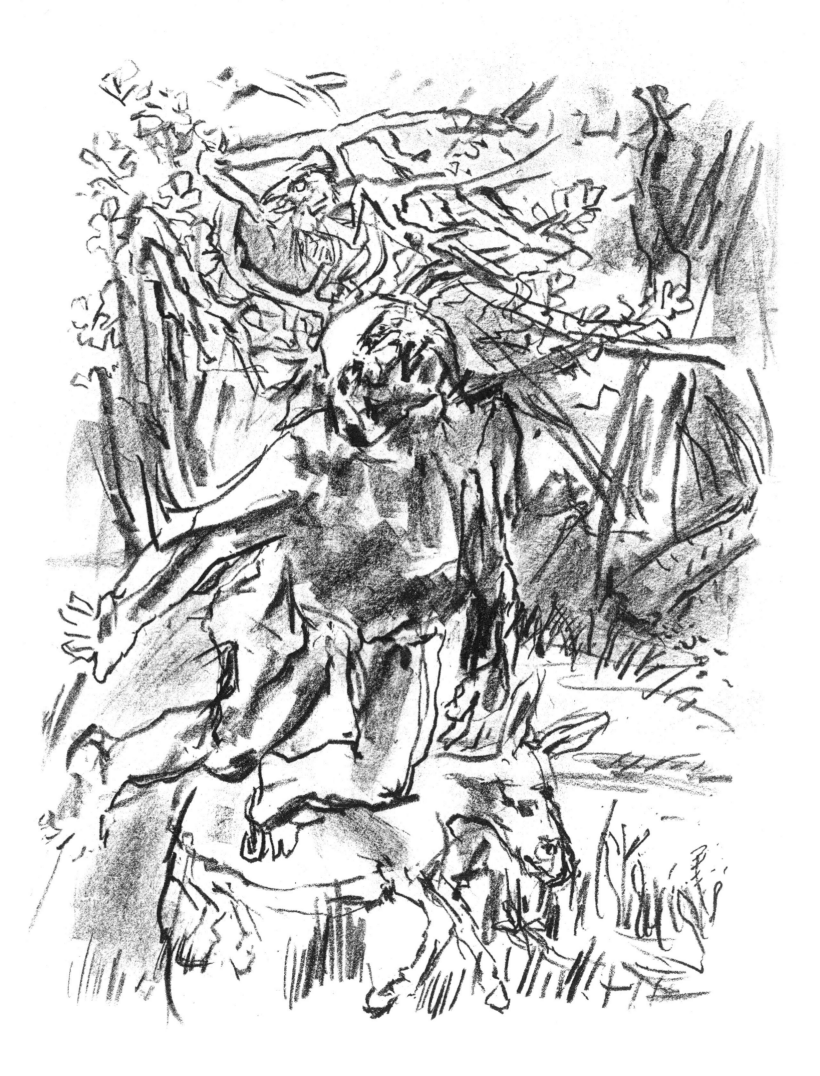

his hand, and thrust them through the heart of Absalom, while he was yet alive in the midst of the oak.

And ten young men that bare Joab's armour compassed about and smote Absalom, and slew him.

And Joab blew the trumpet, and the people returned from pursuing after Israel: for Joab held back the people.

And they took Absalom, and cast him into a great pit in the wood, and laid a very great heap of stones upon him: and all Israel fled every one to his tent.

Now Absalom in his lifetime had taken and reared up for himself a pillar, which is in the king's dale: for he said, I have no son to keep my name in remembrance: and he called the pillar after his own name: and it is called unto this day, Absalom's place.

Then said Ahimaaz the son of Zadok, Let me now run, and bear the king tidings, how that the Lord hath avenged him of his enemies.

And Joab said unto him, Thou shalt not bear tidings this day, but thou shalt bear tidings another day: but this day thou shalt bear no tidings, because the king's son is dead.

Then said Joab to Cushi, Go tell the king what thou hast seen. And Cushi bowed himself unto Joab, and ran.

Then said Ahimaaz the son of Zadok yet again to Joab, But howsoever, let me, I pray thee, also run after Cushi. And Joab said, Wherefore wilt thou run, my son, seeing that thou hast no tidings ready?

But howsoever, said he, let me run. And he said unto him, Run. Then Ahimaaz ran by the way of the plain, and overran Cushi.

And David sat between the two gates: and the watchman went up to the roof over the gate unto the wall, and lifted up his eyes, and looked, and behold a man running alone.

And the watchman cried, and told the king. And the king said, If he be

alone, there is tidings in his mouth. And he came apace, and drew near.

And the watchman saw another man running: and the watchman called unto the porter, and said, Behold another man running alone. And the king said, He also bringeth tidings.

And the watchman said, Me thinketh the running of the foremost is like the running of Ahimaaz the son of Zadok. And the king said, He is a good man, and cometh with good tidings.

And Ahimaaz called, and said unto the king, All is well. And he fell down to the earth upon his face before the king, and said, Blessed be the Lord thy God, which hath delivered up the men that lifted up their hand against my lord the king.

And the king said, Is the young man Absalom safe? And Ahimaaz answered, When Joab sent the king's servant, and me thy servant, I saw a great tumult, but I knew not what it was.

And the king said unto him, Turn aside, and stand here. And he turned aside, and stood still.

And, behold, Cushi came; and Cushi said, Tidings, my lord the king: for the Lord hath avenged thee this day of all them that rose up against thee.

And the king said unto Cushi, Is the young man Absalom safe? And Cushi answered, The enemies of my lord the king, and all that rise against thee to do thee hurt, be as that young man is.

And the king was much moved, and went up to the chamber over the gate, and wept: and as he went, thus he said, O my son Absalom, my son, my son Absalom! would God I had died for thee, O Absalom, my son, my son!

And it was told Joab, Behold, the king weepeth and mourneth for Absalom.

And the victory that day was turned into mourning unto all the people: for the people heard say that day how the king was grieved for his son.

David hears of the death of Absalom

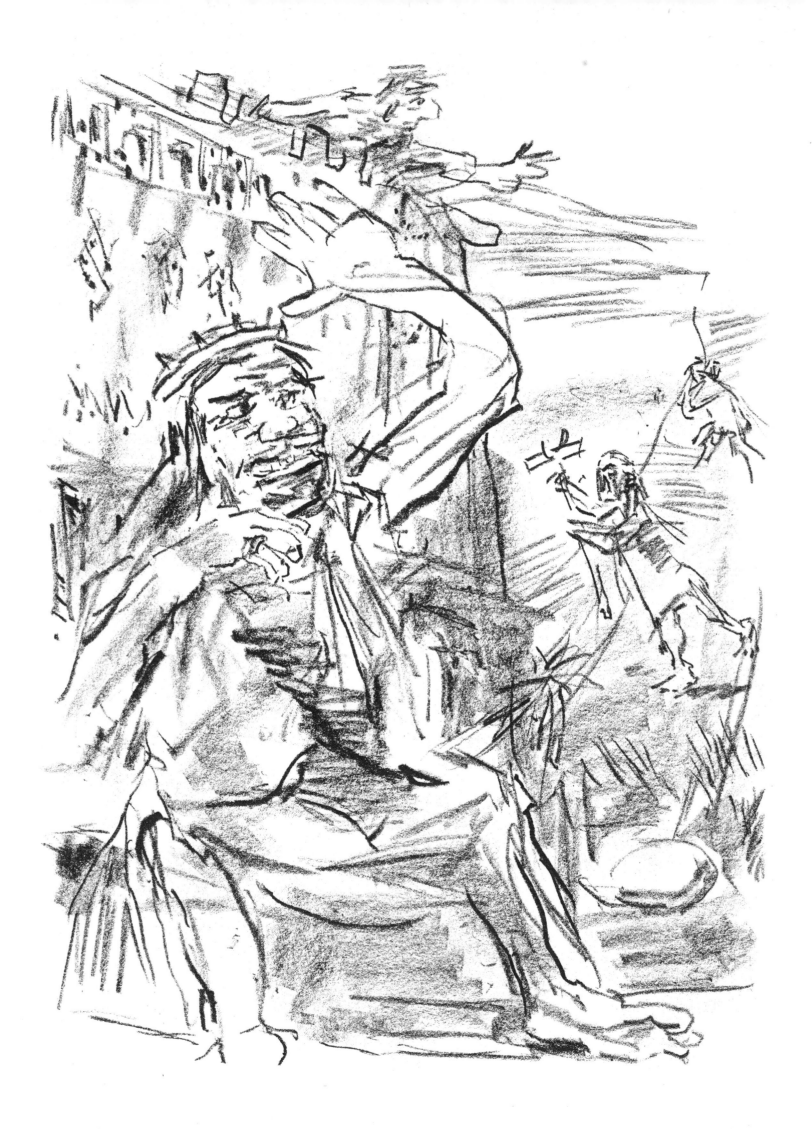

And the people gat them by stealth that day into the city, as people being ashamed steal away when they flee in battle.

But the king covered his face, and the king cried with a loud voice, O my son Absalom, O Absalom, my son, my son!

And Joab came into the house to the king, and said, Thou hast shamed this day the faces of all thy servants, which this day have saved thy life, and the lives of thy sons and of thy daughters, and the lives of thy wives, and the lives of thy concubines;

In that thou lovest thine enemies, and hatest thy friends. For thou hast declared this day, that thou regardest neither princes nor servants: for this day I perceive, that if Absalom had lived, and all we had died this day, then it had pleased thee well.

Now therefore arise, go forth, and speak comfortably unto thy servants: for I swear by the Lord, if thou go not forth, there will not tarry one with thee this night: and that will be worse unto thee than all the evil that befell thee from thy youth until now.

Then the king arose, and sat in the gate. And they told unto all the people, saying, Behold, the king doth sit in the gate. And all the people came before the king: for Israel had fled every man to his tent.

And all the people were at strife throughout all the tribes of Israel, saying, The king saved us out of the hand of our enemies, and he delivered us out of the hand of the Philistines; and now he is fled out of the land for Absalom.

And Absalom, whom we anointed over us, is dead in battle. Now therefore why speak ye not a word of bringing the king back?

And king David sent to Zadok and to Abiathar the priests, saying, Speak unto the elders of Judah, saying, Why are ye the last to bring the king back to his house? seeing the speech of all Israel is come to the king, even to his house.

Ye are my brethren, ye are my bones and my flesh: wherefore then are ye the last to bring back the king?

And say ye to Amasa, Art thou not of my bone, and of my flesh? God do so to me, and more also, if thou be not captain of the host, before me continually in the room of Joab.

And he bowed the heart of all the men of Judah, even as the heart of one man; so that they sent this word unto the king, Return thou, and all thy servants.

So the king returned, and came to Jordan. And Judah came to Gilgal, to go to meet the king, to conduct the king over Jordan.

And Shimei the son of Gera, a Benjamite, which was of Bahurim, hasted and came down with the men of Judah to meet king David.

And there were a thousand men of Benjamin with him, and Ziba the servant of the house of Saul, and his fifteen sons and his twenty servants with him; and they went over Jordan before the king.

And there went over a ferry boat to carry over the king's household, and to do what he thought good. And Shimei the son of Gera fell down before the king, as he was come over Jordan;

And said unto the king, Let not my lord impute iniquity unto me, neither do thou remember that which thy servant did perversely the day that my lord the king went out of Jerusalem, that the king should take it to his heart.

For thy servant doth know that I have sinned: therefore, behold, I am come the first this day of all the house of Joseph to go down to meet my lord the king.

But Abishai the son of Zeruiah answered and said, Shall not Shimei be put to death for this, because he cursed the Lord's anointed?

And David said, What have I to do with you, ye sons of Zeruiah, that ye should this day be adversaries unto me? shall there any man be put to death this day in Israel? for do not I know that I am this day king over Israel?

Therefore the king said unto Shimei, Thou shalt not die. And the king sware unto him.

And Mephibosheth the son of Saul came down to meet the king, and had neither dressed his feet, nor trimmed his beard, nor washed his clothes, from the day the king departed until the day he came again in peace.

And it came to pass, when he was come to Jerusalem to meet the king, that the king said unto him, Wherefore wentest not thou with me, Mephibosheth?

And he answered, My lord, O king, my servant deceived me: for thy servant said, I will saddle me an ass, that I may ride thereon, and go to the king; because thy servant is lame.

And he hath slandered thy servant unto my lord the king; but my lord the king is as an angel of God: do therefore what is good in thine eyes.

For all of my father's house were but dead men before my lord the king: yet didst thou set thy servant among them that did eat at thine own table. What right therefore have I yet to cry any more unto the king?

And the king said unto him, Why speakest thou any more of thy matters? I have said, Thou and Ziba divide the land.

And Mephibosheth said unto the king, Yea, let him take all, forasmuch as my lord the king is come again in peace unto his own house.

And Barzillai the Gileadite came down from Rogelim, and went over Jordan with the king, to conduct him over Jordan.

Now Barzillai was a very aged man, even fourscore years old: and he had provided the king of sustenance while he lay at Mahanaim; for he was a very great man.

And the king said unto Barzillai, Come thou over with me, and I will feed thee with me in Jerusalem.

And Barzillai said unto the king, How long have I to live, that I should go up with the king unto Jerusalem?

I am this day fourscore years old: and can I discern between good and evil? can thy servant taste what I eat or what I drink? can I hear any more the voice of singing men and singing women? wherefore then should thy servant be yet a burden unto my lord the king?

Thy servant will go a little way over Jordan with the king: and why should the king recompense it me with such a reward?

Let thy servant, I pray thee, turn back again, that I may die in mine own city, and be buried by the grave of my father and of my mother. But behold thy servant Chimham; let him go over with my lord the king; and do to him what shall seem good unto thee.

And the king answered, Chimham shall go over with me, and I will do to him that which shall seem good unto thee: and whatsoever thou shalt require of me, that will I do for thee.

And all the people went over Jordan. And when the king was come over, the king kissed Barzillai, and blessed him; and he returned unto his own place.

Then the king went on to Gilgal, and Chimham went on with him: and all the people of Judah conducted the king, and also half the people of Israel.

And, behold, all the men of Israel came to the king, and said unto the king, Why have our brethren the men of Judah stolen thee away, and have brought the king, and his household, and all David's men with him, over Jordan?

And all the men of Judah answered the men of Israel, Because the king is near of kin to us: wherefore then be ye angry for this matter? have we eaten at all of the king's cost? or hath he given us any gift?

And the men of Israel answered the men of Judah, and said, We have ten parts in the king, and we have also more right in David than ye: why then did ye despise us, that our advice should not be first had in bringing back our king? And the words of the men of Judah were fiercer than the words of the men of Israel.

And there happened to be there a man of Belial, whose name was Sheba, the son of Bichri, a Benjamite: and he blew a trumpet, and said, We have no part in David, neither have we inheritance in the son of Jesse: every man to his tents, O Israel.

So every man of Israel went up from after David, and followed Sheba the son of Bichri: but the men of Judah clave unto their king, from Jordan even to Jerusalem.

And David came to his house at Jerusalem; and the king took the ten women his concubines, whom he had left to keep the house, and put them in ward, and fed them, but went not in unto them. So they were shut up unto the day of their death, living in widowhood.

Then said the king to Amasa, Assemble me the men of Judah within three days, and be thou here present.

So Amasa went to assemble the men of Judah: but he tarried longer than the set time which he had appointed him.

And David said to Abishai, Now shall Sheba the son of Bichri do us more harm than did Absalom: take thou thy lord's servants, and pursue after him, lest he get him fenced cities, and escape us.

And there went out after him Joab's men, and the Cherethites, and the Pelethites, and all the mighty men: and they went out of Jerusalem, to pursue after Sheba the son of Bichri.

When they were at the great stone which is in Gibeon, Amasa went before them. And Joab's garment that he had put on was girded unto him, and upon it a girdle with a sword fastened upon his loins in the sheath thereof; and as he went forth it fell out.

And Joab said to Amasa, Art thou in health, my brother? And Joab took Amasa by the beard with the right hand to kiss him.

But Amasa took no heed to the sword that was in Joab's hand: so he smote him therewith in the fifth rib, and shed out his bowels to the

ground, and struck him not again; and he died. So Joab and Abishai his brother pursued after Sheba the son of Bichri.

And one of Joab's men stood by him, and said, He that favoureth Joab, and he that is for David, let him go after Joab.

And Amasa wallowed in blood in the midst of the highway. And when the man saw that all the people stood still, he removed Amasa out of the highway into the field, and cast a cloth upon him, when he saw that every one that came by him stood still.

When he was removed out of the highway, all the people went on after Joab, to pursue after Sheba the son of Bichri.

And he went through all the tribes of Israel unto Abel, and to Beth-maachah, and all the Berites: and they were gathered together, and went also after him.

And they came and besieged him in Abel of Beth-maachah, and they cast up a bank against the city, and it stood in the trench: and all the people that were with Joab battered the wall, to throw it down.

Then cried a wise woman out of the city, Hear, hear; say, I pray you, unto Joab, come near hither, that I may speak with thee.

And when he was come near unto her, the woman said, Art thou Joab? And he answered, I am he. Then she said unto him, Hear the words of thine handmaid. And he answered, I do hear.

Then she spake, saying, they were wont to speak in old time, saying, They shall surely ask counsel at Abel: and so they ended the matter.

I am one of them that are peaceable and faithful in Israel: thou seekest to destroy a city and a mother in Israel: why wilt thou swallow up the inheritance of the Lord?

And Joab answered and said, Far be it, far be it from me, that I should swallow up or destroy.

The matter is not so: but a man of mount Ephraim, Sheba the son of

Bichri by name, hath lifted up his hand against the king, even against David: deliver him only, and I will depart from the city. And the woman said unto Joab, Behold, his head shall be thrown to thee over the wall.

Then the woman went unto all the people in her wisdom. And they cut off the head of Sheba the son of Bichri, and cast it out to Joab. And he blew a trumpet, and they retired from the city, every man to his tent. And Joab returned to Jerusalem unto the king.

Now Joab was over all the host of Israel: and Benaiah the son of Jehoiada was over the Cherethites and over the Pelethites:

And Adoram was over the tribute: and Jehoshaphat the son of Ahilud was recorder:

And Sheva was scribe: and Zadok and Abiathar were the priests:

And Ira also the Jairite was a chief ruler about David.

Then there was a famine in the days of David three years, year after year; and David enquired of the Lord. And the Lord answered, It is for Saul, and for his bloody house, because he slew the Gibeonites.

And the king called the Gibeonites, and said unto them; (now the Gibeonites were not of the children of Israel, but of the remnant of the Amorites; and the children of Israel had sworn unto them: and Saul sought to slay them in his zeal to the children of Israel and Judah.)

Wherefore David said unto the Gibeonites, What shall I do for you? and wherewith shall I make the atonement, that ye may bless the inheritance of the Lord?And the Gibeonites said unto him, We will have no silver nor gold of Saul, nor of his house; neither for us shalt thou kill any man in Israel. And he said, What ye shall say, that will I do for you.

And they answered the king, The man that consumed us, and that devised against us that we should be destroyed from remaining in any of the coasts of Israel,

Let seven men of his sons be delivered unto us, and we will hang them up

unto the Lord in Gibeah of Saul, whom the Lord did choose. And the king said, I will give them.

But the king spared Mephibosheth, the son of Jonathan the son of Saul, because of the Lord's oath that was between them, between David and Jonathan the son of Saul.

But the king took the two sons of Rizpah the daughter of Aiah, whom she bare unto Saul, Armoni and Mephibosheth; and the five sons of Michal the daughter of Saul, whom she brought up for Adriel the son of Barzillai the Meholathite:

And he delivered them into the hands of the Gibeonites, and they hanged them in the hill before the Lord: and they fell all seven together, and were put to death in the days of harvest, in the first days, in the beginning of barley harvest.

And Rizpah the daughter of Aiah took sackcloth, and spread it for her upon the rock, from the beginning of harvest until water dropped upon them out of heaven, and suffered neither the birds of the air to rest on them by day, nor the beasts of the field by night.

And it was told David what Rizpah the daughter of Aiah, the concubine of Saul, had done.

And David went and took the bones of Saul and the bones of Jonathan his son from the men of Jabesh-gilead, which had stolen them from the street of Beth-shan, where the Philistines had hanged them, when the Philistines had slain Saul in Gilboa:

And he brought up from thence the bones of Saul and the bones of Jonathan his son; and they gathered the bones of them that were hanged.

And the bones of Saul and Jonathan his son buried they in the country of Benjamin in Zelah, in the sepulchre of Kish his father: and they performed all that the king commanded. And after that God was intreated for the land.

The mourning of Rizpah

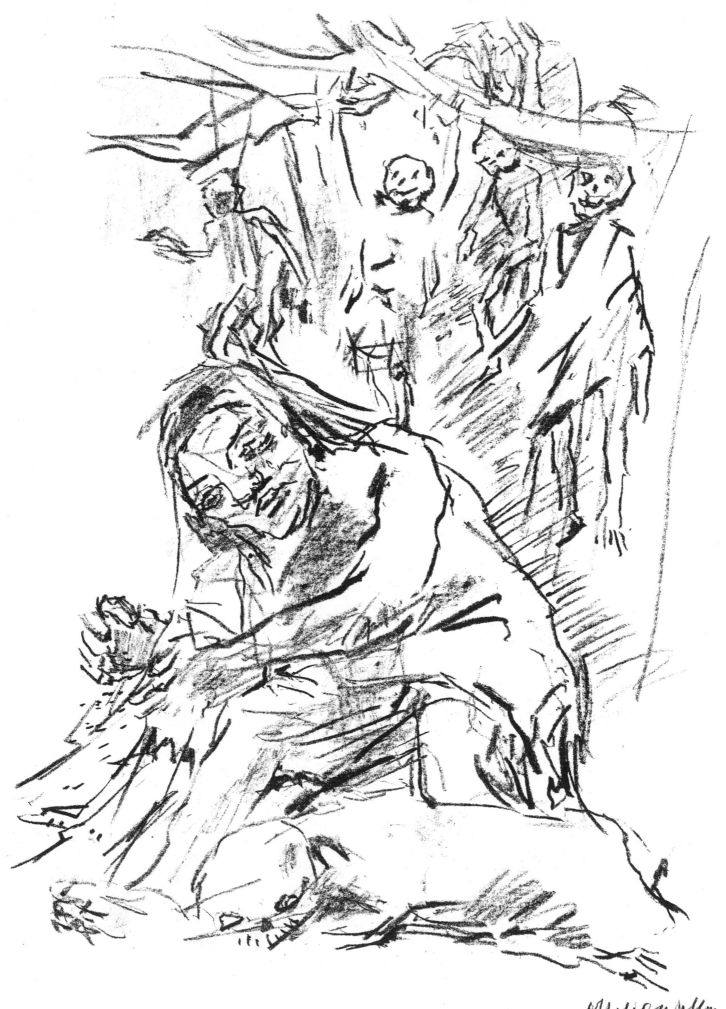

Moreover the Philistines had yet war again with Israel; and David went down, and his servants with him, and fought against the Philistines: and David waxed faint.

And Ishbi-benob, which was of the sons of the giant, the weight of whose spear weighed three hundred shekels of brass in weight, he being girded with a new sword, thought to have slain David.

But Abishai the son of Zeruiah succoured him, and smote the Philistine, and killed him. Then the men of David sware unto him, saying, Thou shalt go no more out with us to battle, that thou quench not the light of Israel.

And it came to pass after this, that there was again a battle with the Philistines at Gob: then Sibbechai the Hushathite slew Saph, which was of the sons of the giant.

And there was again a battle in Gob with the Philistines, where Elhanan the son of Jaare-oregim, a Beth-lehemite, slew the brother of Goliath the Gittite, the staff of whose spear was like a weaver's beam.

And there was yet a battle in Gath, where was a man of great stature, that had on every hand six fingers, and on every foot six toes, four and twenty in number; and he also was born to the giant.

And when he defied Israel, Jonathan the son of Shimeah the brother of David slew him.

These four were born to the giant in Gath, and fell by the hand of David, and by the hand of his servants.

And David spake unto the Lord the words of this song in the day that the Lord had delivered him out of the hand of all his enemies and out of the hand of Saul:

And he said, the Lord is my rock, and my fortress, and my deliverer;

The God of my rock; in him will I trust: he is my shield, and the horn of my salvation, my high tower, and my refuge, my saviour; thou savest me from violence.

I will call on the Lord, who is worthy to be praised: so shall I be saved from mine enemies.

When the waves of death compassed me, the floods of ungodly men made me afraid;

The sorrows of hell compassed me about; the snares of death prevented me;

In my distress I called upon the Lord, and cried to my God: and he did hear my voice out of his temple, and my cry did enter into his ears.

Then the earth shook and trembled; the foundations of heaven moved and shook, because he was wroth.

There went up a smoke out of his nostrils, and fire out of his mouth devoured: coals were kindled by it.

He bowed the heavens also, and came down; and darkness was under his feet.

And he rode upon a cherub, and did fly: and he was seen upon the wings of the wind.

And he made darkness pavilions round about him, dark waters, and thick clouds of the skies.

Through the brightness before him were coals of fire kindled.

The Lord thundered from heaven, and the most High uttered his voice.

And he sent out arrows, and scattered them; lightning, and discomfited them.

And the channels of the sea appeared, the foundations of the world were discovered, at the rebuking of the Lord, at the blast of the breath of his nostrils.

He sent from above, he took me; he drew me out of many waters;

He delivered me from my strong enemy, and from them that hated me: for they were too strong for me.

They prevented me in the day of my calamity: but the Lord was my stay.

He brought me forth also into a large place: he delivered me, because be delighted in me.

The Lord rewarded me according to my righteousness: according to the cleanness of my hands hath he recompensed me.

For I have kept the ways of the Lord, and have not wickedly departed from my God.

For all his judgments were before me: and as for his statutes, I did not depart from them.

I was also upright before him, and have kept myself from mine iniquity.

Therefore the Lord hath recompensed me according to my righteousness; according to my cleanness in his eye sight.

With the merciful thou wilt shew thyself merciful, and with the upright man thou wilt shew thyself upright.

With the pure thou wilt shew thyself pure; and with the froward thou wilt shew thyself unsavoury.

And the afflicted people thou wilt save: but thine eyes are upon the haughty, that thou mayest bring them down.

For thou art my lamp, O Lord: and the Lord will lighten my darkness.

For by thee I have run through a troop: by my God have I leaped over a wall.

As for God, his way is perfect; the word of the Lord is tried: he is a buckler to all them that trust in him.

For who is God, save the Lord? and who is a rock, save our God?

God is my strength and power: and he maketh my way perfect.

He maketh my feet like hinds' feet: and setteth me upon my high places.

He teacheth my hands to war; so that a bow of steel is broken by mine arms.

Thou hast also given me the shield of thy salvation: and thy gentleness hath made me great.

Thou hast enlarged my steps under me; so that my feet did not slip.

I have pursued mine enemies, and destroyed them; and turned not again until I had consumed them.

And I have consumed them, and wounded them, that they could not arise: yea, they are fallen under my feet.

For thou hast girded me with strength to battle: them that rose up against me hast thou subdued under me.

Thou hast also given me the necks of mine enemies, that I might destroy them that hate me.

They looked, but there was none to save; even unto the Lord, but he answered them not.

Then did I beat them as small as the dust of the earth, I did stamp them as the mire of the street, and did spread them abroad.

Thou also hast delivered me from the strivings of my people, thou hast kept me to be head of the heathen: a people which I knew not shall serve me.

Strangers shall submit themselves unto me: as soon as they hear, they shall be obedient unto me.

Strangers shall fade away, and they shall be afraid out of their close places.

The Lord liveth; and blessed be my rock; and exalted be the God of the rock of my salvation.

It is God that avengeth me, and that bringeth down the people under me,

And that bringeth me forth from mine enemies: thou also hast lifted me up on high above them that rose up against me: thou hast delivered me from the violent man.

Therefore I will give thanks unto thee, O Lord, among the heathen, and I will sing praises unto thy name.

He is the tower of salvation for his king: and sheweth mercy to his anointed, unto David, and to his seed for evermore.

Now these be the last words of David. David the son of Jesse said, and the man who was raised up on high, the anointed of the God of Jacob, and the sweet psalmist of Israel, said,

The Spirit of the Lord spake by me and his word was in my tongue.

The God of Israel said, the Rock of Israel spake to me, He that ruleth over men must be just, ruling in the fear of God.

And he shall be as the light of the morning, when the sun riseth, even a morning without clouds; as the tender grass springing out of the earth by clear shining after rain.

Although my house be not so with God; yet he hath made with me an everlasting covenant, ordered in all things, and sure: for this is all my salvation, and all my desire, although he make it not to grow.

But the sons of Belial shall be all of them as thorns thrust away, because they cannot be taken with hands:

But the man that shall touch them must be fenced with iron and the staff of a spear; and they shall be utterly burned with fire in the same place.

First Book of Kings

Chapter 1
Chapter 2, verses 1–12

Now king David was old and stricken in years; and they covered him with clothes, but he gat no heat.

Wherefore his servants said unto him, Let there be sought for my lord the king a young virgin: and let her stand before the king, and let her cherish him, and let her lie in thy bosom, that my lord the king may get heat.

So they sought for a fair damsel throughout all the coasts of Israel, and found Abishag a Shunammite, and brought her to the king.

And the damsel was very fair, and cherished the king, and ministered to him: but the king knew her not.

Then Adonijah the son of Haggith exalted himself, saying, I will be king: and he prepared him chariots and horsemen, and fifty men to run before him.

And his father had not displeased him at any time in saying, why hast thou done so? and he also was a very goodly man; and his mother bare him after Absalom.

And he conferred with Joab the son of Zeruiah, and with Abiathar the priest: and they following Adonijah helped him.

But Zadok the priest, and Benaiah the son of Jehoiada, and Nathan the prophet, and Shimei, and Rei, and the mighty men which belonged to David, were not with Adonijah.

And Adonijah slew sheep and oxen and fat cattle by the stone of Zoheleth, which is by En-rogel, and called all his brethren the king's sons, and all the men of Judah the king's servants:

But Nathan the prophet, and Benaiah, and the mighty men, and Solomon his brother, he called not.

Wherefore Nathan spake unto Bath-sheba the mother of Solomon, saying, Hast thou not heard that Adonijah the son of Haggith doth reign, and David our lord knoweth it not?

Now therefore come, let me, I pray thee, give thee counsel, that thou mayest save thine own life, and the life of thy son Solomon.

Go and get thee in unto king David, and say unto him, Didst not thou, my lord, O king, swear unto thine handmaid, saying, Assuredly Solomon thy son shall reign after me, and he shall sit upon my throne? why then doth Adonijah reign?

Behold, while thou yet talkest there with the king, I also will come in after thee, and confirm thy words.

And Bath-sheba went in unto the king into the chamber: and the king was very old; and Abishag the Shunammite ministered unto the king.

And Bath-sheba bowed, and did obeisance unto the king. And the king said, What wouldest thou?

And she said unto him, My lord, thou swarest by the Lord thy God unto thine handmaid, saying, Assuredly Solomon thy son shall reign after me, and he shall sit upon my throne.

And now, behold, Adonijah reigneth; and now, my lord the king, thou knowest it not:

And he hath slain oxen and fat cattle and sheep in abundance, and hath called all the sons of the king, and Abiathar the priest, and Joab the captain of the host: but Solomon thy servant hath he not called.

And thou, my lord, O king, the eyes of all Israel are upon thee, that thou shouldest tell them who shall sit on the throne of my lord the king after him.

Abishag and David

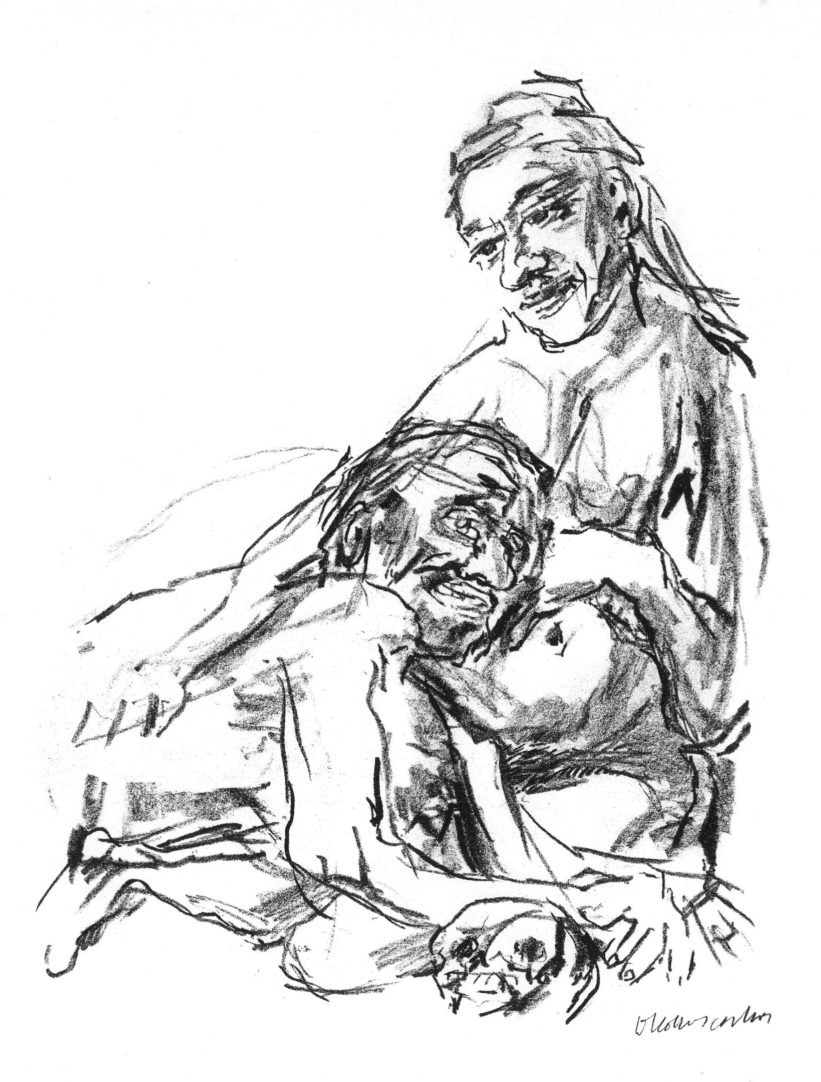

Otherwise it shall come to pass, when my lord the king shall sleep with his fathers, that I and my son Solomon shall be counted offenders.

And, lo, while she yet talked with the king, Nathan the prophet also came in.

And they told the king, saying, Behold Nathan the prophet. And when he was come in before the king, he bowed himself before the king with his face to the ground.

And Nathan said, My lord, O king, hast thou said, Adonijah shall reign after me, and he shall sit upon my throne?

For he is gone down this day, and hath slain oxen and fat cattle and sheep in abundance, and hath called all the king's sons, and the captains of the host, and Abiathar the priest; and, behold, they eat and drink before him, and say, God save king Adonijah.

But me, even me thy servant, and Zadok the priest, and Benaiah the son of Jehoiada, and thy servant Solomon, hath he not called.

Is this thing done by my lord the king, and thou hast not shewed it unto thy servant, who should sit on the throne of my lord the king after him?

Then king David answered and said, Call me Bath-sheba. And she came into the king's presence, and stood before the king.

And the king sware, and said, As the Lord liveth, that hath redeemed my soul out of all distress,

Even as I sware unto thee by the Lord God of Israel, saying, Assuredly Solomon thy son shall reign after me, and he shall sit upon my throne in my stead; even so will I certainly do this day.

Then Bath-sheba bowed with her face to the earth, and did reverence to the king, and said, Let my lord king David live for ever.

And king David said, Call me Zadok the priest, and Nathan the prophet, and Benaiah the son of Jehoiada. And they came before the king.

The king also said unto them, Take with you the servants of your lord,

ands cause Solomon my son to ride upon mine own mule, and bring him down to Gihon:

And let Zadok the priest and Nathan the prophet anoint him there king over Israel: and blow ye with the trumpet, and say, God save king Solomon.

Then ye shall come up after him, that he may come and sit upon my throne; for he shall be king in my stead: and I have appointed him to be ruler over Israel and over Judah.

And Benaiah the son of Jehoiada answered the king, and said, Amen: the Lord God of my lord the king say so too.

As the Lord hath been with my lord the king, even so be he with Solomon, and make his throne greater than the throne of my lord king David.

So Zadok the priest, and Nathan the prophet, and Benaiah the son of Jehoiada, and the Cherethites, and the Pelethites, went down, and caused Solomon to ride upon king David's mule, and brought him to Gihon.

And Zadok the priest took an horn of oil out of the tabernacle, and anointed Solomon. And they blew the trumpet; and all the people said, God save king Solomon.

And all the people came up after him, and the people piped with pipes, and rejoiced with great joy, so that the earth rent with the sound of them.

And Adonijah and all the guests that were with him heard it as they had made an end of eating. And when Joab heard the sound of the trumpet, he said, wherefore is this noise of the city being in an uproar?

And while he yet spake, behold, Jonathan the son of Abiathar the priest came: and Adonijah said unto him, Come in; for thou art a valiant man, and bringest good tidings.

And Jonathan answered and said to Adonijah, Verily our lord king David hath made Solomon king.

And the king hath sent with him Zadok the priest, and Nathan the

'God save King Solomon!'

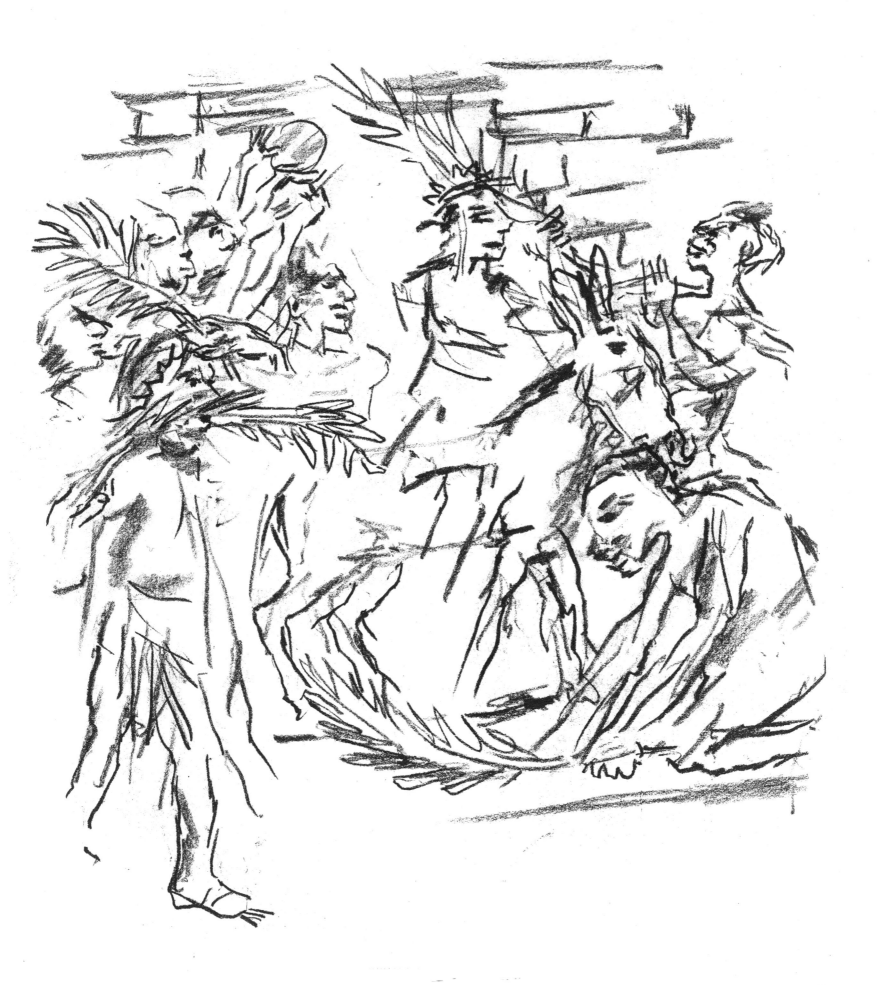

prophet, and Benaiah the son of Jehoiada, and the Cherethites, and the Pelethites, and they have caused him to ride upon the king's mule:

And Zadok the priest and Nathan the prophet have anointed him king in Gihon: and they are come up from thence rejoicing, so that the city rang again. This is the noise that ye have heard.

And also Solomon sitteth on the throne of the kingdom.

And moreover the king's servants came to bless our lord king David, saying, God make the name of Solomon better than thy name, and make his throne greater than thy throne. And the king bowed himself upon the bed.

And also thus said the king, Blessed be the Lord God of Israel, which hath given one to sit on my throne this day, mine eyes even seeing it.

And all the guests that were with Adonijah were afraid, and rose up, and went every man his way.

And Adonijah feared because of Solomon, and arose, and went, and caught hold on the horns of the altar.

And it was told Solomon, saying, Behold, Adonijah feareth king Solomon: for, lo, he hath caught hold on the horns of the altar, saying, Let king Solomon swear unto me today that he will not slay his servant with the sword.

And Solomon said, If he will shew himself a worthy man, there shall not an hair of him fall to the earth: but if wickedness shall be found in him, he shall die.

So king Solomon sent, and they brought him down from the altar. And he came and bowed himself to king Solomon: and Solomon said unto him, Go to thine house.

Now the days of David drew nigh that he should die; and he charged Solomon his son, saying,

I go the way of all the earth: be thou strong therefore, and shew thyself a man;

And keep the charge of the Lord thy God, to walk in his ways, to keep his statutes, and his commandments, and his judgments, and his testimonies, as it is written in the law of Moses, that thou mayest prosper in all that thou doest, and whithersoever thou turnest thyself:

That the Lord may continue his word which he spake concerning me, saying, If thy children take heed to their way, to walk before me in truth with all their heart and with all their soul, there shall not fail thee (said he) a man on the throne of Israel.

Moreover thou knowest also what Joab the son of Zeruiah did to me, and what he did to the two captains of the hosts of Israel, unto Abner the son of Ner, and unto Amasa the son of Jether, whom he slew, and shed the blood of war in peace, and put the blood of war upon his girdle that was about his loins, and in his shoes that were on his feet.

Do therefore according to thy wisdom, and let not his hoar head go down to the grave in peace.

But shew kindness unto the sons of Barzillai the Gileadite, and let them be of those that eat at thy table: for so they came to me when I fled because of Absalom thy brother.

And, behold, thou hast with thee Shimei the son of Gera, a Benjamite of Bahurim, which cursed me with a grievous curse in the day when I went to Mahanaim: but he came down to meet me at Jordan, and I sware to him by the Lord, saying, I will not put thee to death with the sword.

Now therefore hold him not guiltless: for thou art a wise man, and knowest what thou oughtest to do unto him; but his hoar head bring thou down to the grave with blood.

So David slept with his fathers, and was buried in the city of David.

And the days that David reigned over Israel were forty years: seven years reigned he in Hebron, and thirty and three years reigned he in Jerusalem.

Then sat Solomon upon the throne of David his father; and his kingdom was established greatly.

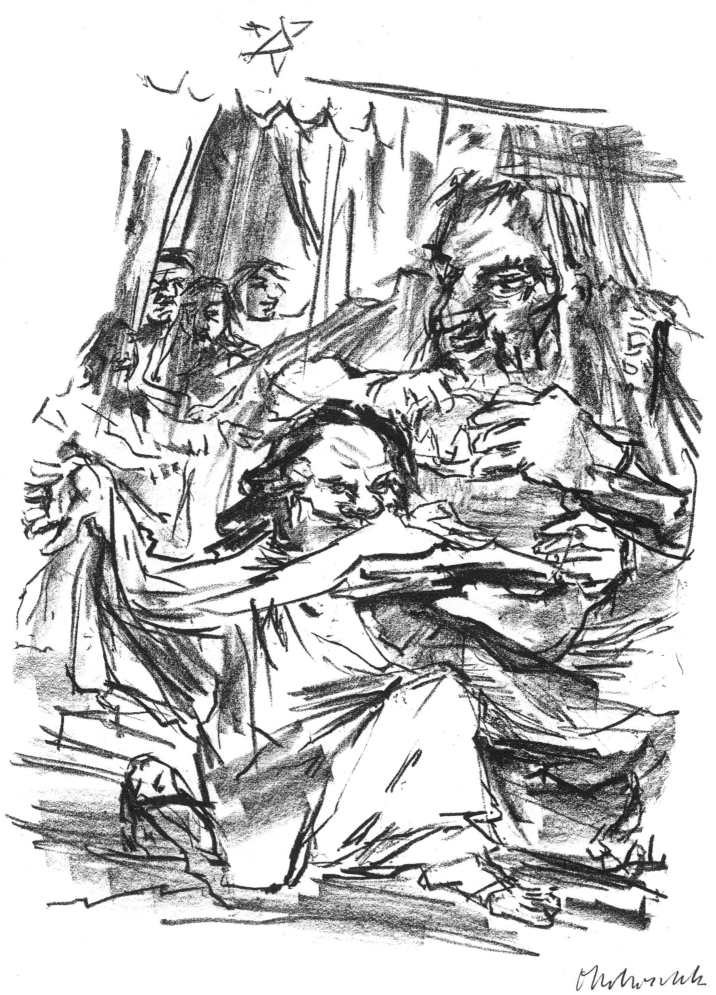